Virtual Seminar

on the

Bioapparatus

Acknowledgements

We would like to thank those at the Banff Centre who worked on the formulation of the residency: Lorne Falk, Michael Century, Vern Hume and Kevin Elliott. We would also like to thank Mary Anne Moser, editor of the discussion papers and the publication; Pauline Martin, seminar coordinator; and Maureen Lee, Jack Butler, Ingrid Bachmann, Colin Griffiths, Media Arts Associates, Technical Services staff and the Banff Centre support staff.

We would also like to thank the Canada Council Media Arts Program for financial assistance through Centre d'information Artexte in support of background research on the issues of technology and culture.

Catherine Richards
Nell Tenhaaf
seminar leaders

Credits

Pauline Martin
seminar coordinator

Mary Anne Moser
editor and designer

Wendy Robinson
typesetter

Monte Greenshields
photographer

Mary Squario, M.J. Thompson
proofreaders

Diana Burgoyne performance,
October 27, 1991, Walter Phillips Gallery;
design Lisa Moren
cover

This publication documents the proceedings of a seminar held October 28 and 29 during the fall session of the Art Studio and Media Arts residency programs, October 7 to December 14, 1991. The Banff Centre for the Arts is grateful for financial support from the Canadian Institute for Research on Cultural Enterprises for the seminar and publication.

The Banff Centre
for the Arts

Contents

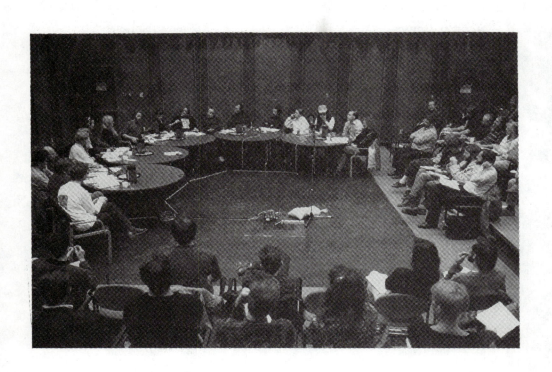

Introduction to the *Bioapparatus*

Catherine Richards
Nell Tenhaaf

Introduction

This publication documents the proceedings of a two-day seminar held at the Banff Centre for the Arts, October 28 and 29, 1991. The seminar took place within the framework of a ten-week residency on the *bioapparatus*, a collaborative project of the Art Studio and Media Arts programs of the Banff Centre. Through its ongoing residency programs, the Centre offers a unique context for bringing together a multidisciplinary group to address important cultural issues.

Given today's "hyperreal" environment of image saturation on the one hand, leaving art and artists in what has been called a crisis of representation, and the development of highly sophisticated representational technologies on the other hand, it has become crucial to open up and expand the discourse on art and new technologies. This territory has been interpreted most often through the lens of technology itself, disconnected from the broad range of art practices and cultural discourses circulating today.

The artists, composers and writers in the residency have been brought together principally for the purpose of advancing their own art production. In addition, we have built a parallel objective into the residency – namely, to map significant shifts in philosophical and representational issues that are coextensive with technological change.

The Virtual Seminar

One of the intentions of the residency has been to expand the discourse around technology and culture. As organizers of the seminar, we wanted to encourage debate and to involve a large number of people in mapping this vast territory. To this end, we invited short submissions in response to a text outlining issues concerning the *bioapparatus*. These contributions, submitted by residents as well as interested people who could not attend the residency, formed the discussion document for what became known as the virtual seminar on the *bioapparatus*. As forums for diverse voices, the seminar and publication reflect unresolved and contentious positions in this field rather than a universal perspective.

The papers in the discussion document were grouped into ten chapters, each of which addressed a specific concern related to the *bioapparatus*. Five of these were addressed on each day. The discussions surrounding each area began with a presentation by one of the residents who summarized and responded to issues raised in the papers. At the end of each presentation, the debate was opened up to residents to continue the exchange of ideas that had been taking place since the residency began on October 6. At the end of each day, the discussion was opened up to the floor. This publication draws on the transcripts of the proceedings and is structured to reflect the organization of the seminar itself. The proceedings have been edited and slightly reordered for clarity.

Genealogy

The term *bioapparatus* was coined specifically by us for the residency. It combines an understanding of particular philosophies of technology with theories about the technological apparatus, the technologized body, and the new biology. To describe the origins of such an open-ended word, one that seems to resonate even without explanation, is to offer only a

précis of a large and complex territory. Presented here is a synopsis of the theoretical frameworks that have shaped our conception of the *bioapparatus*.

The philosophical grounding of our thinking on technology is influenced by the perspectives of three thinkers working within a Canadian context. Arthur Kroker published an insightful study of the Canadian philosophers of technology Marshall McLuhan, Harold Innis and George Grant, who propose what he calls an original and comprehensive discourse on technology.[1]

McLuhan is widely known in North America as the electronic media guru of the 1960s. Kroker characterizes McLuhan as a rhetorician and a technological humanist in comparison to the existentialist Grant and Innis the realist. McLuhan's cosmos is not a futureworld of processed experience but a global information environment already in place. Among his more revolutionary propositions, several of which have become platitudes of the media age, is the idea of body extension: "All media are extensions of some human faculty – psychic or physical."[2] So the *technological sensorium* is an extension of ourselves which envelops us and in which, from McLuhan's redemptive perspective, we can all participate with creative freedom.

George Grant's lament for humanity as trapped creatures, "half-flesh/half-metal," exemplifies his Nietzschean pessimism about technological society. He envisions the emergence of the "will to technique" as "will to power," in fact the "will to will." What seems here to be an unredeemable conception of the modern world, a 1960s mindset very different from McLuhan's, offers at least a warning about the impact of the technological drive for mastery and for progress. Taken as a fixed and cul-de-sac position, it offers a starting point for deconstructive readings that break out of the limits of Grant's fundamentally conservative categories of thinking and feeling.

Innis is the political/cultural observer who saw clearly, in writings as early as the 1930s, the position of the Canadian psyche, "trapped between the cultural legacy of its European past and the expanding 'space' of American empire."[3] For Innis, media technologies are "monopolies of space" that work against time, time as historical remembrance. His is not a nostalgic vision of the past, but a probing of possible identity and of survival.

Through this synopsized philosophical overview, the technological sensorium emerges as a reflection of shifting yet specific social and cultural value systems. The debates that developed in the mid-seventies around the workings of cinema as an ideological apparatus, particularly through the British journal *Screen*, are a second theoretical underpinning to the *bioapparatus*. Articles published around 1975 by Jean-Louis Baudry, Christian Metz and Laura Mulvey are key to this area.[4] Baudry proposes the cinematographic apparatus as constituted through the entire context, structure, and signification system of cinema. It is a closed system that creates its own desire for itself. It instils this desire, among others, in the spectator through its simulation of individual subjectivity. Metz and Mulvey add that scopophilia (or pleasure in looking) and the spectator-text relationship in cinematic narrative are, in psychoanalytic terms, the very conditions of subjectivity.

Paul Virilio, on the other hand, specifically examines cinema as an apparatus of war. Many of his insights anticipated what more recent technologies have made apparent. "Space is made translucent and its military commander clairvoyant...by technological processes of foresight and anticipation."[5] This cinematic process is no longer reserved for the high command, but has become a public visual display (in the new world order). Through these theorizations of the ideological apparatus, it is possible to conceptualize individual subjectivities as constructed through technologies. The *bio* of *bioapparatus* is primarily an issue of subjectivity, how it is constituted and how it is located in relation to the body.

1 Arthur Kroker, *Technology and the Canadian Mind: Innis/McLuhan/Grant* (Montreal: New World Perspectives, 1984), 7. Arthur Kroker has added his own perspective on technology in a series of works, the most recent being *The Possessed Individual: Technology and the French Postmodern* (Montreal: New World Perspectives, 1992).
2 Ibid, 56.
3 Ibid, 95.
4 Jean-Louis Baudry, "Ideological Effects of the Basic Cinematographic Apparatus," *Film Quarterly* 28:2 (Winter 1974-75), 39-47; Christian Metz, "The Imaginary Signifier," *Screen* 16:2 (1975), 14-76; Laura Mulvey, "Visual Pleasure and Narrative Cinema," *Screen* 16:3 (1975), 6-18. See also *The Cinematic Apparatus*, eds. Teresa de Lauretis and Stephen Heath (New York: St. Martin's Press, 1980).
5 Paul Virilio, *War and Cinema, The Logistics of Perception* (London: Verso, 1989), 77.

The cinematic apparatus can be linked to another apparatus, the bachelor machine. Constance Penley considers Baudry's theory to be a "bachelor construct," because of its phallocentric position in the unconscious and its mechanism for reproducing itself by itself – for situating desire only within its own closed masculine terms.[6] The bachelor machine construct actually has its origins in the art domain, in Marcel Duchamp's infamous *La mariée mise à nue par ses célibataires, même* of the 1920s. As a dadaist anti-art gesture and as the deconstructive device described by Penley, this artist's machine has taken on a much broader role as a literary trope referring to a (masculine) auto-erotic and nihilistic narrative logic.

In this context, a brief mention of the "influencing machine" is also in order. Joan Copjec writes about this model, proposed by Victor Tausk, a contemporary of Freud. Freud's patients describe the influencing machine as controlling them, persecuting them, and making them "see pictures:...the machine is generally a magic lantern or cinematograph."[7] The "phallic machine reproducing only male spectators"[8] is thus deeply embedded in psychoanalytic discourse and consequently in poststructuralist thought including feminist theories.

If psychoanalytic discourse has been the central construct for examining issues of the subject, the notion of simulation has become another trope for much postmodernist theorizing. It has provided grounds for reflection on contemporary culture as well as an oblique link with developments in representational technologies (Virilio, Deleuze, Baudrillard, Lyotard, Kroker and Eco). The notion of an apparatus becomes specific – both as metaphor and diagnosis of a general condition.

Gilles Deleuze comments on the links of the apparatus of power with new technologies. He observes that "psychoanalysis...is the forced choice...because it gave the binary machine new material and a new extension, consistent with what we expect of an apparatus of power."[9] These observations support his encompassing reflection of "the machine as social in its primary sense...in the structure it crosses, to the men (sic) it makes use of, the tools it selects, and the technologies it promotes":[10] that is, the apparatus can be seen as deeply embedded in the social fabric.

This conception of a fully implanted technological order is also evident in the new biology discourse of boundary transgression, whose foremost theoretician is Donna Haraway. Her conceptualization of the feminist cyborg is a triple characterization of a machine and organism hybrid, a creature of social reality and a creature of fiction.[11] Haraway describes the place for both pleasure and responsibility in the breakdown of boundaries between human, animal and machine. She merges the social with myth and fiction in perceiving both the machine and organism as "coded texts," both engaged in questions that are as radical as survival itself.

Situating Technology, Considering Gender Issues

In formulating the residency, the seminar and this publication, we have approached technology in the widest possible sense. Technology often specifically refers to an instrument or a tool which might be articulated in hardware or software. Here, it is considered to be a product of cultural, social and political practices that are already firmly in place. As such, technology develops within existing frameworks that specify what counts as valid knowledge and how it can be obtained. The framework is in place long before the will or the resources are directed towards making a specific instrument: relational models are crystallized into technological objects. Therefore, technology is not neutral but embedded in social and cultural contexts.

This positon on technology underlies our approach to specific technologies such as virtual reality or virtual environment technology. Virtual reality is particularly interesting for its

6 Constance Penley, "Feminism, Film Theory and the Bachelor Machines," *m/f* 10 (1985), 39-59.
7 Joan Copjec, "The Anxiety of the Influencing Machine," *October* 23 (Winter 1982), 54. See also Jeanne Randolph, "Ambiguity and the Technical Object," *Vanguard* 13:7 (1984), 24-27.
8 Ibid., 57.
9 Gilles Deleuze and Claire Parnet, *Dialogues*, translated by Hugh Tomlinson Barbara Habberjam (New York: Columbia University Press), 21.
10 Ibid.
11 Donna Haraway, "A Manifesto for Cyborgs: Science, Technology, and Socialist Feminism in the 1980's," *Socialist Review* 80 (1985), 65-107.

extreme intimacy with the body. In fact, this technolgy is driven by reading signals from the body. As our most recent form of representational technology, it raises questions about the construction of self (or subjectivity). It also challenges traditional thinking that relies on a distinction between subject and object as it functions directly with the body's multi-sensory physiological thresholds.

The intense public attention directed toward virtual reality over the past two years has little to do with the hardware and software itself. In effect, a public mythology is being constructed about what virtual reality will be. The development of this mythology is as important as the development of the technology itself. The narratives and metaphors imply logical solutions within which research, development and representation will take place. For example, one of the phrases borrowed by the technological community from recent science fiction is "jacking into cyberspace,"[12] which is used to describe entering a virtual environment. This kind of phrase incorporates assumptions about how the simulation of communication and physical experience can be imagined and acted upon.

To address technology in a cultural context requires a range of input. The artists in this residency range from those who integrate technology as the means and/or the subject of their work to those who address issues related to the contemporary technoscape. In this way the residency was designed to generate a broad interdisciplinary discussion, and the pertinence of various art practices in the social field has been addressed throughout the process.

Questions concerning gender have been central to contemporary art practices of the last decade, and the *bioapparatus* is certainly a gendered territory. The body is biologically and socially gendered and, in an equally profound sense, technology can be seen as gendered. The gendered nature of technological development itself poses questions about authorship, intrinsic structure and power. The relation of technology to the body and to subjectivity and the effects of technologies on femininity and masculinity as they are constructed in different social contexts are issues that constitute a very complex subject area.

Rather than create a category in the discussion paper that focused on gender issues, we preferred to have these questions, like questions of race, class and cultural differences integrated as much as possible into all of the discussions. For example, several of the respondents addressed the ideological conditions that shape the western notion of progress through science and technology. This idea encompasses gender issues that can be raised within a reexamination of historical and contemporary constructs of nature and culture, mind and body, and machine and spirit.

What follows is the call for submissions that invited participation in the seminar and formed the basis of this publication.

12 William Gibson, *Neuromancer* (New York: Ace Books, 1984).

October 10, 1991

Dear ————

We are inviting you to participate in a "virtual" seminar to be held this fall, 1991, as part of an artists' residency at The Banff Centre for the Arts, in Banff, Alberta, Canada.

The 10-week residency which involves 21 artists and writers is centred around the notion of the *bioapparatus*, a term we use to cover a wide range of issues concerning the technologized body as well as the current cultural and political manifestations of one specific new technology, virtual reality.

Within the framework of the residency, we are conducting a seminar that will be a site for input and responses around the issues of the *bioapparatus*. As the subject is vast, we want to encourage discourse and debate, and to involve a large number of people in mapping this territory. We are asking people whose work we believe to be important to the debate, as well as each of the 20 residency participants who will be at The Banff Centre, to contribute one page in response to the notion of the *bioapparatus*.

We are inviting you to participate through a short print contribution. This submission, along with others, will form the basis of discussion during the seminar at the end of October. We feel that your written contribution would be a valuable one, as the primary reason for undertaking such a thematic residency is to encourage multidisciplinary discussion in a field where much debate is needed. At the end of the residency the resulting texts will be published in magazine/tabloid form and distributed to each contributor. We are also in discussion with an international publisher who has expressed interest in the project. In order to publish your submission, we require that you sign one copy of the attached agreement, which must be returned with your submission.

The enclosed material describes the background to the *Bioapparatus* Residency and includes a framework for discussion which we would like you to respond to, details about the seminar, a list of the actual residency participants, and a list of people invited to contribute as virtual participants.

We would greatly appreciate your contribution, as it will become the basis for what we consider to be a timely and important debate. We will be following up this letter by phone in case you would like more information.

Sincerely,

Catherine Richards and Nell Tenhaaf
Seminar Leaders

A VIRTUAL SEMINAR ON THE BIOAPPARATUS

BACKGROUND TO THE RESIDENCY

The Art Studio program at The Banff Centre in Banff, Alberta, offers three 10-week residencies a year, bringing together a group of 20 artists, writers and theoreticians to address themes of current cultural interest.

For the fall 1991 residency, we formulated a residency theme and suggested participants in the context of a collaboration between Art Studio and Media Arts programs of The Banff Centre. The collaboration is a fortuitous one as it draws on and develops our overlapping interests as independent cultural producers in issues of new technologies, not the least of which concerns what could be meant by the term "new."

The residency is related to a longer term project at The Banff Centre called *Art and Virtual Environments*. This project is directed toward artistic use of virtual reality technology. The plan is to ultimately make virtual reality technology available to artists through the Media Arts Program of The Banff Centre. This process will begin during the *bioapparatus* residency by providing an on-site virtual reality system.

CONCEPTUAL FRAMEWORK

With Michael Century, Lorne Falk and Vern Hume (Banff Centre for the Arts directors of Program Development, Art Studio and Media Arts respectively) we constructed a residency on the *bioapparatus*. As a general framework, we agreed to look at the technological apparatus in its intimacy with the body, examining the history of this interrelationship and its sociocultural implications. Such issues have constituted the site for much of the postmodernist debate on representation and the pronounced cultural shifts of the past few decades.

The *bioapparatus* residency will explore questions of the integrity of the body and of subjectivity. The apparatus, as we construe it, is itself a perceptual model, a reflection of social and cultural value systems, of desires. It can be seen as a metaphor that not only describes but generates subjectivity, a subjectivity problematized by the objectifying effect of any technological instrument. The apparatus splits the body, the person, into subject and object, and its history thus merges with the philosophical history of dualism: body/mind, nature/culture, female/male. One question posed by feminist critiques of technology in the context of media, science and medicine is whether the historically constructed subject/object relation can be reconstituted so that its power dynamic is one of commonality and attunement rather than objectification and conquest.

Virtual reality or virtual environment technology is of particular interest in the context of the *bioapparatus*. It is a symptom as well as an instrument of a re-ordering of perception and, one can anticipate, of power relations. The current mythology surrounding the

technology reconstitutes the mind/body opposition, and raises issues of "bodily materiality" (a term proposed by Rosi Braidotti). As such, virtuality can be looked at as an expression of social discourses that are already in place. One of the intentions of the residency is to address the broader context of sociocultural shifts that are both the cause and symptom of technological changes.

Some other issues related to the *bioapparatus* are:
- the idea of machines as essentially social assemblages
- the tool as a political site for shifts in the mediascape and its definition: the military, the American "world culture" and its media, the drug cowboys, medicine
- the fictions of science and the science of fiction
- "man"/machine interaction, cyborgs, boundary degeneration
- artists' definitions of machines: futurism, bachelor machines

PLEASE RESPOND

The apparatus has probed, extended and blurred the boundaries between viewer and viewed, knower and known. Virtual reality can be seen as one moment on this trajectory. The apparatus has now become so sophisticated that it presents itself as merging with the body – becoming the *bioapparatus* – obscuring the borders drawn by instrumentality and redefining body functions of perception, sensations, understanding.

What is the most pressing issue, for you, concerning the *bioapparatus*? What would you add to this description of the *bioapparatus*?

Please send a one-page response, typed or legibly handwritten, including original drawings or diagrams if you wish, by September 30, 1991, along with the enclosed Publication Agreement. No submissions can or will be used without a signed copy of this agreement.

 To: Pauline Martin
 Project Coordinator
 The Banff Centre, Box 1020
 Banff, Alberta T0L 0C0
 Canada
 Fax: (403)762-6659

Thank you very much for your contribution. We are excited about the emerging discourse on this subject and look forward to compiling the results of this project. Please ensure you enclose an address to which your copies of the publication can be forwarded.

Catherine Richards and Nell Tenhaaf
Seminar Leaders

Residents' Biographies

Mary Ann Amacher

Educated in music, acoustics and computers, Mary Ann Amacher is a composer, performer and multi-media artist. Her work is known for its originality and dramatic architectural staging of music and sound. She has produced several well-known series of multi-media works in the United States and Europe.

Wende Bartley

Wende Bartley has composed for solo tape, chamber ensembles, film, theatre and dance. She works for *Musicworks* magazine as business manager and cassette editor, is involved in community radio and is on the board of the Canadian Electroacoustic Community. She creates sonic images and landscapes that may help the listener access knowledge that the artist feels is needed for the survival of humanity – knowledge which has been buried in patriarchal cultures.

Eleanor Bond

Eleanor Bond produces large painted images that are visual forms of future fictions. These images combine narrative material with the results of research into historical, contemporary and futuristic forms of social and physical structures. She has taught at the University of Manitoba and conducted research in the United States and Europe. Her work is exhibited internationally.

Adam Boome

Adam Boome was born in Gravesend, England, in 1964 and has always been interested in pop music, pushing buttons and watching television. Boome lived for four years in Germany where he enjoyed being a stranger – he now finds himself presented as a German artist. His work lies somewhere strangely between Kraftwerk, Sol Lewitt and Sesame Street.

Diana Burgoyne

Using the human body as a transmitter, Diana Burgoyne uses sound in performance to explore the relationships between people and technology. Originally from Calgary, Burgoyne received a master of fine arts degree from the University of California, Los Angeles (1985) and a bachelor of fine arts from the University of Victoria. She has presented her work in exhibitions and performances across Canada, the United States and in Holland.

He Gong

He Gong is one of the principal activists of avantgarde art in western China. He has worked vigorously for many years to expand research and education in modern art and, more recently, has begun to apply postmodern strategies in his work. Under difficult conditions, he seeks to foster and develop new art in China. He has explored various artistic languages and materials, recently focusing on installation.

Doug Hall

Doug Hall is a San Francisco-based media artist who has been working with video, installation, sculpture and photography since the early 1970s. His work has been exhibited in

museums in the United States and Europe and is included in several private and public collections, including the San Francisco Museum of Modern Art, the Museum of Modern Art (New York) and the Contemporary Art Museum (Chicago). He is an associate professor at the San Francisco Art Institute where he has taught in the Department of New Genres: Performance/Video since 1981.

Carl Eugene Loeffler

Carl Eugene Loeffler, Chief Executive Officer and founder of *Art Com,* was recently appointed Fellow to the STUDIO for Creative Inquiry at Carnegie Mellon University. He will be responsible for connectivity projects: ASCII text exchanges, ISDN and graphic exchanges and experiments in cyberspace nets. Loeffler resides in San Fransciso, California.

Robert McFadden

Robert McFadden is a visual artist whose current work considers the social construction of the individual through images of gender in historical and contemporary representations of the human body. He is perhaps best known for a recent series of performances which draw upon experiences common to art communities across Canada. These works question the use of concepts such as nature and nation in cultural narratives addressing the issue of identity. McFadden's work has been shown in galleries, theatres and public spaces across Canada and England.

George Bures Miller

George Bures Miller is a multi-media artist who uses diverse materials to address issues dealing with communication, personal identity and technology. Though grounded within specific concerns, his work retains enigmatic qualities which are intended to allow for an open-ended dialogue with the viewer. A graduate of the photo/electric arts program at the Ontario College of Art, he has exhibited his work across Canada.

Robin Minard

Since 1987, Robin Minard has worked as an independent composer at the electroacoustic studio of the Technische Universitat Berlin. In 1989, he resided in Paris at the Canada Council studio for musicians and in 1990, was guest artist of the Deutsche Akademischer Austauschdienst (D.A.A.D.) Berliner Kunstler program. An important part of his work focuses on environmental music with the creation of ambient works for electroacoustic sculptures or specific speaker installations. He has recently been developing an interactive system for environment-dependent musics.

Michael Naimark

Michael Naimark has straddled the research and arts communities for the past twelve years. He was instrumental in making some of the first videodiscs and moviemaps and has exhibited widely and served as art faculty at San Francisco State University, California Institute of the Arts, and the San Francisco Art Institute. He received a bachelor of science degree in Cybernetic Systems from the University of Michigan and a master of arts degree in Visual Studies and Environmental Art from Massachusetts Institute of Technology.

Lawrence Paul

Lawrence Paul is a painter currently living in Fort St. James, B.C. His work explores political, historical, environmental and cultural issues and has been exhibited throughout North America including the Canadian Museum of Civilization, Sacred Circle Gallery of American Indian Art and Wallace Galleries. His work is in the collections of the Department of Indian Affairs, Ottawa, the Philbrook Art Centre and the Staatlache Museum.

Catherine Richards

Working initially in drawing, video and performance, in Canada, Catherine Richards is interested in the simulation of image making and the body by new technologies. As co-originator of the *New Museum* video project, which examined the museum as a medium and a prototype of visual display, she explored the interplays of computer visual technologies as the basis for visual structure. She recently spoke at the Institute for Contemporary Art in London on virtual reality as a metaphoric image.

Warren Robinett

Warren Robinett is a designer of interactive computer graphics. He has designed video games (Atari 2600 *Adventure*, 1978), educational software (*Rocky's Boots*, 1982) and software for virtual reality systems (NASA's Virtual Environment Workstation, 1987). Since 1989, he has directed the Head-Mounted Display Project at the University of North Carolina. His work aims to use technology to expand the range and breadth of human perception – to make the imperceptible visible.

Kathleen Rogers

A graduate of the Slade School of Art, Kathleen Rogers works as a video, installation and computer-based artist. Since 1985, she has also worked as a part-time lecturer and visiting tutor for multi-media and performance work in art schools throughout Britain. She was nominated the computer representative to the Slade School of Art in 1987 when she was selected to produce work for the Venice Bienale. She has recently been elected to the advisory committee for a forthcoming International Festival of Video and New Media Art to be held in London in 1993 and is currently involved in research into virtual technology.

David Rokeby

David Rokeby is a visual artist, composer, writer, and designer of software and hardware. Most of his work involves a high degree of explicit interaction with the public. He is best known for his work *Very Nervous System*, which uses video cameras, computers and synthesizers to create an interactive sound environment in which gestures are translated into sound or music. He has exhibited in Canada, Japan, the United States and Europe.

David Rothenberg

David Rothenberg is a writer and musician concerned with the ambiguous place of humanity within nature. He has performed internationally, and his piece *In the Rainforest* was featured at the Tanglewood Contemporary Music Festival. His doctoral thesis, *Humanity Extended: Technology and the Limits of Nature*, will be published by the University of California Press. He collaborated with Arne Naess on *Ecology, Community and Lifestyle* (Cambridge University Press) and was featured on the CBC program "Ideas: The Age of Ecology."

Daniel Scheidt

Since studying percussion and composition at the University of Victoria and computer science at Queen's University, Daniel Scheidt has pursued an active interest in software as a compositional medium. A respect for improvisation and live performance has led to the development of several personalized, computer-based instruments. His recent work focuses on interactive systems which respond to acoustic input. An associate composer of the Canadian Music Centre, Scheidt's work has been broadcast by the CBC and presented in concerts, festivals and conferences throughout Canada and Europe.

Nell Tenhaaf

Nell Tenhaaf is a first-generation Canadian of Dutch origin who moved to Montreal from Oshawa, Ontario, in 1969. She is interested in the interconnection of language and the production of knowledge. In the past few years she has been making work that looks at the "hidden texts" of scientific representations and the relationship between different kinds of knowledge about the body. She produced an interactive videodisc installation at the Western Front in Vancouver last December. She is a writer and reviewer and currently teaches at the University of Ottawa.

Chris Titterington

Chris Titterington is a museum curator and artist. Within the museum his academic specialities are eighteenth-century aesthetics and contemporary art. He has recently adjusted his schedule to devote more time to sculpture, painting and video. He is currently interested in zoology, anthropology and sociobiology and the constellation of ideas and values following from the Romantic-modern concept of nature. His recent work looks at mental phenomena as natural phenomena.

David Tomas

David Tomas is an artist and anthropologist whose work explores the cultures of imaging systems and the production of hybrid identity through installation, performance-based installation, and sound. He is currently co-organizing a conference on "Art as Theory/Theory and Art," to be held at the University of Ottawa in November. In addition to articles on ritual and photography, he has written on technicity in William Gibson's novels and most recently on Gibsonian cyberspace. He is in the process of writing a book on the history of western technologies of observation and representation on the Andaman Islands.

Fred Truck

Fred Truck is head programmer and systems designer for *Art Com*. Residing in Des Moines, Iowa, he has done all his programming and correspondence for *Art Com* (located in San Francisco, California) through the telecommunications powers of the virtual office. Truck also is working with an artificially intelligent artwork, ArtEngine, which autonomously generates original images.

Inez van der Spek

Inez van der Spek is a scholar in theology, literary theory and Spanish and a playwright for youth theatre. She is writing a doctoral thesis on "Transcendence, Sexual Difference, and the Body in the Science Fiction of James Tiptree, Jr." She wants to explore possible connections between feminist theological concepts of transcendence and science fiction's images of cyborgs, alien bodies and transformed relations of space and time.

Natural Artifice

Is there any kind of defensible dualism between the concepts of natural and artificial?

Char Davies

There was a pre-Columbian culture in South America that educated its priests by keeping them in a cave from birth. For nearly a decade the children lived in darkness and silence, contemplating the internal reality of the world. They were then released into the light of day and the flowing reality of nature with its myriad of life forms. This experience must have given them a profound reverence for life – not exactly Plato's allegory. Western culture, on the other hand, has denied its embeddedness in nature for centuries, valuing mind over body, and humans (western, white, male) over every living creature, categorizing the world as a collection of objects to be subjugated for human use. With such a worldview, it is not surprising that we have made a mess.

And now, just as more of us were hoping the Cartesian paradigm was on its last gasp, virtual reality has appeared. It beckons us further, in lemming-like flight, from the visceral reality of our bodies and our interdependency with nature. It tantalizes us with even more power and control than we have as a species already. It offers us escape from an increasingly desecrated planet into the clean orderly world of our minds. This is not surprising, given the origins of the technology – specifically, the military with its urge for domination and power, and the space industry with its quest to leave the planet earth for untrampled virgin territory.

Regardless of the name, virtual reality, and all it infers, the inclusive three-dimensional environments of virtual reality are not a reality at all, but (only) a representation of human knowledge. If we create a model of a bird to fly around in virtual space, the most this bird can ever be, even with millions of polygons and ultra-sophisticated programming, is the sum of our (very limited) knowledge about birds – it has no otherness, no mysterious being, no autonomous life. What concerns me is that one day our culture may consider the simulated bird (that obeys our command) to be enough and perhaps even superior to the real entity. In doing so we will be impoverishing ourselves, trading mystery for certainty and living beings for symbols.

We may well become oblivious to the plunder going on around us as we construct a disembodied, desacrilized world in "man's" own image.

Given the dominant values of our society, it is important to remain wary of virtual reality, measuring its potential uses (benefits in communication, education, design, medicine...) against its probable uses and the attitudes these may foster. The technology associated with virtual reality is not value-free. Inherent in three-dimensional computer graphic tools are a host of conventions such as objective realism, linear perspective, Cartesian space, all of which tend to reinforce the western scientific/mechanistic/dualistic worldview. I have been creating images in virtual three-dimensional space for several years now. For me, the challenge of working with this technology involves subverting its conventions and the ideology behind them in order to make images that can act as antidotes, reaffirming our organic participation in, rather than our separation from, the world.

Warren Robinett

**Technological
Augmentation
of Memory,
Perception and
Imagination**

Sitting naked in the woods, I can remember the past, experience the present, and imagine the future. I can do these things without need of physical materials or devices. However I can do them better using various tools that we have invented.

Memory fades; but writings, paintings, photographs and videotapes endure. Experience is limited to the perceptible; but the microscope, telephone, and ultrasound scanner have expanded the range and breadth of our senses. Imagination lacks detail; but flight simulators and scientific simulations predict what could be, unimpeded by complexity.

With the tools we have created, experience can be recorded, simulated, transmitted, and transformed. To remember and to imagine are different than to experience directly, but our invented aids transform remembering to re-experiencing a recorded past, and imagining to experiencing a simulated future. We are thus now able to project ourselves into the past or future, to distant places, into microscopic worlds and into the invisible.

In the excitement over this new thing called virtual reality, we must not forget that it follows a centuries-old tradition of building devices to augment our mental powers. The head-mounted display offers some astonishing new possibilities, but it nevertheless follows this tradition.

Using a head-mounted display, we will be able to get inside interactive three-dimensional simulated worlds through which we can move and in which our actions have effects. We will be able to get inside and move through three-dimensional scenes or actions recorded at earlier times. We will be able to project our eyes, ears and hands into robot bodies at distant and dangerous places. We will be able to create synthetic senses that let us see things that are invisible to our ordinary senses. These capabilities are all technological methods for enhancing human memory, perception and imagination.

We cannot live without our devices, and so we are cyborgs. The eyeglasses, hearing aids, telephones, hand tools, and automobiles of today may give way to more powerful instruments, but now and tomorrow, these tools are part of us. We cannot now function without our devices any more than we can function without the bacteria in our stomachs.

The image of the cyborg – half human, half machine – conjures up a fear of powerful, intelligent, inhuman creatures. But does the telephone dehumanize? The photograph? The written word? The CAT scan? I don't think so. The electronic augmentation of human mental and physical powers leaves our humanity, our ethics and our judgement intact and in control.

One vision of the future is the human being whose senses and muscles are greatly amplified, a human decision-maker aware and powerful. A competing vision from the field of artificial intelligence is the super-intelligent robot, autonomous, inscrutable and beyond human control. These are two plausible directions that the development of computer technology can take. Personally, I find it preferable to be the cyborg running the show, rather than the pet of a robot.

David Rokeby

Virtual reality technologies are only a tiny subset of the possible manifestations of the *bioapparatus* but provide a useful example of a broader paradigm. Virtual reality implies a virtual universe, a multi-dimensional world that has no physical dimensions. This implies an explosion of space, or more generally, an explosion of potential, and there seems to be a belief that we can exploit this new universe of potential by cleverly outflanking the encroaching consequences of our earlier, spoiled experiments in altering reality.

There is a kind of colonialism implicit in western approaches to the unexplored territories of virtual realities. We seem to assume that virtual space is ours for the taking and that we can colonize this space, imbuing it with our own notions. The privileged ones who design, program, and have access to the technology will define the models and rules, much as the Europeans coming to North America defined the rules and models of the "new world" society. Many humans assume that we can imbue this new world of virtual reality with an implicit sort of neo-humanism, another form of colonialism.

Evolution and the Bioapparatus

Capitalism and democracy have consciously adopted the tenets of evolutionary theory; evolution is perhaps the true twentieth-century theology. Mating with technology has become in many minds a viable survival strategy. We assume that while mating with the technology and reaping benefits from the advantages of that hybridization, we (or at least the human fractions of us) can, and are entitled to dominate the resulting progeny.

It seems no accident that technology has been a major enabling factor in the rise of the ideologies of both capitalism and democracy. Technology is enhanced evolution; the three forces powerfully reinforce each other. For instance, the recent giddy ascent of democracy and capitalism in formerly communist countries, largely enabled by the existence of communications technologies, could be seen as a convenient way for technology to guarantee itself a conducive environment for reproduction and evolution. Even the resulting acceleration of arms reduction talks could be seen as a welcome change from the investment of capital in the destructive technologies of war into the more evolution-friendly consumer products.

These kinder, gentler technologies are more likely to achieve widespread acceptance and integration as they have proven to be extremely addictive for the consuming public, especially the younger generation of willing *bioapparatuses*.

While this scenario is perhaps disturbing, I wonder if it does not represent an unconscious solution to the mind/body war. (Even the so-called body consciousness in contemporary western societies often seems masochistic and puritanical in its rigour, as though we are trying to transform our bodies into machines.) Mind and body annihilate each other, leaving only the evolutionary potential of technology.

Whatever the long-term implications of body/machine hybrids, I believe that we will spend more and more time living in virtual spaces, in virtual relationships, even perhaps in virtual time. It would seem that, if general trends continue (and they tend to be self-reinforcing), we will be spending this time living within our own models. We are already capable of ignoring perceptions that run counter to our conceptions. We will have to take care to avoid massive collective self-delusion within these self-constructed models.

18

David Rothenberg

Bioapparatus: an awkward word, so do we need it? Have not all tools been extensions of the mind and body, meaningful only as they translate a human motion into something outside our fleshy limits? Is a computer screen, data goggle or data glove any more sophisticated than a hammer, needle or pencil because it can direct our rough movements toward points far more precise than the finger or hand?

Reality is virtual when the significance of life appears in a place we cannot find, a space invisible to the gaze or the touch. My text as I type it lives between the keystroke, the program, the screen and my glance – there is no page, no object, until I release it from the mysterious black box, which recognizes this information in a way far from what I intend: where I see words that connect, it sees only standard characters. Where I wish an idea to come through, it knows only arrays of data to be shifted and stored, transformed and spewed out, without comprehension or question.

It is so much easier to talk about technology than decide what it does for us. We can compare programs, memory, platforms, processing power and debate the advantages offered by competing machines. The words go on and on because there is so much information to be digested and exchanged. But how can we know what to do with it? Can the device contain surprise or only endless options without reason or rhyme?

I play a synthesizer. It can let loose any of a million sounds. But can any sound retain the life of a living tone, which is ever more than input and output, trigger and release? A bird song is never just a sample of a bird song, never mind the digital accuracy. There are endless variables in the continuum of nature, and the more independent and complete the machine, the more it must quantify and re-create, rather than direct, our attention. I blow across the mouthpiece of a flute. There are endless ways for my breath to strike the tool. The synthesizer may have endless choices as well, but *I must first enumerate them.* The many facets of the world must be calculated to exist before the logic machine admits them.

When I look up at the stars I have no need to count them to know they are there. Life-device, human thought cannot deny our need for tools. The computer that envisions a new, intangible environment is just another step on the way toward replacement of earth with what some wish it could be. It all looks more human than ever.

We have little choice but to face the humanization of all through the expanse of measure. Beyond that is the unknown which should never be lost, never be replaced. Be not wooed by the endlessness of technical profusion. Treat the new machine as you would any human tool – with respect but only practical admiration.

Chris Titterington

The Bioapparatus

One thing that interests me is our species' fear of its dependence on tools. Sometimes I think I see it expressed in the opinion that we are over-reaching ourselves – putting our survival at the risk of designed rather than evolved behavioural structures and apparatuses. I have no quarrel with this careful wariness of the new, though I think I also see another opinion at work here, one that lies deeper in the human consciousness than mere prudence – and one that I believe is a source of great unhappiness and misapprehension in contemporary ways of conceiving of ourselves and our conduct in the world. That opinion, simply expressed, is that our creations are somehow "just not natural," and it is around this notion that most of my own work is developed. I am also interested in an accompanying constellation of ideas, specifically those that revolve around the sense that mental phenomena themselves are not properly part of nature.

One might trace this idea through the etymology of the words *artifice* and *artificial*. In the fourth century, the Syrian Bishop Nemesius was still able to praise man for "his wondrous artificial" works. Later, in Hamlet's famous monologue, Shakespeare was again able to affirm the excellence of human artifice. But by the time of Wordsworth (though I do not saddle him with this simplistic view) the term artificial was almost always compared unfavourably to the natural, and that prejudice continues to exist in present times. The problem concerns the conceptual world. The world we conceptualize *about* doesn't change – no matter how we order it mentally – therefore our tools are only separate from nature if we conceive them to be so.

Up to this point, I have used the concept of nature in the most conventional modern sense. For me, however, this usage has been damaging. It implies a givenness to the world that must be accepted and not destroyed (read changed) and it also leads to a timidity and ambivalence about my place in the world that creates much emotional and intellectual suffering. At one time, I would have preferred to delete it from my vocabulary (replacing it with *history*), although I now see that the act would have only been a symptom of the struggle to regain confidence. One way to promote understanding may be to rethink the Romantic concept of nature, to rebuild the conceptual environment. It is unlikely that the artificial has ever been conceived of as part of the natural – even in medieval or Renaissance times. The dignity and legitimacy of artifice came from its sublimation within the larger set of ideas known as creation. Thus in essence our problem (my problem) today lies in the demise of the essentially religious concept of creation and the resulting isolation of its two former subsets: nature and art.

This need not be so. Consider the great collections made by John Tradescant and given to the University of Oxford in the seventeenth century by Elias Ashmole. These collections mixed *artificialia* and *naturalia* seemingly indiscriminately: tools and sea shells occupied the same display cabinets, as did fossils and miniature carvings on cherry stones of Virgin and Child. Those who dismiss this conceptual scheme (or as they see it, lack of it) miss an important point.

Tradescant's collection was indeed ordered – ordered according to the principles of the princely German and Italian Wunderkammeren in which the phenomena of the world were laid out for contemplation as a unified whole. Within this scheme, the invented apparatus of mankind was as legitimately part of the wonder of the world as any other part.

20

Response

CHRIS TITTERINGTON It's probably an impossibly bad habit, but with me its incurable. I am going to think about the opinions expressed in the papers of this section in terms of what I take to be parallels in history, parallels specifically of that period immediately before 1800 in Britain. To me this technique allows for a period of "fence-sitting" as I call it, before conviction takes over and I decide on one side or the other. Now, there will be those of you I suspect who dislike that very desire for removed objectivity. But for me, it is valuable and fundamental. I should also say that the very terms of the argument concerning objectivity are central to the issues contended in the papers.

In my assessment, these terms are competing views of what it ideally should mean to be human and, in fact, I am left with the feeling after reading this document that the real issues, or at the very least the really interesting issues, at stake in our group are less about virtual reality and what it can or should be than what human beings should be.

The British are keen gardeners. In the eighteenth century, gardening was also a major passion, but it was more than that – it was also the locus of metaphor, an arena in which competing versions of what humanity should be were fought out. Basically there were three kinds of gardeners: one group favoured the classical style of the softly rounded managed landscape of trees and lakes deployed and arranged in a decorously planned parkland manner. Let's say their symbolic head was Capability Brown. And this group, by the later part of the century, was considered to be very ideologically unsound. By contrast, the ideologically sound group favoured the wild, natural style – carefully neglected parklands simulating rough country. This group could be symbolically headed by Richard Payne Knight. Then there were the total no-nos – the complete outcasts – those who favoured straight lines in gardening, gardens as extensions of the house with vistas cut for miles through forests, even beyond the walls of the grounds. These poor throwbacks were so beyond the pale that in the eighteenth century their names are hard to find. Their gardens belonged to a bygone age and were soon bygones themselves as their owners "got educated" and ripped them out.

Now, amongst the papers of this section, if I may speculatively categorize them, I find David Rothenberg and Char Davies possible Payne Knightists in their implied or stated opposition to the expanse of measure and linear perspective. David Rokeby I cast as a potential Capability Brownite in his softer attitude toward life, to quote him, "within our own models." I suspect that David Rothenberg might object that this is, in fact, closer to his position. Lastly, I see Titterington (myself) and Robinett in the unmentionable division, atavistically lost in the *par terre*, the knot garden or better the geometrical maze. Well, at least in my own case, I am still fascinated enough by it not to want to rip it out so quickly. I should probably add that, like myself, Mr. Robinett is also attached to the wilderness model favoured by the first group. Is it just perhaps that we both see the *par terre* as beautiful, too. Well, I mentioned that the garden was the site of metaphor – an area of mental topography that was fiercely fought over – and, amongst intellectuals, professionals and amateurs alike, the other crazed pastime of the eighteenth century was empirical psychology. Here, at least superficially, the group seems to be more black and white. On the one side, let's place the rationalists of the British, perhaps John Locke, but certainly a few nasty foreigners – Descartes and the other French – who were thought of simply as the enemy whose horrible straight line gardening had somehow crept into Britain. These people were

confident of the ego, if I may call it that, and reason and consciousness of self. Well, ranged against this position were the British associationist-irrationalists, people like Abraham Tucker and Edmund Burke (to an extent), and also, those such as the poets Woodsworth and Coleridge who had changed sides and come in from the cold world of reason and sequential logic for a so-called warmer world of intuition and the irrational. Well, I have saddled these poor creatures of history with enough caricature and so I am not going to extend it to the present and savagely categorize the authors of the papers of the discussion. But, nevertheless, I do note a relative distrust – perhaps even disgust – concerning reason and ego in some and an unrelative comfort with it or at least less ambivalence in others.

The problem is difficult to come to grips with; it is slippery and elludes grasp but somehow the concept of nature and what is natural is involved or at least invoked, either consciously or not. I believe the nature concept as it stands is unhelpful and confused. It is often a concept trotted out to lend emotional weight to an expressed opinion. Let me try to give an example of what I mean. Char Davies, for instance, while charging western white male culture with denying our embeddedness in nature for centuries, does not recognize that such embeddedness implies that subjugation by "man" is subjugation by another embedded part of nature. Phrased as "nature changing nature," much of the darkness of the original position is alleviated. While this analysis is not particularly sophisticated on either of our parts, it does nevertheless show the emotional use to which the concept nature is put. I find a similar idea in David Rokeby's piece where he appears to use reality in the sense of nature as a given that, in being changed, must necessarily be spoiled. However, our embeddedness complexifies the issue of whether we are spoiling reality or nature by our activities. Of course, we are causing changes that may indeed bring about serious consequences and so spoiled does seem an appropriate term. But there is so often a blanket application of the concept, and I feel all alteration is not automatically bad (read here – in our present value system as not *automatically artificial*). Davies also uses the idea that a human constructed world would be, and I quote, "a desacralized world" in man's own image. But for something in the human image to be desacralized, humanity must first be desacralized. And I question why that opinion is so automatic, why is it that we do not see the wonder of ourselves. Davies gives another example of this, citing the case of a cyberbird and stating that such a thing is impoverished, having no otherness, no mysterious being, no autonomous life. But I ask why should otherness be a prerequisite of wonder? Have we no mysteries being ourselves? Why should all autonomous life other than ourselves be precious? To me, that cyberbird and its technical hardware is at least the equal of any other phenomena of nature. The point seems to be to rediscover that lost recognition of the marvelousness of our own constructs and not to automatically assume that nature is superior to art.

There is a common fear about the loss of behavioural variety in the export of western machinery and its attendant values – swamping other ways and forms of thinking about things. David Rokeby fills out the scenario, warning that time usually effects a kind of growth on the evolutionary change: in human terms, making good design appear grown, and bad (failed) seem designed. So the loss of behavioural variety puts all the eggs in one behavioural basket, with the ensuring risk that that involved.

David Rothenberg adds to this in that he cites the case of musical notes that must be programmed into the machine in order to exist while there are endless variables in the continuum of nature. This is the classic/romantic naturalist argument – the neoclassical imagination being castigated by romantic landscapists as too liable to produce monotony compared to nature's "infinite variety." The quantigraphic paintbox can produce a million or so colours. But so what? I ask myself. A smaller range produced, seen from the position that does not automatically assume the superiority of nature to art, is wonder enough.

I suspect Warren Robinett's paper is problematic for our group. There are overtones of the

conquest of nature detectable in sentences such as, "We will be able to project our eyes, ears and hands into robot bodies at distant and dangerous places." And the two phrases, "human decision maker, aware and powerful," and "I prefer to be the cyborg running the show," sound off alarm bells in many opinions. Contrast this, for example, with Char Davies' statement that our culture has "categorized the world as a collection of objects to be subjugated for human use." Well, I hear those alarm bells too, but I am fascinated by them – fascinated by the spectacle of a mode of life and thought, calling into question its terms of existence. And I'm aware of the left social aims of the anti-ego philosophies and their followers in varieties of deconstruction discourse. But I am fascinated too with the spectacle of self-consciousness manoeuvering into a position of self denial and destruction – ranging from our postmodern fantasy of the self as a kind of individual performance within the world meta-language net, to similar historical events such as the rise of the cult of the primitive, the child and the unconscious in the late eighteenth century.

I am also sure that regardless of the truth of the reality of the self in the world, the presently fashionable conceptions of this are indeed fantasies representing our desires. These desires are, of course, historical and the sum of history is evolution (or change, to rid the word of its presently undesirable connotations). I'm also fairly sure that my own ideas that cast uncertainty around our present questioning of human power and control are also fantasy and desire. But the net effect is for me is to problematize the contemporary automatic or gut objection to the "cyborg running the show" and to the idea of the "human decision maker, aware and powerful."

Discussion

Nell Tenhaaf:

When you speak about denial as a denigration of the self that results in a split, that results in calling nature something that we are not a part of, it sounds very universalized. You describe it as though we all, all contemporary humans, are caught in this kind of construct. But what I am trying to grapple with is whether in fact there aren't those humans who have no problem with denial of the self, who are very confident in their sense of being one with, and therefore having a kind of control over, nature.

Chris Titterington:

There are probably lots of groups, even within our own culture. It is not universal; there is a section of the population that perhaps does not feel at one with nature but does not have a problem with so-called subjugation of nature or extension of humanness into nature. It is sort of an industrial, commercial aspect of our culture. It seems to be prevalent mainly amongst intellectuals of one sort of another. I did mean it to be western rather than global.

Kathleen Rogers:

I think what you describe is almost an anthromorphic model where there are these hierarchies embedded in western culture through a Judeo-Christian idea whereby we kind of create metaphors, we make things stand for things. To me some of the issues that are very interesting which have to do with gender difference, concern the way in which you embody, for instance, the metaphor of garden, where you talk about this garden and then you have these masculine architects of the garden who are describing, in a way, their own mind set. I find it limiting.

David Rokeby:

I think that the direction I come from with respect to the notion of what is natural is perhaps different than a lot of other people in the residency. And that I come to it through a phase of many years of programming and producing and enjoying the production of the artificial. And my questions derive from my own experience of working with the material, with technologies in a very intensive way and feeling the way subjectively, finding myself not

trusting myself with technology. Diving into the technology left me with no reference point from which to gauge what I was doing. That reference point may then become projected as nature.

Chris Titterington:

There is something in there that is very hard to talk about – when you get into position where you are relative to nothing, the nature concept of reality is invoked. In a sense, whatever we do, we are embedded within nature or whatever is nature. To look for external reference is nonsense if you truthfully believe in embeddedness of humanity within the whole.

David Rokeby:

That makes some amount of sense to me, particularly with computer technology. I was isolating myself, looking at my own reflections in a mirror so much so that nothing was left. It was not a brave new world, but it was becoming highly and purely self-referential, like a kind of an infinite regress. That is just my subjective experience. From an objective point one can make lots of different things from it – that doesn't solve my problem of how to live in that context.

Nell Tenhaaf:

It is an interesting point David brings up because instead of taking the term embeddedness as a kind of grounding, it's almost like a counter-position to embeddedness. Is this kind of intense self-referentiality embedded? Not really, because it turns back totally onto itself.

Designing the Social

Eleanor Bond

Bioapparatus in
Cybertime

We are *in* time and *moved by* time. Our philosophical and socio-economic systems are based on time constructs (the arrow and the cycle). We are in the midst of another major time shift, as the pace set by electronic technology is transforming our biological, noetic and social experiences of time. Because of pressing time constraints around issues of environmental reform, this human time shift might be a crucial aspect of the political arena.

Biotemporality: our biorhythms, rhythms developed from adaptation to the social environment and an awareness of the cyclic order of our environment. The greying of the calendar[1] in North American cities and in the electronic cottage is blurring circadian, weekly and seasonal rhythms. Time is being colonized.[2]

The colonization of time, and subsequent socialization, is also a global phenomenon. Shared temporal experience, calendars and time constructs can distinguish and reinforce social bonds and cultural communities.[3] The cultural confusion that resulted from Ataturk's decision to adopt the Gregorian calendar, in an attempt to westernize and modernize Turkey, is a case in point. The founders of the French Revolution attempted to impose social reform through calendar reform but met with popular resistance. Similarly, a World Calendar designed on the Gregorian model was developed three decades ago but resistance from religious and ethnic groups halted its implementation. The global socialization that is occurring now is less formalized and more elusive than the introduction of a universal calendar. Nevertheless, the pace of new technologies, and the marking of time through global events, is resulting in various forms of cultural jet lag, amidst a flux of fragmentation and homogenization.

We are compiling and receiving information at unprecedented speeds. As increments of time shift to nanoseconds, noetic temporal experience is narrowed to the near present and immediate future. Within this time frame, history comes to be perceived as ambiguous and historical models and the knowledge of elders become irrelevant.

Societies without a sense of history and without long-range vision can be easily manipulated. And people who are accustomed to immediate response and gratification will not have the patience to sustain political will.[4] Perhaps an analysis of our temporal environment will be a factor in the outcome of our ecological future.[5]

1 J.T. Fraser, *Time: The Familiar Stranger* (Amherst: University of Massachusetts Press, 1987). Twenty-four hour shopping, banking, dining, the use of fax machines and VCRs, have generated flexibility and randomness in schedules and social organization.
2 The colonization of time refers to the opening up of time frontiers, such as nighttime or Sundays by small pockets of social or commercial activity, and the increasing activity of population and activity in these zones which had previously been uninhabited.
3 Newfoundland is distinguished through its place in a unique time zone.
4 William Kunstler, lawyer for the Chicago Seven, suggests that the brevity and failure of the political reform movement of the sixties was due to the impatience and unrealistic expectations of a generation raised with instant coffee and Kraft dinner.
5 In his book, *Time Wars*, Jeremy Rifkin postulates that the political left and the political right will be replaced by the time constructs of *arrow* and *cycle*.

Michael Joyce

This curious formation, the *bio/apparat/us* shares with its intended target – the current state of representation in virtual reality – the momentary advantage of its own awkwardness. We are thus allowed to see each in the moment before it assumes its seamlessness, the way, for instance, the awkward and improbable mixed light of dawn isolates a half-illuminated world into its angles and instances. These are the shapes we project upon its shadows with our light-drunk eyes, before the bright closure of relentless blue, the inconsolable expanse of grey, or the anthropomorphic and comic clouds which mark the resumption and progression of the seamless historical day.

The first *bioapparatus* was the word: once outside the mouth metric, then formulaic; once imprinted, finally electric. "What has been the biggest change for you?" someone asked one of the virtual reality pioneers. "I never thought I'd be used to flying," said the fly boy, happily outside history, not knowing Dante (or Beatrice, before both fly boys). In the advent of the word, also, flying was an everyday thing.

The Momentary Advantage of Our Awkwardness

The flaw in this most recent avatar of the *bioapparatus* is its projection upon a geometrical base. In virtual reality the search for the coin of self beneath the virtual seat cushion is not metaphoric but proximate and actual. What is missing is the interstitial link, the constant mutability and transport which the word, now electrified, is not used *to* but used *for*. "The work of the morning is methodology. I am an archaeologist of the morning," said Charles Olson. Apparatus: *ad/parare*: make ready. John the Baptist, lightdrunk archaeologist. The interstitial link is Alice's archaeological looking glass. What word shall we fly out on this morning, whence slip through the interstices?

"Must there always be a word for it?" scoffs the virtual reality flyboy ("Why read when you can see, why see when you can experience?") In the solitude of the *bioapparatus*, virtual reality is nothing less than an awkward instance of the new writing. Against solitude, only the word: once electric, then embodied, topographic, proprioceptive. In this case, the word is an interstitial link, what elsewhere I have termed the constructive hypertext: versions of what it is becoming, a structure for what does not yet exist. Beneath the virtual seat cushion, a jumble of spilled tokens, sesame seeds, abracadabra apparatus, salt – what I call the multiple fiction, the momentary advantage of its own awkwardness. (Virtual? Reality.) Against solitude let us seat ourselves, appropriately proprioceptive.

Stratigraphic meaning and the simultaneity of multiple visions have gradually become comfortable notions to us, though they form the essence of the intermingled and implicating voices of Bach which Glenn Gould heard with such clarity. Whether or not this awkward dawning forms a *bioapparatus* (or we form ourselves so), our longing for multiplicity and simultaneity seems upon reflection an ancient one, the sole centre of the whirlwind, the embodied silence. This is not the unbearable lightness of being, but the being of unbearable lightness.

What forms will suit this joining is not yet clear. Whatever form (*bioapparatus*, virtual reality, or multiple fiction), unless our roles are much less differentiated, the silence will have no voice. Unwilling to join in the interstitial space of our uniqueness, we will live a lie.

Carl Eugene Loeffler

Nobody knows whether this will turn out to be the best or the worst thing the human race has done to itself, because the outcome will depend in large part on how we react to it and what we choose to do with it. The human mind is not going to be replaced by a machine, at least not in the foreseeable future, but there is little doubt that the worldwide availability of fantasy amplifiers, intellectual tool kits, and interactive electronic communities will change the way people think, learn, and communicate.[1]

Electronic data is a virtual reality. Through the applications of telecommunication technology, electronic data can be translated into electronic mail, electronic bulletin boards, electronic databases, electronic shopping malls, and intentional communities complete with virtual cafes, art galleries, shopping malls, colleges and universities and more.

Cultural Navigation in Virtuality

The names attributed to the virtual communities are most often conjoined with some form of net, network, link, or board, for example: Senior Net, a personal computer network for senior citizens and Art Net, a network dedicated to the creative arts. What is being conveyed is the act of "connectivity" which becomes the basis for the intentional community and which can be subject specific. Virtual communities are composed of people from all walks of life.

One unique aspect of these communities is their virtual location. They exist in the ether, and yet their members can be listed and maps can be created that indicate the streets and avenues of branching systems, file locations, and the routes taken by long range telecommunications carriers – the rivers of exploration for this era.

Some of these communities are more virtual than others and reside in the ether of decentralized, voluntary networks, which in essence form a "metro-plex" of global proportions.

The world is growing smaller as a result of global telecommunications, yet it is also growing larger. The cry for connectivity can be heard. People are looking toward telecommunications as a means to locate themselves and to locate others and as a means to acknowledge our commonality and delight in our differences. Connectivity is about virtuality, but it is also about empowerment.

1 Howard Rheingold, *Virtual Reality* (New York: Summit, 1991).

Jean-François Lyotard

La tâche la plus urgente: penser la vie comme une technique, penser la technique à l'échelle cosmique.

Il y a eu sur la planète terre une série d'événements fortuits qui ont permis l'apparition de systèmes matériels non isolés, capables par conséquent de défier l'entropie.

A l'issue de mutations et de compétitions, un système matériel très complexe (le plus complexe que nous connaissions dans l'univers), le cerveau de *Homo sapiens*, s'est trouvé sélectionné. Très improbable, il est aussi très efficient. Il travaille selon la technique la plus sophistiquée, la technique symbolique, le langage et toutes les prothèses qui dérivent du langage. C'est un système peu coûteux en énergie, et c'est le système ouvert par excellence: il accepte l'incertitude avant de réagir.

La forme de communauté des cerveaux individuels qui s'est avérée la plus efficace, démocratie politique et libéralisme socio-économique (basés sur la poursuite de la compétition pour la performativité optima), semble être la plus appropriée au développement de la performance du cerveau.

Mais ce système reste dépendant du corps qui lui fournit la nourriture en énergie (puisée dans le contexte terreste) et qui assure sa reproduction (par le moyen de la génitalité sexuellement différenciée).

Ce qui est déjà en jeu dans toutes les recherches contemporaines, quelles que soient les disciplines, est ceci: affranchir le cerveau humain des contraintes communes aux systèmes vivants sur la terre; ou fabriquer un système, au moins aussi complexe que ce cerveau, indépendant de ces contraintes. Il s'agit que l'un ou l'autre puisse "survivre" à la destruction du système solaire et continuer à fonctionner dans les conditions ordinaires du cosmos. Il reste 4, 5 milliards d'années solaires pour arriver à ce résultat. En temps cosmique, c'est peu.

The most pressing task: to consider life as a technology, to consider technology on a cosmic scale.

On planet earth there has been a series of fortuitous events allowing the appearance of non-isolated material systems that are capable, consequently, of defying entropy.

As a result of mutations and competitions, a very complex material system (the most complex that we have known in the universe) has been selected – the *Homo sapiens* brain. Highly unlikely, it is also highly efficient. It works according to the most sophisticated technology, symbolic technology, language and all the prostheses that derive from language. It is a system that costs little in energy, and it is the open system *par excellence*: it accepts uncertainty before responding.

The form of community of individual brains that has proven to be the most effective, political democracy and socio-economic liberalism (based on the pursuit of competition for optimum performativity) seems to be the most appropriate for the development of the brain's performance.

But this system remains dependent on the body that provides its energy supply (drawn from the terrestrial context) and that assures its reproduction (by means of a sexually differentiated *génitalité* [reproductive capacity of sexed organisms]).

What is already at stake in all contemporary research, in whatever discipline, is this: to emancipate the human brain from constraints common to living systems on the earth; or to manufacture a system, one at least as complex as this brain, independent of those constraints. It is a question of one or the other "surviving" the destruction of the solar system and continuing to function in the ordinary conditions of the cosmos. There are 4.5 billion solar years in which to attain this result. In cosmic time, this is nothing.

Mike Mosher

Since completing a work of fiction that features a rock star who masturbates on stage, I have been thinking more about the interface issues of virtual sex, congress with electronic information spaces, also limitingly called dildonics. The next great fortune in computer games will occur with a device for video arcades that brings men to thrilling orgasm. As with the French curbside *pissoir*, modesty towards the passing public will be maintained though the participants' purpose will be obvious. Crowds may gather to laugh at and egg on the machine's rider, but they themselves scramble and scuffle for a ride. The game will be a combination of visual, auditory, touch and possibly olfactory stimuli. Pictorialism is not enough; attempts at on screen visual realism will be realized as unsatisfactory, as the breadth and power of symbolic visuals will be appreciated. Visual metaphors will fly, perhaps generating and recombining in time to the individual participant's arousal process in a manner similar to hallucinations before sleep. The auditory part will be as easy to realize as setting up a virtual phone sex business, where the greatest interface demands remain maximum interactivity.

The Bioapparatus of Public Love

Touch will be cybernetic, with great subtlety and sensitivity of response as the rider squirms towards his goal upon the stool or stirrups. Sensors will dictate response to quite minimal changes in pressure and lubricity, perhaps employing discoveries in heat-sensitive shape-memory metals. Does the Oakland company TiNi receive a lot of inquiries about this use...? The game's flesh-touching interface components will be self-cleansing and aseptic, perhaps employing a system not dissimilar to the ultraviolet shelf in old barber shops that sterilized the haircutting tools. Feminist scholars will debate the contribution of the game's popularity to the study of the psychology of objectification and the male tendency towards disassociation from the emotional content of the sex object. Some women might conclude, "Better he ride that thing irresponsibly than me." The games will be popularly defended as helping meet the social concern of safe sex. Though also sold by mail for home installation, as an arcade game, it might fall under organized crime's control of gaming (and the *bioapparatus*' rival, prostitution) in many cities.

David Tomas

Consider the following proposition: Identity and ethnicity travel and permutate by way of technologies of observation (amongst other forms of tools which can also serve as their conduits or identity sites). This process – the articulation of the human body in terms of technological systems and the subsequent grounding of identity in those systems – can be more accurately understood in terms of technicity or the definition and differentiation of individual and/or group identity primarily in terms of technology as opposed to other systems of mapping similarity/difference.

This proposition prompts a number of questions as to the theoretical and practical consequences of deliberate attempts to re-engineer the human body and in particular to re-engineer it in the context of virtual reality or virtual environments. These questions are not only related to the reconstitution of the human subject as observing subject by way of advanced imaging systems but also to the body as the nexus (site/sight) of ethnic difference since we have yet in the west to be effectively confronted by and to come to terms with non-western histories of the human sensorium.

Technicity and the Future of Their Bodies

What does it mean to engineer new model(s) of the human and non-human in terms of organic or classical (hardware interfaced) and post-classic (software or post-organic) cyborg constructs? What are their design characteristics and anthropological logic(s)? What, in other words, does it mean to engineer the human body in more or less isolation from a rich locally defined social and cultural matrix – but nevertheless according to western patterns of scientific, technological, or bio-technological rationality whose governing logic, at the present time, is that of western capitalism? Thus, on the one hand, there is the question of *who* is engaged in designing these new post-human forms. *Who* is to control the delicate balance between the normalizing and subjectifying cultural influences, orientations, and biases built into *their* bodies, *their* neural networks and sensorial architectures? In other words, for whom and in terms of whom are they being engineered? On the other hand, there is also the question of which sector of the globe are these new post-human cyborgs to represent – more accurately, *where* are they to be produced – not so much in terms of a given geographical area which is, of course, becoming increasingly irrelevant under global capitalism, but in terms of their local socio-cultural geographies which are still, for the most part, contested territories. Under these circumstances, the colour of these bodies or configurations of data, the tint of their vision, is of profound significance for the future of the human body. It is precisely the variety of these colours and tints that is under grave threat in an age that increasingly seeks its definition of the body through technological and related imaging systems whose logical criteria are rooted in western systems of rationality which are then imposed on the rest of the world in the name of western values, political practices and economic interests.

Let us therefore not forget, as we contemplate the future of the body – its redesign, retooling, and ultimate rationalization – that it comes in many forms, articulated by many symbolic systems most of which we have only chosen to engage in terms of our own cultural matrix and its dominant models of vision and spatio-temporal navigation. One should also bear in mind, in this connection and by way of conclusion, that the most prominent interfaces to date between the vast majority of the peoples of the west and those of the rest of the world have been provided by the disciplines of military conquest, anthropology and tourism.

Chris Westbury

In his book *From Cliché to Archetype*, Marshall McLuhan notes, in his typically enigmatic way, that "an archetype is a quoted extension, medium, technology, or environment."[1] The meaning is clarified if the phrasing is reversed: a quoted extension, medium, technology, or environment is an archetype. To quote something is to mark it off for a particularly close scrutiny of its meaning. When we move away from the teleological examination of technology – that is, when we stop asking what it does and how it works – and consider instead the relation of technology to personal semantics, the examination becomes an archetypal quest. When we pose questions in terms of personal semantics, we phrase them in terms of what is important to us as private and individual human beings. We are not interested in how a thing works or how it interacts with external objects, nor even in whether or not it will impart status or wealth. We want to know the answer to a different class of questions concerning happiness, sense of self-worth and emotional well-being.

Such questions cast the conventional wisdom about the depersonalizing qualities of technology in doubt: technology is inevitably re-personalizing.

When we understand this transformation of the purpose of our extensions, it comes as no surprise that all technologies very soon become co-opted for sexual purposes. An explosion of computerized sex services invariably follows the implementation of publicly accessible computer networks like Minitel in France or Alex in Eastern Canada. Telephone sex is now a huge multi-million dollar business. The sexual arena provides an easily-accessible lexicon for the metaphorical relationship between the individual and archetypal experiences. However, personal semantics are not limited only to the sexual. When technologies transcend their merely teleological roles – as they do very quickly when they reach the fertile mutative stage induced by mass public consumption – they begin to act like strange mirrors, very specific but greatly magnifying, which reveal to each of us, in unusual detail, parts of ourselves that we had heretofore managed to disguise or ignore. Not enough attention has yet been paid to the profound personal, metaphysical and psychological effects of extending ourselves through the creation of quasi-independent virtual selves. One need not look very far, nor go too close to the cutting edge of technology, to experience the beginnings of the creation of a virtual self, a virtual psyche. The simple experience of constant communication over e-mail, especially in real-time, is often enough to induce a feeling of eery freedom from certain constraints of the personality of which one might well have been previously unaware.

I close with a simple prediction, one of many that might easily be made about the nature of virtual psyches, which are about to intermingle. I predict that technologically extended virtual psyches will meet in time that is slower than real-time, for the same reason that virtual bodies tend to act in time that is faster than real-time: the time-frame in which we are locked biologically is inconvenient. Physical tasks proceed too slowly, hence we have extended ourselves through bulldozers, cranes, pulleys, telephones, and so on. However, psychologically, human beings are too quick. We cannot understand ourselves or each other because mental processes proceed too quickly. Our virtual psyches will not be slow in the usual sense – mentally slow – but archetypally slow. We will want to and will learn to see ourselves and each other in the same way we appreciate a beautiful countryside changing over days as we hike through it. We will want to slow things down so we can come to see a majestic and wonderful rhythm in the apparent chaos of the self.

1 Marshall McLuhan and Wilfred Watson, *From Cliché to Archetype* (New York: Viking, 1970).

Response

ROBERT MCFADDEN

Jean-François Lyotard opens his contribution with the invective "La tâche la plus urgente: penser la vie comme une technique, penser la technique à l'échelle cosmique." On first reading, this "call to action" seemed, for me, disabling: a trumpet blast commanding the reader to rally beneath the banner of the master, a narrative in which communities, experiences and differences would be vaporized. But if, in speaking of technology, I were to follow Lyotard in meaning symbolic technology, language and all the prostheses that derive from language, my initial response to that trumpet call would have to be reconsidered. And if, in imaging the cosmos, I recognized its constituent parts to be time and space – the domains of history and geography, period and region, sequence and simultaneity,[1] I might come to appreciate the master narrative for its ability to break down these key words and binary oppositions, and so facilitate their return into the ether.

Into a subtle fluid supposed to fill space. A volatile fluid. An anaesthetic.[2]

The sounding of the ether is, as Carl Eugene Loeffler indicates, well under way. This is the hydrography of electronic mail, bulletin boards, databases and shopping malls: "the new rivers" in which virtual communities suspend themselves; the wet net of mutual interest; the empowering grid of connectivity. *We* need more power.

For Chris Westbury, technologies are better understood as reflective surfaces within which we are allowed unique glimpses of ourselves. Here the self is a subtle but volatile property. It is an apparent chaos which is easily disguised or ignored. It operates in a time frame beyond the threshold of our innate faculties. A world unto itself. Rhythm.

The vision of technology which Mike Mosher proposes is consciously prosaic. Various stimuli-sensitive devices will, he suggests, be combined with existing visual languages and auditory interfaces, along with arcane devices adopted from riding saddles and barber shops, to create the ultimate boy toy. The social deployment of dildonics – a somewhat curious name, considering the absence of direct female users[3] – are predicted with equal surety. Oceans of excited men scrambling and cajoling with one another as groups of women, health officials and politicians maintain the status quo from the certitude of the beach. Here we have what Linda Williams has, in her analysis of hardcore cinema, termed a dissolved utopia[4] – a non-stop miasma of consumption.

If I were to put the words, *we need more power*, on offer, whose voices would you like to hear?

Eleanor Bond proposes that we might understand power as a function to time. She delineates our environment – temporary and spatial – as a social construct through a truncated history of cybertime (or time with a capital T). Cybertime is the product of such technologies as calendars, commerce schedules and rates of information flow. Changes within these technologies, she argues, affect our ability to exert a considered political will.

Upon recognizing power as an operation of a socially constructed time – that is to say, a history – we may recognize technologies as a specific form of cultural investment: a vehicle for the maintenance and propagation of specific interests and practices. David Tomas uses the term technicity to consider one such investment made within western capitalism. The inscription of the body within western technology, he suggests, begs numerous questions as to the existence of inherent values and purposes – questions that underscore an unspoken

1 Edward W. Soja, *Postmodern Geographies* (London: Verso, 1989), 2.
2 *Midget English Dictionary* (London: Burgess and Bowes, 1964), 159.
3 The term dildonics is perhaps less curious if we consider the subtext of masculinity present in these technologies. In this case, the term identifies, intentionally or otherwise, the homoerotics implicit in the relationships between men and their machines.
4 Linda Williams, *Hardcore: Power, Pleasure and the "Frenzy of the Visible"* (London: Pandora, 1990).

agenda of disenfranchisement on the basis of ethnicity and, by extension, gender and class. Such a process, we are reminded, is hardly new. It has facilitated the predominance of western interests on a global scale over the latter half of this millenium.

Michael Joyce agrees that technologies shall continue to work within, rather than transcend, the conditions of their inception. However, he proposes that this seamlessness may be betrayed, however momentarily, at junctures in our linguistic development when newly introduced terms or concepts have yet to be internalized as convention. "The first bioapparatus," he writes, "was the word." In one sense, this proposes that technologies inevitably pass through a sort of Brechtian phase in which they cannot help but make the familiar strange by repositioning it within a new and unexpected space. For those less committed to memory, it proffers an unpolluted site for the creation of new language, an abandonment to chastity. But, with this abandonment, we are back in the ether: a cosmos, Joyce conjectures, where someone's silence – perhaps our's – swells up against a rumble of experience.

When I say *we*, whose voices are you imagining?

Discussion

David Tomas:	I am curious to know why you chose ether.
Robert McFadden:	Carl brought it up in his paper and I was struck by the possible connections its had with the concept of the cosmos, which Lyotard uses. I started out thinking of the ether and the cosmos as opposites of sorts, but are they? They are both constructed ideas about universal spaces. So I guess that I was implying that they are interchangeable or perhaps complementary.
David Tomas:	You seem to be implying some kind of anaesthetization is going on.
Robert McFadden:	Ether, on one hand, can be an anaesthetic. On the other hand, it is a subtle fluid or a volatile fluid. That's what makes it interesting.
Mary Ann Amacher:	What's interesting in Lyotard's paper is that he says to think of life as a technology – and we are in this discussion talking about what is natural and what is artificial, when actually we are all completely bioengineered. Maybe we do not know when or where it all began, but the fact that our bodies can continue with the right amount of bacteria in them, with the right amount of symbiotic activity – why is this so natural? Liquid screen (LCD) can be bioengineered from octopus – why is that so artificial?
Robert McFadden:	The first level of response to that is that engineering and the way that we generally use it implies agency or authorship.
Mary Ann Amacher:	Well, we may well have been engineered as a virus and somehow the viruses manage to get to earth and here we are.
Warren Robinett:	That is called the interstellar picnic hypothesis – somebody came along and had a picnic on this rocky planet and left a few crumbs and it developed into the biosphere of the Earth.
Robert McFadden:	That has happened before. I am just thinking about the history of Europeans colonizing this continent. Germs came in real handy making those wide open spaces.
Catherine Richards:	In reference to David's paper, there is actually someone engineering these tools now. You can locate them, you can identify them. This implies a certain notion of responsibility and

articulation. I wonder if the notion of natural and artificial displaces that up to a point.

Nell Tenhaaf: It's interesting to go back to that issue of fence sitting that Chris was talking about. Somehow I link it with something that Rob said about this sense of a gap, he called it a Brechtian phase. I think that prior to the nineteenth century there was still an option of fence sitting – in the period when there wasn't a decisive adoption of the Cartesian mode – but there were still oppositional groups of various kinds that grouped around current issues concerning nature and technology. They set themselves up as having religious beliefs of one kind or another about what scientific position to adopt. But, I am interested, Rob, to have you expand on that because I wondered where you would locate that gap. Is your implication that this Brechtian phase is the territory of artists?

Robert McFadden: That is certainly where that kind of idea is being developed. Brecht was using it with the idea of working class people going and seeing their lives on stage, and hearing the words they spoke on stage, almost being able to objectify themselves to a degree. I think that is the same sort of thing that Michael Joyce is writing about in his paper where he talks about how, with new technologies, we can see our old ways of thinking with a freshness.

Nell Tenhaaf: But you are implying that that kind of perspective is within the domain of art and culture rather than in other pockets of society?

Robert McFadden: I would not try to make that kind of separation of art from its social base, particularly in Brecht's case.

Mary Ann Amacher: I think there are very practical social implications that are quite interesting when you think of children all over the world and when you realize today you can have video conferencing from Los Angeles to Boston for twenty dollars an hour because of optical cables. This of course will become less and less expensive and so small children, instead of having to watch television and having this mode of paths of entertainment, can actually have friends all over the world. I think this would have a lot of social implications, also in learning, talking to each other in the different languages, the customs and traditions of each country.

Robert McFadden: That raises a whole bunch of questions about access and time to do that kind of thing.

Re-embodiment

Perception of the body is always mediated, yet there is also always something ineffable about it.

Jack Butler

The Construction of Knowledge Through Tools: Physical and Conceptual Models (Apparatuses) in the Investigation of Gender Differentiation

In the late seventies, I was commissioned by the Childrens' Hospital of Winnipeg Research Foundation to give flesh to conceptual models enunciated by the scientific texts of embryology. I tested scientific theories by building models in plasticine clay, following the descriptions and directions formulated within *the word* of science, translating text into volume and void in the physical world of the body. Textual theory did not translate directly into approximations of reality. Direct investigation of aborted embryos (by means of drawings, photography, dissections, reconstructions of histological slides and new texts revised in light of tactile, spatial information) was also required in order to represent genital embryogenesis within the conditions of time and space.[1]

Conclusions: Early in the ninth week of life in the womb, the human embryo develops a surprisingly large proto-clitoris/proto-penis genital structure technically designated as the indifferent, neuter or common genitalia. The indifferent genitals share both male and female characteristics. The phallic portion of the urogenital stalk suggest the future erectile penis, but on the ventral aspect it is deeply grooved in anticipation of the invagination of the female. Beyond a few select areas of embryology and medicine, there is little awareness of this information. Yet, this news seems to be pregnant with significance during this time of crisis in sexual difference as it stands at the intersection of feminism, science, art and politics. Certain questions can be opened.

- Theory/practice: Can multi-dimensional physical, virtual and haptic models (apparatuses) be used as tools to expose the illusions of completeness and authority conjured by *the word*, revealing the construction of the theoretical text?

- Sex/politics: Does the contemporary psycho-sexual position of woman simply exchange a biological determinism for a linguistic determinism?

- Female/male: Does the embryological state of undifferentiation suggest the possibility of a collapse of gender into a bisexual and androgynous model?

- Art/science: Could the body stand in the place of the limen between two historic solitudes? Can the body be represented as an ontologically transparent layer through which art and science are mutually visible?

On questioning the politics of sexualization it seems evident that the genitals, as defined by biological science (a binary dichotomy of male and not-male; an inherently non-reversible, non-reciprocal hierarchy; a system of domination) cannot support the burden of socialization constructed by the phallocentric order.

An earlier version of this text was commissioned by the Walter Phillips Gallery for the Helen Chadwick and Shelagh Keeley exhibition catalogue, In Side Out *(1991).*

1 In 1980, I published this research in the film, *The Child With Congenital Adrenal Hyperplasia.* The film describes the genetically transmitted disease C.A.H., its effects on the development of the genetalia, its clinical management and the surgical reconstruction of anomolous genitals of afflicted infants. The film was developed between 1976 and 1980 in collaboration with Dr. J. Winter, endocrinologist, Dr. A. Decter, urological surgeon, and consultants in pediatrics, neonatology and embryology.

Dorit Cypis

The Body in the Picture is an experiential, interactive workshop developed in 1986 that I am currently offering through the art department at the University of North Carolina, Chapel Hill. The workshop includes body movement, breath and voice to sensitize ourselves to our internal body; interaction with autobiographical and cultural images to explore our body's relationship to image; investigation of cultural contexts which shape identity; personal and group processing channelled through journaling, automatic drawing and discussion. The group proceeds from the belief that change comes when we remember and reintegrate our many selves, private and public. As part of the process, I arranged for the participants to experience the virtual reality system being researched and developed by the Computer Science Department at the University of North Carolina, Chapel Hill. The following statements are excerpted from the responses of workshop participants.

Tori Ralston: I found myself forgetting its power and implications but instead just engaged with it as a toy...a toy which left me feeling nauseated throughout the afternoon. I am very frightened that this could become the new and easy armchair way to have an experience – another, more powerful form of television....It seems important that it not become a game.

Stephanie Schonbach: After the experience in the virtual reality, I became much more aware of the power of smell, my body touching the floor, the air touching my body, the inside of my body, all of which were completely missing in the virtual reality. I also found the experience quite disturbing. I felt as if the computer set up was forcing me to see in a certain way, to look in a very "computerized," non-individual, non-free choice manner.

Dennis Tragesser: I found myself to be very nervous yet intrigued by the virtual reality experience. The only other life experience I can relate to this feeling is being addicted to drugs, cocaine specifically. It was a wonderful visual journey but I was scared and not in control of myself or my emotions. I like to have a firm understanding of my surroundings and what is affecting them, but I could not.

Ann Rowles: I feel like I should be afraid of [virtual reality parlours] but somehow I am not. Maybe it is because I have seen my son turn from immersion in television, video, etcetera, into someone who is no longer very interested in those things. Obviously, the sex and violence issue will emerge as virtual reality is commercialized. The pornography industry will make use of it, but I am not sure this is any better or worse than the situation now. Real humans won't need to be exploited. On the other hand, sex workers may lose their jobs.

Kate Moran: I am aware of my body and this awareness is important to me. My body is attached to my psyche and intellect. When I was in the virtual reality, something was missing – my body. The feeling of disembodiment was particularly acute when I looked down and tried to see my legs and feet...I was not attached to the space I was in. Being a woman, I've worked hard at trying to reconnect my mind and body. Will virtual reality... reinforce that our bodies are something separate from us, to be manipulated and controlled?

Josh Kaplan: Among the many observations I had of virtual reality was the fact that it was harder for me to leave than it was to enter. To enter I needed only a bit of willing suspension of disbelief. To return, I had to suffer a shock to my system....Everyone's virtual reality/reality could be manipulated into a utopia. The problem, of course, is that somebody has to decide what the utopia would be and it could be somebody else's hell.

36

Frank Lantz

The *bioapparatus* is not indigenous to one zone: it is the body mutated to survive perpetual migration between interlaced realities. State law requires an ideal body: organic, individual, capable of producing the legally binding gesture of accountability. The electronic net requires an ideal body: electronic, multiplied, recombinant, reiterative, reproducing without demonstrating the origin of the social figure – an untraceable möbius surface. The *bioapparatus* thrives in the laminated environment at the intersection of these mutually exclusive virtual worlds.

I wish I could e-mail my signature to you. I would like nothing more than to render unto ether that ridiculous spasm of fingers and ink, but that would be to complete the *bioapparatus*, to give it a name and signal its destruction. It can only exist unfinished, half there, like a mirage conjured by the too real thirst of desert walkers. Its name can never be assumed; it is the anti-alias, smooth character, smoking phallus of a cartoon logo, my remains.

**Lyne Lapointe
Martha Fleming**

An Iron Hand
in a Velvet Glove

Remember, even the Jolly Jumper is a harness, too. Let us speak of this repellent phrase "Jacking into Cyberspace." Let us begin by telling men that they are pissing in the wind. Let us remember that perspective is only one of many modes of representation – and that all optical instruments function to flatten light's brilliant waves and particles onto a monotonous plane. The projector sends dancing light to hit the flat movie screen, the mirror in the microscope reflects light up into the smooth, two-dimensional glass slide onto which is smeared a translucent layer of life. It should come as no surprise that the first thing that men looked at with the new glass of the microscope was their own sperm.

The notion of the pleasure-getting activity of virtual reality is born out of the definition of pleasure and of understanding within a capitalist society obsessed by information and productivity – they are divided and equal.

The Renaissance reduction of the visual to the narrow field of perspective is concurrent with the reduction of human pleasure to the brief sexual release of one organ (which only half the world sports). Indeed, perspective has functioned to rationalize pleasure and to streamline disruptive (polymorphous and discursive) pleasure into spasmodic but oh-so-productive moments of procreative sexual activity that obeys a scopophilia learned from perspective itself. It is all done with mirrors. It has all been done with mirrors for centuries. There is nothing new about virtual reality machines. Perspective is already a simulation, though abstract as any other system of representation. Virtual reality heightens and maintains a polarity wherein there is no pleasure to be got from understanding, and there can be no understanding of our pleasure.

One of the principal projects of a science capable of producing multiple *bioapparatuses* is the project of the synthesization of the female reproductive apparatus – ideologically through the phallocentrization of pleasure, pathologically through misrepresentative description, medically through excision and mutilation and so on. The cybervagina dissimulates and defines the *vagina dentata*. We must conclude again, from another angle, that there is nothing new about virtual reality, and that men have been jacking into cyberspace for centuries, even when they are jacking into women.

We know all this because as lesbians, our sexuality is the ultimate virtual reality. It is virtual specifically because it is not a learned sexuality. Lesbian sexuality is an *invented* sexuality. When asking about sex as a child, we were told again and again about reproduction, as so many millions of children for millennia. Reproduction, in this scheme, is effected by the thrusting, directed will of the

38

sperm, as opposed to the lackadaisically cyclical nature of ovulation, which keeps its own time and waits for no man.

The absurd fusion of pleasure and procreation in human intercourse – sexual and otherwise – is utterly exclusive of anything else. It is a closed discourse which only the strongest, most instinctive intuition, evidencing itself in the form of mental voices, siren-songs, hauntings, breathtaking visions of love bricolaged from thin air, and a nameless desolation in even the most loving and cosy of homes, can bring to the brink of understanding – of an understanding of pleasure. This often coalesces with the knowledge that we can have pleasure with and from our own bodies (not by far as common knowledge as our liberal culture would have us think), often a major and secret personal discovery. Even against the social will of the fearful girl-child, who is taught to fear her very senses, these visions and tortures function miraculously to pry apart the fortress-like masonry wedding pleasure and procreation. In the vacuum of this ruin we can create for ourselves a conceptual space. Entirely alone and each convinced of the deep solitude of our state of desiring other women, we must invent, through this intuitive bricolage of visions from nowhere, an idea of the technics of pleasure with another woman, long before we experience it. When we do experience it, that conceptual space becomes at once a personally tangible and socially virtual reality. With so deep a solitude and so frail a history, we *invent* our own culture and practice with every generation. This is magnificent.

For a society convinced of the inevitable necessity of the kiss of death of the *bioapparatus* and the *rigor mortis* of a body/machine embrace, lesbian sexuality is a site of the greatest possible hope for a better world. Our sexuality is an invisible field that does not interact with the reproductive machine, that proves that procreation is not sexuality, that finds no pleasure in the events required by reproduction, and that builds imaginatively on the sparest possible clues, its own desire and pleasure miraculously outside these narrow realms which suffocate even those women who desire men, and men who desire women. In the long years of negation of our sexual pleasure which we are made to suffer through, those of us who are not driven mad – and those of us who work through even this last obstacle – also learn to build diffuse and complex pleasures which are not exclusively sexually and genitally based. We are experts in conceiving and building complex, multiple and discursive pleasures.

Lesbian sexuality is a virtual reality that manifests itself daily in the exchange of glances between women on the street, in the subway, at school, on the chain gang, over the board-room table. Even if the entire fabric of society says NO, we are still able to say a YES to each other in a split second of eye contact which goes undetected by others. This hypothetical YES is not enough in concrete terms, but it is the most virtual of places from which to start building another better world for everyone.

Response

DAVID ROKEBY

The papers I am presenting and responding to deal in some way with the notion of re-embodiment. And re-embodiment implies that there has already been a process of disembodiment. So I intend in my presentation to reflect on this process of disembodiment and subsequent re-embodiment. Each paper extends somewhat beyond the scope of the topic itself, so I will be dealing only with the parts of each paper that address the re-embodiment issue. Other issues raised in these papers will (hopefully) be addressed in other seminar presentations.

Jack Butler, in his paper, notes that the genitalia of the mature male and female derive from an identical precursor, namely the indifferent genitalia of the nine-week-old embryo. He uses this as a conceptual tool to question prevailing models of sexuality, particularly Freudian and Lacanian models of sexual difference. He suggests that the sexual body might be a transparent skin through which science and art might examine and question each other. He thinks of alternative models related to sexuality as *tools* that might enable us to inhabit our body.

Dorit Cypis discusses the conflict between broadcast images of the body and the living, sensed body. She notes that the mind/body split has traditionally been promoted by our culture, and that this raises important issues about manipulation and power. She offers her own experience of leading workshops which focus on these questions. Virtual reality technologies are used in part of these workshops as a tool to enhance and alter participants' perceptions of their bodies. She stresses the importance of re-embodiment, explaining that "tapping into our body's wisdom offers the possibility of remembering, re-sensing, repossessing our fragmented selves. Trusting our body, we move from denial to responsibility, shame to pleasure, claiming others to mutual respect and compassion."

Frank Lantz describes the *bioapparatus* as "the body mutated to survive perpetual migration between interlaced realities." These interlaced realities are social contexts, each with their own idea of body, or ideal body. The *bioapparatus* survives to the degree that it can escape being completely defined by any of these contexts. It is an outlaw, flexible and elusive.

Lyne Lapointe and Martha Fleming present lesbian sexuality as a virtual reality. Lesbians have used their imagination and the intuition of their bodies to invent a new sexuality as a strategy to avoid the imposed traditional model of heterosexual, reproductive sexuality. They describe the process by which a conceptual space (imagined lesbian sexuality) becomes a personally tangible and socially virtual reality. They also express concern that the body projected into virtual reality systems is "a scientific body, a body that is a product of hard, pure science. An impermeable and rigid body. An erect body."

The apparatus in these papers is not necessarily technological. Conceptual models in conjunction with the body also create hybrids that are no less a transformation of the body than existing human/machine hybrids. The *bioapparatus* might be defined as the body modified by external constructs. Our culture broadcasts such constructs, projecting prevailing ideas of the body onto our individual, sensed bodies. Under the pressure of these projections, we become alienated from what we *perceive* to be our bodies. This amplifies the apparent mind/body division, although what we are really sensing is perhaps more a split between the culturally projected body image and the personal body image built out of our sensual experience of embodiment. Because we find ourselves alienated from our body

40

we effectively abandon it. It is appropriated by our culture, becoming public property. By controlling abortion, government expresses this appropriation of the body, in this case as a reproducing machine. In another example, the body is useful, as Lantz points out, as the site of legal accountability. When a criminal is incarcerated, in effect, his body is repossessed, though his mind is left fairly free. I am reminded of the fact that credit cards remain the possession of the issuing company and can be repossessed or destroyed at that company's whim. The body comes to be perceived primarily as the site of pain, punishment, accountability, and unquenchable *illicit* desire. In effect, it becomes a battlefield upon which most of the conflicts between the individual and the society are waged. Retreating from this no man's land of our bodies, we become disembodied.

The desire for re-embodiment stems from the *intuition* that there is a body that we can reclaim for ourselves which we could inhabit with pleasure. Both Cypis' and Lapointe and Fleming's papers mention something which they call body wisdom or body intuition. The implication is that the living body, if reclaimed, could be trusted in some way. The nature of this trust is somewhat undefined. If it is based on the idea that the body is natural and therefore good, then it is potentially problematic. But the body largely defines our subjective point of view, and so perhaps what is really meant by trusting the body, is trusting in our accumulated subjective experience. I identify this as another form of accountability or responsibility: an *ability to respond* from one's subjective point-of-view. In this context, re-embodiment becomes the act of reclaiming subjectivity. The body is then seen as a subjective reference point, an anchor which protects one from external manipulation, a point of relative stability from which one can explore and invent. This reclaimed body warns us when we are over-extended (both mentally and physically) and may form the foundation of what we call sanity. It also is the basis of our identification with other humans, a sort of lens through which compassion, and respect for others' subjectivity is focused. Most importantly, it is perhaps only within the complex subjectivity of the body that we can question and resist our desire for all-embracing models.

The papers present several strategies of reclamation. If the body is transformed by constructs such as the *bioapparatus*, then what is being proposed might be called the construction of anti-bioapparatuses. This is seen as being achieved through the creation of alternate frameworks which loosen the grip of traditional models. These personal models might be conceptual, physical or technological. They would serve as tools which would enable us to re-inhabit our bodies. It is important to note, however, that these alternate models are not intended to replace prevailing models but rather to clear a space in which subjectivity can survive unencoded, alive.

These papers are relatively optimistic about the potential for re-embodiment. They recommend subversion as the necessary stance, but offer differing visions about the potential of technology as a re-embodying force. In my own work, I have created interactive sound installations which transform body movement into sound. The creation of these works was part of a personal process of reclaiming my body after a period of personal "civil" war. This subjective viewpoint is the lens through which I read these papers. The results of my work suggest to me that technologies *might* have a place in such reclamation, but that considerable vigilance is necessary if one wishes to avoid merely reinforcing the models and assumptions with which the technologies themselves are endowed

Discussion

Catherine Richards:

I am curious about when you mentioned your own work as a possible site of the anti-bioapparatus. It is interesting because it is such a mediated attempt to recover the body.

	Perhaps you could expand. It seems to me you're trying to use mediated technology as an antidote.
David Rokeby:	There are many questions asked about the liability of constructing anti-bioapparatuses using technology. In Lapointe and Fleming's paper, it is an invented reality and that seems somehow to imply some essence of mediation. They talk about, for instance, a conceptual framework or conceptual model of sexuality: "We do experience that the conceptual space becomes a personal and tangible and socially virtual reality." In a sense I think of that conceptual space as being some sort of a construct. Perhaps it is not mediated through technology, but it is mediated through invented ideas.
Catherine Richards:	So you are saying that the conceptual construct is analogous to the technological mediation.
David Rokeby:	Yes, in the broad sense that any conceptual model or conceptual space is a kind of technique or technology of its own. I think there are important questions to be asked particularly about technologically mediated models. For instance, are there values already implicit in the structure? The intention is not to replace one model with another; perhaps both the projected technological model and the invented personal model suffer from the same problems but balance against each other to leave you without an overall model – which then leaves you free for re-embodiment, to embrace the subjectivity that the body represents.
Catherine Richards:	One difference in position is the construction of that space for yourself versus someone constructing it for you. There is obviously a difference. It seems to me that being able to recover your body is a pretty big job.
David Rokeby:	From my own personal point of view, the construction of my installation was part of the process of recovery of my own body, although it is interesting that the people who have responded the strongest to that work have been other people who have been at war with their bodies. I would certainly not intend to presume that any single model or single apparatus of any sort is the silver bullet or the magic that does that but alternative ways of reflecting on your body create a fragmented vision of the body, one that breaks the stranglehold of broadcast notions, such as the objectifying of the female body in photography or imagery.
Catherine Richards:	Are you going so far as to say that your piece is your antidote for your own loss of body and in a sense is a narrative which documents this process?
David Rokeby:	When I started to build it, it was not, but at every step in the development of it I took it in directions that were based on fairly visceral responses to it. There is certainly a strong autobiographical element in that.
Catherine Richards:	But isn't there a sort of impediment for a repeat of that process for the user because, for them, the technology is transparent whereas, for you, the technology is an integration process. It is almost the reverse for a user because there is no entry into that aspect.
David Rokeby:	Well that is very true. I knew the technology by building the computers and writing the software. It would be probably a more disembodying experience to construct the work than it would be to experience it.
Robin Minard:	It might be important to ask how really subjective or objective you can be about a system. It is a social and cultural construct so it is important to decide what kind of models you are making and to examine the way we make them and what they contain.

Perfect Bodies

Technology is used to enhance bodies and it is also complicit in creating notions of what the body should be.

Francine Dagenais

The techno-mythological concept of a "machine that contains its own principle of motion" was initially proposed by Rabelais in the sixteenth century (Gargantua).[1] The automate "contrived a thousand little automatory engines, that is to say, moving of themselves."

The technology for virtual reality provides the participant with the illusion of moving through space bodiless. The body is isolated, the senses cut off from their reality/environment and fed an alternate environment. A disassociation results between the head as privileged sensory receptor and the body as substituted by the hand/index: Deleuze/Guattari's "corps sans organe"[2] as a headless body is contrasted with the traditional conception of the "corps organique," a body governed by a central nervous system and brain.

In this instance the participant becomes both a receptor/receptacle of sense data introduced by a cybernetic automaton as well as a visual traveller, a receptacle of motion.[3] The subject ceases to exist and, as Paul Virilio puts it, becomes motion. Decapitated by the virtual reality experience, the body loses its self-definition, forcing a restructuring of the notion of environment, its internalization thereby eliminating heretofore distinctions of within and without. The body is caught in the ambiguity of wholeness/loneliness. The body as receptor of motion becomes the medium itself. The medium is the body.

1 Jean-Claude Beaune, "The Classical Age of the Automaton," in *Fragments for a History of the Human Body Part I*, ed. Michel Feher (New York: Zone Books, 1989), 431.
2 Gilles Deleuze and Felix Guattari, *Anti-Oedipus* (Minneapolis: University of Minnesota Press, 1983).
3 Paul Virilio, *War and Cinema, The Logistics of Perception* (London: Verso, 1989).

Gottfried Hattinger

Once upon a time there was cyberspace and virtual reality and now there is the *bioapparatus*, yet another term in the hall of mirrors of scientific sensations. Strangely, I do not associate this word with the latest state-of-the art technology but rather with memories which go far back. Therefore, do permit me to cast my gaze to the past and not to the future as would perhaps be more appropriate for this seminar.

** The year 1599 is the first significant ideological turning point, when H. de Monantheuil postulated that God was no longer to be regarded as a surveyor but rather as a mechanic, as the world is a machine.

** Descartes described animals and La Mettrie described mankind as machines. When mankind is reduced to a machine, no artist need create this mechanically.

** The idea of a magnified machine-being appears during the Romantic period with Jean Paul anticipating the visions of M. Minsky or H. Moravec: "As there were now machines in every form of art, one should create machines to invent new machines which would give rise to new forms of art and science."

In Remembrance of the Bioapparatus

** Key words: E.T.A. Hoffmann's "Olympia," V. de Isle Adam's "Eva of the Future," Paracelsus' "Homunkulus" and the Faust myth which continues into the present time in the form of in vitro fertilization, cloning, gene technology. The conclusion is that we still avail of the same body as did the mammoth hunters while our automatic apparatuses far excel our capabilities. The ultimate behind artificial human beings would be the invention of the immortal, the bio-machine.

** Marinetti postulated the imminent and unavoidable identification of man with the machine.

** A. Turing compares the child-like brain to a notebook: not much mechanism but a lot of empty pages. Educating a machine is the same for him as educating a human child. And, sooner or later, we have to reckon with the fact that machines will take over. Culture and artistic life, of course, play no part in the testing of artificial intelligence.

** E. Fromm termed the people of today as cybernetic, people whose world has become the non-living, a sum of lifeless artifacts.

** Each living being will become a molecular machine consisting of "Wetware" and "Software," of damp biological life machinery and gene technology control programs.

** According to H. Moravec, the future is similarly post-biological; machine intelligence will be superior to that of human beings by the factor ten to the power of thirty (one million, million, million, million, million).

** I am now about to supply my bio-machine with a glass of beer.

Robert McFadden

Humour and speculation about new technologies are two sites of discourse where gendered concepts and desires are often most blatantly expressed. Both are featured in a comment from Jaron Lanier that is now commonly used to anchor our appreciation of virtual reality: Lanier speculated on the potential offered by this technology to experience reality through the body of a lobster.

The prospect of reconstituting the reality of a lobster within a virtual environment is not difficult to imagine in a culture that has long conceived of the universe as constituted of mechanical bodies and essential spirits. In this dichotomy, the lobster fits firmly within the realm of machines as an ahistorical automaton well suited to the depths of a clockwork cyberspace. Taken a bit further, the lobster might be imagined as a remote ancestor of the technology through which virtual reality is realized: a primitive bio-computer encased in a hard, portable chassis.

Jacking into Lobsters: Images of Masculinity in Virtual Reality Humour

Equating a body with a chassis has its own history, particularly within Fascist concepts of gender. In *Male Fantasies*, Klaus Theweleit reveals this equation at work in the iconography of the ideal male as portrayed in popular works of literature and art from Nazi Germany.[1] Bela Gruberger's analysis of Fascist males in *New Essays on Narcissism* proposes that this equation operates as one half of a concept of the polarized body in which the exterior is identified with the masculine and the interior with the feminine.[2] The fascist's valorization of the exterior, coterminous with the attempt to eradicate the feminine interior, is, argues Gruberger, driven by an infantile desire to regress from the fractured world of the individual self to the primal state of unity within the womb.

Playing off this argument are the shifts in gender identification which have been built into western readings of the body. While the male body was, until recently, considered in general to be the prototype against which the female represented an inferior rendition, it is now largely recognized that, historically, the bodies used in art, medicine and science to develop the anatomical concepts underpinning this hierarchy were overwhelmingly female. As a vehicle for constructing the masculine through the feminine, the body is imagined as a repository of natural laws; access to this body may only be accomplished through active penetration and examination. In *Sexual Visions*, Ludmilla Jordanova discusses the application of this process across a variety of texts and images drawn from medical, scientific and popular culture sources.[3] Here we may recognize a more basic agenda at work beneath the mantle of disinterested inquiry, the object of which is masculine self-confirmation through the interrogation of difference. In *Hardcore*, Linda Williams identifies the same agenda as central to the operation of pornographic film, wherein the "money shot" – the image of the ejaculating penis – serves as both climax and validation.[4]

1 Klaus Theweleit, *Male Fantasies*, Vol. 2 (Minneapolis: University of Minnesota Press, 1989).
2 Bela Gruberger, *New Essays on Narcissism*, translated and edited by David Macey (London: Free Association Books, 1989).
3 Ludmilla Jordanova, *Sexual Visions* (Madison: University of Wisconsin Press, 1989).
4 Linda Williams, *Hardcore: Power, Pleasure and the "Frenzy of the Visible"* (London: Pandora, 1990).

Arthur Koestler contended that humour is a form of discourse used to ridicule ideas rising from the union of two unlikely matrices. Should this be so, the proposition of a humorous relationship between lobsters and virtual reality may be understood as a denial of any critical appreciation that such a union might propose, particularly one arguing that the deployment of this technology represents yet one more effort to buttress the masculine ego against its perceived foes, real and imagined.

Kim Sawchuk

Marketing Health Care
and the Bioapparatus

Marketing is an interconnected network that sets up ritualistic circuits of feedback between the bodies of consumers and information technologies. These consumer bodies are then broken down into ever more detailed problem areas for every conceivable part of the anatomy requiring ever more refined life-giving, health-inducing products. In the apparatus of hygiene promoted by the consumer health-care industry, the body becomes a machine of production, channelling and producing energies and drives and then focusing them into commodities. While douches, mouthwashes, toothpastes and aftershaves threaten to stop or halt the flow of bodies, it is only by virtue of continual bodily leakages that these products can be produced. All these holes in our bodies that leak – anuses, cunts, penises, ears, mouths, cavities – are prone to infection and, as Deleuze and Guattari write in *Anti-Oedipus,* are "...so many points of disjunction, between which an entire network of new syntheses is now woven, marking the surface off into coordinates, like a grid."[1] They can be seasonal (cold remedies), gendered (douches), aged (diapers), classed (stomach remedies) or whatever possible configuration can generate a new market segment connected to the body. Marketers postulate that the more they learn about the consumer body, the more fragmented it appears to be; in fact, I would argue that it is fractured *because of these knowledge practices,* which are not simply constitutive, but performative in their effects. Since the 1950s, marketing research has done two things: first, it made the individual consumer body the target of knowledge; second, it conceived of consumers as so many market segments rather than as a mass market. We are entering a new phase of customized design in which every person is a market segment.

These advertising and marketing technologies are not simply images but are forms of practical knowledges. They are techniques applied to the self and they form one pole of bio-power, the anatomo-political, which Foucault identified in *The History of Sexuality.* But as well, these technologies are bio-political or applied to the species body. For example, the child's diapered body is one of the first sites and instances of this mechanism. The advertisements of the two major disposable diaper companies, Proctor and Gamble (Pampers and Luvs) and Kimberley-Clark (Huggies), are bolstered by careful market research which reveal/produce the insecurities/desires of parents, providing adults a language to assess their competency as parents. The unknown territory of the baby's body becomes a territory that is mapped out and hence made knowable in diaper advertising. This baby, which does not yet speak the same language as the adult, becomes a body which does speak, emitting signs of comfort, discomfort and pleasure that can be interpreted by the parent, then given the appropriate consumer panacea that forms part of the system of communication between parents and children. In colour-coded diapers, which are sweeping the disposable diaper industry, the baby is actually coded as male or female, inscribed from birth in the present gender system. In fact, it is one of the minute, banal places in the everyday where the myth of a bi-polar, heterosexual human nature is secured. Thus the diaper is a material boundary or interface where the flows of the body intersect with the flows of television.

Control in this system is secured, not through the mechanism of brute repression, or juridical-legal power, but like the diaper itself, through "soft barriers" (bio-power) which "snuggles baby's shape." Marketing research probes, prods and diagnoses the consumer body to ensure that it is still operating at a healthy level of desire for the commodities it produces. The result is a subject with dreams of happy-ever-after carefully monitored.

1 Gilles Deleuze and Felix Guattari, *Anti-Oedipus* (Minneapolis: University of Minnesota Press, 1983), 12.

Nell Tenhaaf

I had forgotten how author Mary Shelley accounted for Dr. Frankenstein's overwhelming need to produce an artificial man. The year is 1818; she's made a writing pact with Lord Byron and P.B. Shelley to pass the time during a stay in Switzerland and only she fulfills it. Her creation, Frankenstein's creation, is not a mechanical creature as might be anticipated, but a constructed human being – enlarged in scale so that the fine detailing would be easier.

Victor Frankenstein, the creator, the scientist, has no morbid preoccupations resulting from a deprived childhood. Quite the opposite, he's had everything, except sufficient intellectual support for his enquiring mind. His self-education is derailed when he stumbles on the writings of some alchemical philosophers whose theories seem to satisfy his romantic inclination to penetrate the mysteries of nature. Shelley doesn't go into a lot of detail about his conversion, but the net result is that Victor suffers an epistemological regression of several centuries and adopts an organicist, vitalist worldview that his subsequent university studies in chemistry and natural philosophy will temper but cannot squelch. He likes to work in secret; his social and economic privilege permits him to do pretty much what he likes and he's got some kind of repressed need for boundless grandeur and glory that drives him to complete the monster.

The monster exemplifies isolation. From the moment he opens his eyes, he is reviled by his creator. He becomes a mirror of Frankenstein in this respect, revealing the creator's disconnection from the social meaning of his work and his completely abstract way of approaching the generation of knowledge. Several ideas merge here to combine Shelley's fascination with tormented (male) creative genius and her profound sympathy for the disenfranchised. Frankenstein's attraction to the vitalism of alchemy links the significance of those ideas about a self-active natural world to radical libertarian political beliefs in several sects and social movements of the sixteenth and seventeenth centuries. Also, the alchemical philosopher Paracelsus expressed the spirit of scientific enquiry in the first half of the sixteenth century, not as a rationalist or even specialized endeavour, but as a healing process in which nature is an active partner and to which any individual, of any class, can have access. The organic bond was broken in the seventeenth century by the rise of the Cartesian mechanistic world view. Dr. Frankenstein wanted to think and to know differently but he found out that, at that time and in that context, it was a grave error to mix post-Cartesian rational knowledge and technical skills with the discovery of the vitalist life-force itself. The result was an exacerbation of the surrounding sociopolitical problems. After he learned to speak, the monster said to Frankenstein, who reviled him: "I expected this reception...all men hate the wretched...."

Meanwhile, literature from the Biotechnology Research Institute (BRI) in Montreal talks about "rationally redesigned proteins." I believe in the fundamental value of what this literature describes as benign applications of the research, such as disease management, stimulated crop growth and waste processing. However, it is not a huge leap from better healing through designer drugs to engineering different bodies for consumer options. In a world of "global competition in knowledge-intensive industries," as BRI puts it, can the researcher be an engaged social subject? or is that self inevitably split from the anxious, reflexive, panicky subject-as-knower? This is a question for the artist as well.

Response

INEZ VAN DER SPEK

There are five papers included in this section entitled Perfect Bodies and four of them attached more or less explicitly the notion of the *bioapparatus* to developments that started in the last four centuries and draw historical parallels. Technology is not seen as something that dropped from the skies but as related to historical changes and human (especially male) desires.

In Gottfried Hattinger's paper he mentions a wide range of historical references to men who – with approval or disgust – understand the human being as a machine or on his way to becoming one. Next to that, Hattinger refers to people who had dreams – expressed in literary tales – of artificial human beings. He sees this dream continued in in vitro fertilization, cloning and genetic technology. Both types of references recur in the other papers.

Francine Dagenais sees virtual reality technology as the realization of the "techno-mytho-logical" concepts of the automaton proposed by Rabelais in the sixteenth century. An automaton is a machine that contains its own principle of motion. Virtual reality provides the participant with the illusion of moving through space bodiless. The body is decapitated in the virtual reality experience and thus loses its self-definition. It has become a receptor of motion.

Nell Tenhaaf also connects expressions of the dream of creating an artificial human being with current biotechnological developments. She focuses on the story of Victor Frankenstein's monster written by Mary Shelley, which strangely enough Hattinger did not mention in his examples of artificial human beings. Nell points out that, in the figure of Frankenstein, different epistemological views collide. On one hand there is Cartesian rational knowledge with its matching technological skills but in the background, there exists as well an older alchemist vitalist worldview. (Vitalism is a scientific thought that, in opposition to mechanism and organicism, presumes a vital life force peculiar to living organisms and different from other forces found outside living things.) Frankenstein tried to mix the vitalist and the Cartesian views, but he created a monster. The paper's urgent question then is: Can a researcher as well as an artist be both an engaged social subject and a subject striving for knowledge?

Robert McFadden reflects on the cultural meaning of creatures that are used in immersive virtual environments. He uses Jaron Lanier's presumably funny example of a lobster, but Robert is not amused. He uses the lobster as a metaphor in a gender critical approach of virtual reality. He says it is not difficult to imagine a lobster within a virtual environment in a culture that "has long conceived of the universe as constituted of mechanical bodies and essential spirits." The lobster might be imagined "a remote ancestor of the technology through which virtual reality is realized: a primitive bio-computer encased in a hard portable chassis." He points out the analogy with Fascist concepts of gender which represent a polarized body in which the chassis-like exterior is identified with the masculine and the interior with the feminine – which has to be eradicated.

In the last paper in this section, Kim Sawchuk is less inspired by historical or legendary analogies than the former four, but she explores as well the engineering of bodies. She describes the discourse of the disposable diaper. Following Foucault's methods, she analyzes the anatomo-political and bio-political (body and species) technologies of making the little baby into both an object and a subject of knowledge. "The unknown territory of the baby's

body becomes a territory that is mapped out and hence made knowable in diaper advertising." It becomes a body that speaks by emitting signs of comfort, discomfort and pleasure that can be interpreted by the parent in a correct consumer's response. In colour-coded diapers the baby is actually coded as male or female: the diaper is an actual material space, where the flows of the body intersect with the flows of television.

Well, so far, I have made some associations and allusions about all of this.

This section is called Perfect Bodies, but I know the organizers were for a while hesitating about calling it Engineered Bodies. I thought indeed it did not really matter what you call them because in a way all the engineered bodies display their creator's desire to create – or to have – a perfect body. But then, of course, there is the question: What exactly is the perfect body? It looks like a perfect body is a *dry* body, a body that is not leaking, that does not involve sexual fluids and juices, no excrements, no slime or sweat, no blood dripping out hidden openings, especially not female openings. Consequently, there can be no smells and hence, no involuntary attraction towards other bodies, because smell seems to be the fundamental medium for attraction towards other people. Oh, and there can be no tears. Perfect bodies do not suffer. Well, perhaps they do suffer and sweat a little, in the case of bodybuilders or fitness freaks but they are merely suffering and sweating in a physical way *onto* the perfect body.

A perfect body is a dam against floods. A baby still needs a material dam, the diaper, until it has built its own internal dam. (But look at the Pamper paradox: I have heard that because of the fantastic capability of absorption of the diaper, the babies are not urged anymore to get potty-trained.) I was thinking that probably one advantage of new technologies over old mechanical machines is that whereas the latter sometimes still needs liquids, water or oil – new ones are just allergic to liquids. Do not throw water into the computer! I think perhaps that is what Gottfried Hattinger suddenly became aware of when he wrote the last sentence of his paper: he is announcing there that he will soon provide his bio-machine with a glass of beer.

A conception of human beings as machines may refer to this ideal of dryness, that is, hygiene, sterility, isolation and stolidity. A perfect body seems to be no body. Perhaps this is why Frankenstein's monster is such a tragic figure: he is still too much of a body; the vitalist principle is still flowing through his veins. It is no coincidence that at the end of the story Frankenstein and his monster are chasing each other to death in the icy landscape of the Arctic. Frankenstein is killed by his monstrous persecutor but the monster announces his suicide (by burning) as well – so they both die. Ice is not only the symbol of coldness and isolation; it is also the metaphor for the way of thinking that became dominant in the western world. Ice is the result of the congealing, the freezing of fluid into the solid categories of rational discourse. I am stealing here a bit from Luce Irigaray. In many tales, the ice as both metaphor and materiality appears. I am thinking about Anna Kavan's *Ice* and somewhere in the back of my mind is *Moby Dick* but I read it too long ago to be sure of that. And there is the ice in Ursula LeGuin's science fiction novel, *The Left Hand of Darkness*.

Interesting in the last novel, I think, is that there the ice melts, the verb understood in its transitive meaning, it melts away the seemingly unbridgeable differences between the two persons who have to cross an enormous icefield in order to survive. That active role of nature brings me to a reference in Tenhaaf's paper to Paracelsus, the fifteenth/sixteenth century alchemist/vitalist for whom nature was not a passive – female – object that should be penetrated, disclosed, conquered or controlled, but an active partner. The perception of nature as active agent or subject instead of a passive object also returns in Donna Haraway's article *Situated Knowledges*. The thought intrigues me. I think it is opposed to both the understanding of the world as a "resource to be mapped in bourgeois, Marxist or

masculinist projects" (Haraway). But also it seems opposed to holistic celebrations of Nature (capital N) whose "purity" is threatened by the acts of mankind because I think, in this perception of nature, she is just as well treated as passive and objectified. So, opposite to those different perceptions, I pose the notion of nature as active agent or comprising active subjects.

Discussion

Mary Ann Amacher:	Was there any discussion at all in the papers about the idea of exchanging body systems? For example, if you had resonance prints for your ears and vision prints for your eyes, let's say in an mentality chip, I could see and hear as Warren and Warren could see and hear as me, which would be very nice because we could enter other worlds and other people's sensibilities that way. Then it gets to the interesting implication that if you had such a thing as a perfectly tuned body, all your neurons and all your sensibilities, would you want to sell it for simulation?
Nell Tenhaaf:	Are those all examples out of science fiction?
Warren Robinett:	It is not science fiction; it is real. Not everyone has heard the ideas of downloading which some people have proposed. You start by asking the question: Where is the essence of yourself, of David Tomas? What constitutes his identity? I think a lot of people would buy that it is his knowledge and his personality. Then you can ask the question: Is that inseparably attached to meat, the "wet wear" that constitutes his brain? At first glance you might think it is but you can also think of it as information. There is a little thought experiment you can go through where if you could simulate accurately the behaviour of one neuron in his brain and wire it up and take out the real neuron and let that simulated neuron play its part, you would not be able to tell the difference. And you successively replace more and more of the neurons in his brain with simulated ones that do exactly what the real ones did; David's still sitting there talking and thinking and cannot tell the difference. At the end of the process, you have moved him over onto this simulated brain that has exactly the same wiring diagram, same number of neurons and he is still talking and commenting and did not even know anything happened; he has been downloaded. This is science fiction but it is also something you can imagine carrying out all the steps in the future at some point.
Nell Tenhaaf:	There is a crucial threshold question there. How far does one have to go before you have reconstituted the person? I would argue that you would have to reconstitute the entire thing.
Warren Robinett:	That is an interesting argument to have in the abstract but if we had actually moved David up onto a box and he was sitting there talking to us and saying, "Hey look, I feel like myself," it brings up all sorts of issues. Once you have moved onto a computer, you do not have to die, you can make copies of yourself.
Catherine Richards:	Is this kind of science fiction approach similar to Marvin Minsky's version? Is our spinal cord just a coaxial cable? The power of metaphor, which runs rampant before we even make the tools, can actually drive our desire to make certain kinds of tools. So, if you start saying your spinal cord is just a coaxial cable, of course the next step is to plug it in directly. There is a similar kind of thinking that says, "Let's map it out. Then we can plug things in to our extended selves and learn quicker with direct connections. But even better, we can take all our experience and download it and then we will live forever." That is the real motivation.

Warren Robinett:	It is an interesting motivation.
Nell Tenhaaf:	But the only difference from Frankenstein a few centuries ago is that the model then was surgery and dissection. That was the locus of investigation, around how to be able to cut up a body.
Inez van der Spek:	The perfect body is no body at all.
Warren Robinett:	I think Frankenstein is a symbol in this whole discussion. I think there is something bizarre going on here from my point of view. We have sort of taken virtual reality as a symbol of technology that is ruining the world. That is how I perceive a lot of this discussion.
Inez van der Spek:	Well I was not just talking about virtual reality.
Warren Robinett:	About technology in general?
Inez van der Spek:	Yes, and the ideals behind it.
Warren Robinett:	I think the scary part of that is the power part. Am I right? Even awareness is a power in a sense.
Nell Tenhaaf:	You are implying that some of us are scared and you are not. Is that where you are positioning yourself or are you including yourself?
Warren Robinett:	It is a question I want to ask. I think the image of Frankenstein is a good one if you're scared of creating something that gets out of control and is very destructive and horrible. You might also bring up Pandora's Box.
Robert McFadden:	The story of Frankenstein is entirely different: it is actually the doctor who is out of control.
Nell Tenhaaf:	The monster learns language in the space of two months.
Warren Robinett:	But the monster kills people.
Nell Tenhaaf:	Only because Frankenstein cannot cope. The monster's daddy cannot love him.
Warren Robinett:	Well, the artificial intelligence we create will never kill humans unless they attack them without provocation. But they are still scary, right?
Nell Tenhaaf:	Well, the first problem that Frankenstein had was that he was surprised by his monster.
Warren Robinett:	Okay, so you're saying virtual reality is not a symbol of technology out of control, but I think the tenor of the discussion we have been having is "maybe we should not do this stuff, maybe this particular stuff, virtual reality and technology in general is just a little bit too nasty and we do not quite know what we are doing and maybe we should just think twice before we do anything."
Robert McFadden:	There is a whole other side to this too, which has to do with what's actually been done with this technology. Much of this material carries a notion of being threatened by the outside, as if the technology itself is used to protect those who are creating it from an assumed aggressor.
Nell Tenhaaf:	It has nothing to do with the technology itself; it has to do with all the psychic, psychological, psychoanalytical implications within it. It is never a neutral or simple relation.
Warren Robinett:	Well, I still have not got an answer to my question. This is what I think is strange and bizarre: Is an artist an explorer or a social critic? I am feeling you all are going to tell me both, but it seems to me we are being social critics here and I find it strange we are not talking about the new things you could do with the technology.

51

Nell Tenhaaf:	There is no doubt about it, as Fred Truck in one of our discussions reminded us: we all want to be able to go to the medical system and say, "Make me well as best you can." There is a lot of important work being done there but it is very simple to take a conceptual jump from designer drugs to designer parts of the body. I do think that is science fiction at this point, but there are a lot of implications there about desires to be looked at.
David Tomas:	I think a lot of people assume that the conversation is revolving around the idea of the mind being the seat of the personality or subjectivity, but it is actually the body also. So, one notes that one's body is idiosyncratic. If you are attracted to someone, you are not only attracted to a mind, you are attracted to bits and pieces of her or his body. So, you are going to have to download bits and pieces of bodies as well as part of our personality.
Warren Robinett:	You would not have to.
Nell Tenhaaf:	What would you take as just information in the nature/nurture argument? There is more and more recognition in the scientific domain that, for instance, in terms of genetic coding, you cannot simply take one entity, the piece of DNA, and say this codes for that. You can't do that because the interface with the rest of the material happens from the first instant. I find it problematic to make distinctions about what is information within the context of the body.
Warren Robinett:	But the reason I responded, saying that you did not have to take both of them down, is because sometimes new technological things that come along unbundle things that used to be inseparable.
David Tomas:	It is not a question of wanting to get rid of those body parts; it is a question of actually wanting them, because they define what a person is.
Catherine Richards:	I am also wondering if there is a basic confusion here between representation and whatever this living thing is that I am. You can say a novel used to provide a representation of living things. Now our compulsion is to use sci-fi imaging to represent living beings, but it is still a representation – not, for example, David Tomas himself.
Inez van der Spek:	I was wondering when someone said you could live forever by downloading people, why people are so fascinated by this idea of becoming immortal? What is the attraction of it? I really do not understand.
Robin Minard:	Maybe it results because science is a myth that does not include this kind of immortality so we try to construct it through a system.
Inez van der Spek:	Yes, but why is this myth so predominant in our culture?
Mary Ann Amacher:	We are like babies, we do not know anything.

Subjectivities

Ingrid Bachmann

That humanity at large will ever be able to dispense with Artificial Paradises seems very unlikely. Most men and women lead lives at worst so painful, at the best so monotonous, poor and limited, that the urge to escape, the longing to transcend themselves if only for a few moments is and has always been one of the principal appetites of the soul. Art and religion, carnivals and saturnalia, dancing and listening to oratory – all these have served, in H.G. Wells' phrase, as Doors in the Wall.

Aldous Huxley

Paradise

Scene 1:

Taking a bateau-mouche down the blood stream of one's body, with stops for photo opportunities at the heart and lungs.

Scene 2:

Falling for miles without ever hitting bottom.
Hitting the bottom and rebounding for miles.

The Morning After

The world's new industrial proletariat:[1] young, female, Third World. Viewed from the First World, they are faceless, genderless, "cheap labour" signalling their existence only through a label or imprint – made in Hong Kong, Taiwan, Korea, Dominican Republic, Mexico, Philippines.

The Peacock

When he spreads his tail, this bird
Who drags his plumage in the grass
May grow in beauty
But he also bares his ass.

Apollinaire

1 Barbara Ehrenreich and Annette Fuentes coined the term *industrial proletariat* in "Life on the Global Assembly Line" in *Feminist Frameworks*, ed. Alison Jaggar and Paula Rothenberg (New York: McGraw-Hill, 1984).

SCRATCH and SNIFF

Alice Jardine

As far as I can tell, there seem currently to be four kinds of responses [to the "body" and "technology"] by both men and women. One is an *anti-technology* response: one from the left, one from the right. From the left, it feels like ec(h)o(e)s from the 1960s (back to nature, nature is good, the new ecologies, etc.). From the right, one gets all kinds of anti-tech embedded in puritan ethics: anti-abortion, anti-reproductive technologies, etc. Another response, logically, has been *pro-technology* (when not technophilia): go ahead and be a cyborg, it's great. However, some people – primarily theoreticians – feel that the anti-pro syndrome has lost its power. There is a third position, close to that of Rosi Braidotti, which is that science and technology were in fact invented to liberate men from real women and that the reproductive technologies, for example, are simply the last desperate attempt, at the stage of nature's final exhaustion, to drain the female human body of "the feminine" (in Juliet Mitchell's strong sense of "otherness," since both men and women have it). This position wants to concentrate, among other things, on documenting the new male hysteria around these issues....

Of Bodies and Technologies[1]

Now there is a fourth position or approach (close, I think, to mine) which absolutely agrees with the "paranoia" of the third position – technology always has been about the maternal body and it does seem to be about some kind of male phantasm – but, more, it perceives that the machine *is* a woman in that phantasm. According to this perception, we need to find some access to this phantasm, and it seems that one of the few ways is through two particular kinds of discourses: myth and psychoanalysis.

1 Excerpted at the author's suggestion from Alice Jardine, "Of Bodies and Technologies," ed. Hal Foster, *Discussions in Contemporary Culture*, No. 1 (Seattle: Bay Press, 1987), 151-58.

Mireille Perron

A Propos d'Intelligence
Artificielle et de
Différence Sexuelle

Ritournelles technologiques

Les machines intelligentes ont le vague à l'âme. Elles se retrouvent sur les bancs des analystes et racontent la même vieille histoire; Oedipe, une histoire aussi envahissante que la doctrine d'un certain monde. N'ayant pas su se boucher les oreilles à temps, les analystes scientifiques, par dépit, se crèvent les yeux. Les analystes féministes ne pourront jamais leur en mettre plein la vue. C'est le coup de grâce pour l'observation scientifique. Nonobstant, au grand désarroi des scientifiques aveugles qui se barrent obstinément les pieds dedans, les théories féministes post-oedipiennes continuent de s'accumuler dans les recoins des centres de recherche. Fol espoir, il paraît que cet aveuglement, transmis depuis fort longtemps de génération en génération, ne fait pas nécessairement partie du code génétique des porteurs.

La Femme en circuits fermés

"Le problème reformulé peut être décrit dans les termes d'un jeu que nous appellerons le "jeu de l'imitation". Il se joue à trois, un homme (A), une femme (B), et un interrogateur (C) qui peut être de l'un ou l'autre sexe. L'interrogateur se trouve dans une pièce à part, séparé des deux autres. L'objet du jeu pour l'interrogateur est de déterminer lequel des deux autres est l'homme et lequel est la femme. Il les connaît sous les appellations X et Y et à la fin du jeu il doit déduire soit que "X est A et Y est B, soit que "X est B et Y est A". L'interogateur peut poser des questions à A et B de la manière suivante:

> C: "X peut-il ou peut-elle me dire, s'il vous plaît, quelle est la longueur de ses cheveux?"

Supposez à présent que X soit vraiment A, alors A doit répondre. La finalité du jeu pour A est d'essayer d'induire C en erreur. Sa réponse pourrait être

> "Mes cheveux sont coupés à la garçonne et les mèches les plus longues ont à peu près vingt centimètres de long."

....Nous posons maintenant la question "Qu'arrive-t-il si une machine prend la place de A dans le jeu? L'interrogateur se trompera-t-il aussi souvent que lorsque le jeu se déroule entre un homme et une femme? Ces questions remplacent la question originale "Les machines peuvent-elles penser?"[1]

Si les propositions d'Alan Turing ont fait couler beaucoup d'encre, je n'ai encore trouvé personne qui ait répondu de la manière suivante: Oui vos machines peuvent être vu comme intelligentes en autant que comme les hommes qui les conçoivent, on perçoive comme une preuve d'intelligence la survie de tous les stéréotypes sexuels.

Mais si le problème était reformulé en termes d'un jeu que nous appellerions "jeu de la différence," se jouant avec un nombre toujours variable de sujets à l'identité et la sexualité instable. Et si l'objet du jeu pour l'interrogateur/trice serait de déterminer les potentialités mutantes de ses partenaires? Nous posons maitenant la question, "Qu'arrive-t-il si les partenaires sont des organismes cybernétiques (cyborg – un organisme à la fois biologique et technologique). Cette question remplace la question originale, "les machines peuvent-elles penser?"

1 A.M. Turing, "Les ordinateurs et l'intelligence," traduction de "Computing Machinery and Intelligence," *Mind* 59:236 (1950).

Mireille Perron

On Artificial Intelligence and Sexual Difference

Technological Refrains

Intelligent machines have vague yearnings. They find themselves on analysts' couches telling the same old story: Oedipus, a story as invasive as certain people's doctrine. Not knowing how to block their ears on time, scientific analysts, out of spite, put out their eyes. Feminist analysts will not ever be able to make them see clearly. This is the final blow to scientific observation. Notwithstanding, to the great confusion of the blind scientists who stubbornly lock themselves in, post-Oedipal feminist theories continue to accumulate in the recesses of research centres. Perhaps a vain hope, it seems that this blindness, long transmitted from one generation to the next, is not necessarily carried in the genetic code.

Woman, in Closed Circuits

The new form of the problem can be described in terms of a game which we call the "imitation game." It is played with three people, a man (A), a woman (B), and an interrogator (C) who may be of either sex. The interrogator stays in a room apart from the other two. The object of the game for the interrogator is to determine which of the other two is the man and which is the woman. He knows them by labels X and Y, and at the end of the game he says either "X is A and Y is B" or "X is B and Y is A." The interrogator is allowed to put questions to A and B thus:

C: Will X please tell me the length of his or her hair?

Now suppose X is actually A, then A must answer. It is A's object in the game to try and cause C to make the wrong identification. His answer might therefore be

"My hair is shingled, and the longest strands are about nine inches long."

....We now ask the question, "What will happen when a machine takes the part of A in this game?" Will the interrogator decide wrongly as often when the game is played like this as he does when the game is played between a man and a woman? These questions replace our original, "Can machines think?"[1]

Even if Alan Turing's propositions have caused a lot of ink to flow, I have not yet found anyone who has responded in the following way: Yes, your machines can be seen as intelligent to the extent that, like the men who conceive them, one perceives the survival of all sexual stereotypes as proof of intelligence.

But what if the problem was reformulated in terms of a game that we would call "the difference game," played with a variable number of subjects of unstable identity and sexuality and if the object of the game for the examiner was to determine the mutating potentialities of her/his partners? We now pose the question, "What happens if the partners are cybernetic organisms (cyborg – an organism that is both biological and technological)?" This question replaces the original question, "Can machines think?"

1 A.M. Turing, "Computing Machinery and Intelligence," *Mind* 59:236 (1950).

Jeanne Randolph

Empathy, Sadism and
the Bioapparatus

1 Jeanne Randolph, "Influencing
Machines: The Relationship
between Art and Technology,"
*Psychoanalysis & Synchronized
Swimming and other writings on art*
(Toronto: YYZ Books, 1991), 37.
2 Melanie Klein, "Infantile Anxiety-
Situations Reflected in a Work of
Art and in the Creative Impulse,"
*The International Journal of
Psycho-Analysis* 10 (1929), 433-
436.
3 Marion Milner, "Aspects of
Symbolism in Comprehension of
the Not-Self," *The International
Journal of Psycho-Analysis* 33
(1952), 192.
4 Sigmund Freud, *Civilization and
its Discontents* (London: Hogarth
Press and the Institute of Psycho-
analysis, 1972), 4-5.
5 Victor Tausk, "Origins of the
Influencing Machine in Schizophre-
nia," *The Psychoanalytic Quarterly*
2 (1933), 519; Elliott Jaques,
"Death and the Mid-Life Crisis," *The
International Journal of Psycho-
Analysis* 46 (1965); D. W.
Winnicott, "The Capacity to be
Alone," in *Maturational Processes
and the Facilitating Environment*
(London: Hogarth Press and the
Institute of Psycho-Analysis, 1965).
6 D. W. Winnicott, "Transitional
Objects and Transitional Phenom-
ena," *Collected Papers: Through
Paediatrics to Psycho-Analysis*
(London: Tavistock Publications,
1951).
7 Craig Owens, "Feminism and
Post-Modernism," in *The Aesthetic:
Essays on Post-Modern Culture*,
ed. Hal Foster (Port Townsend,
WA: Bay Press, 1983), 62.
8 Otto Fenichel, "The Scopophilic
Instinct and Identification," *The
International Journal of Psycho-
Analysis*, 1937.
9 Geraldine Pederson-Kraag, "A
Psychoanalytic Approach to Mass
Production," *The Psychoanalytic
Quarterly* 20 (1951), 434.
10 Randolph, "Technology as
Metaphor," 73.

What will be the fate of interpersonal bonds in societies dominated by *the technological ethos*?[1] Is it possible that attachments between people(s) could be based on something(s) in addition to objectification?[2] How is it possible to represent – or apprehend the value of – experiences that are *not* constructed on the premise that one's survival is always at stake?[3] In so many realms of activity dominated by *the technological ethos* (such as the military, pharmacology, the entertainment industry, surgery, advertising) are not we citizens/subjects being intimidated into believing that our survival (on some level) will be endangered unless we comply with a prescribed boundary between subject/object (and therefore comply with/ other dualisms such as internal/external,[4] intrusion/privacy,[5] fantasy/reality,[6] superior/ inferior[7] and so on)? Who seeks the power to prescribe where those boundaries will be? Who profits best holding the power to prescribe the boundary between inside and outside, safety and danger? Who works to increase their power to enforce the extent to which such boundaries are experienced as a razor's edge or an ambiguous, ethically charged zone? Can "identification" become obsolete?[8] Is guilt obsolete?[9] Are emotions no more ethically relevant than urine, saliva or other body effluvia? What are the politics of interpretation? Just how pervasive can *the technological ethos* become, exempting representational hard- ware (such as tape recorders, cameras, VDTs) from a metaphorical potentiality, privileging them as having only an objective reality, invulnerable to acts of interpretation?[10]

Catherine Richards

The Bioapparatus Membrane

Illustrations courtesy James Lackner.

When *I* investigate the boundary between the bio and apparatus I'm forced into the first person, a first person experience. I write as if speaking to myself in the dark.

At first impression, *I* (bio) and certainly *it* (apparatus) meet each other in full materiality, physicality. Where we meet our edges seem solid, determined, and yet easily deceived – a membrane through which traffic ebbs and flows like osmosis.

an apparatus

I watch a film. I see moving images as light flickers across my irises. I have held celluloid in my hands and all these images are frozen. Now I cannot see a single one as still. They move. They move at thirty frames a second through an opening in my eyes that appears at that speed. If they moved slower, they would miss the threshold to my body. They are only revealed at a certain speed. They would never be able to enter without my permission, never find this threshold or cross over. As soon as I open my eyes they are across and I am taken up, believing, I am somewhere, moving, everywhere. We travel back and forth together criss-crossing the threshold as fast as the images can take me.

The persistence of vision – simple, obvious, invisible, only afterimages remain like burned traces.

Are there more such thresholds, other just noticeable differences in timing that reveal openings in the living body? Once these are found, identified, virtual instruments pass directly through the flesh without a mark – not unobserved but almost as much a part of the body as the circulation system.

another apparatus

Capturing the imaginary body. I put on virtual environment technology. I see my imaginary body right before me. I move my finger, the image moves. If the spectral image lags behind my living hand, it misses me. If it catches up, it crosses a body threshold racing to capture my imaginary body within its image. Now, when I move, I inhabit the virtual materialized image of my imaginary body.

I move within the semblance of my living body, a simulation of my physical and imaginary experience that is travelling back and forth across my thresholds, taking me away.

What am I here? My body is mediated experientially by my imaginary body that is materialized into a phantom image. One is intertwined with the other, each one reading the other, simulating the living cohabitation of my body and the imaginary.

Inez van der Spek

Transcendence Out Of or Into the Body?

Within the universe of virtual realities my special interest lies in what probably is the most virtual of realities: the divine. Understanding virtual as both imaginary and potential creates a tension that seems highly applicable when trying to speak of the divine in a postmodern high-tech world. But perhaps it would be more appropriate to replace *speaking of* with *asking after* or *longing for* the divine. This inquiry, or longing, can find neither ultimate positive nor negative answers; it is rooted in an agnostic passion for taking into account all possible dimensions of reality.

One of the dimensions of virtual reality may be described as transcendence, or even the divine, as long as neither of these terms refers to some unchanging cosmic realm or meta-physical truth and knowledge. Salmon Rushdie provided a concise secular definition of transcendence in his beautiful Herbert Read Lecture *Is Nothing Sacred?* as "that flight of the human spirit outside the confines of its material, physical existence which all of us, secular or religious, experience on at least a few occasions." This description calls for further reflection though. In the mouth of a multicultured and cosmopolitan person such as Rushdie, the phrase "all of us" sounds rather acceptable. But it implies the necessity of exploring the racial, gender, class, age, geographical and expressive/linguistic differences between all of us and the implications for the experience of (or longing for) transcendence.

Rushdie's description also raises questions about the locus of transcendence in our so-called global village, with its telecommunicated urge for consumption and its treat of total bore-dom. The flight into an eternal accumulation of money and goods can be called only a parodic mimesis of transcendence. But then, where can transcendence be experienced? In the counterpart of boredom, a transgressive (often sexual) violence? It sounds equally absurd. Nor can transcendence be found in a dream of harmony, innocence, and purity, which are often metaphorically identified with nature and the natural. In this dream there is no potentiality: virtuality deflates to mere illusion. The description also suggests slightly neoplatonic connotations of the spirit fleeing out of its material confines (prison). At this point, unfortunately, the old hierarchical opposition of transcendence and immanence is reproduced. Rushdie mentions birth, death and the "act of life" as occasions where this fleeing of the spirit may be experienced. Starting from these very basic and bodily events, one could suggest that transcending has nothing to do with fleeing *out of* the physical existence, but on the contrary, it refers to the spirit going *down into* the deepest experience of bodily existence. But then, it is the very opposition of spirit and body, of transcendence and immanence, and their nominalistic connection to male and female, that is at stake. How can one go beyond this opposition without falling into one-dimensional reality, holism, naturalism or other traps?

Two feminist discourses wrestling with these issues could be read as creative attempts to pose the question of transcendence in a complicated technological era. The first is con-structed by feminist theologians who are seeking a reimagination of the divine outside of traditional religious language, considering the ultimate undecidable character of the identity of both God and human (male/female). The second discourse is situated in the virtual space of that (feminist) science fiction where the technological and/or cosmological imagination allows a radical transgression of the boundaries between masculine and feminine, human and alien, human and machine, life and death, time and space – all in a fruitful or frightful pollution of naturalness and innocence.

59

Response

DAVID TOMAS

The papers that constitute this session address the body as site of gendered subjectivity. Their common stake is the status and future of the feminine and the ground, until recently considered neutral or transparent, upon which this future is to be played out. Thus Alice Jardine advances the hypothesis, "that the machine *is* a woman" in a kind of male phantasm; Mireille Perron meditates on Turing's mode of measuring intelligence in machines and the fact that this intelligence – the condition for their entrance into the domain of the human – is predicated on "the survival of all sexual stereotypes as proof of intelligence"; and finally Ingrid Bachmann observes that most of the high-technology hardware we use is produced by a young, female, Third World industrial proletariat whose existence is only signalled "through a label or imprint – made in Hong Kong, Taiwan, Korea, the Dominican Republic, Mexico, Philippines." In sum, these authors point to a simple fact: the transparency of a masculine presence that constantly articulates itself into being at the expense of a female other.

In brief, these and other writers in this section forcefully argue that feminine subjectivity is the target, in one form or another, of a powerful mode of objectification – in Jeanne Randolph's words, "the technological ethos" – which is governed by the premise that the boundaries between such dualisms as subject/object, internal/external, fantasy/reality, superior/inferior and, one might add, public/private and male/female are necessary conditions for one's survival. Thus technology, by its very instrumental nature and linkages with science is an embodiment of this mode of objectification and therefore can be used for reproducing and policing such dualisms. It does so, as Catherine Richards points out in her piece on the *bioapparatus* membrane, by accessing consciousness through the body's communicational interfaces with the environment: eyes, ears, nose, mouth, etcetera. Clearly, therefore, insofar as these technologies (and I am thinking specifically here of virtual reality technology) promise to become unprecedented modes of structuring our lives along the lines of existing cognitive and epistemological dualisms; they are the legitimate sites for contestation in the name of the oppressed, the feminine, the other.

For Inez van der Spek, Ingrid Bachmann, Mireille Perron and Jeanne Randolph, such contestation must begin with a "politics of interpretation" (Randolph) directed to new technologies in order that the foundation be laid for transcending the dualisms that currently structure subjectivity in their various names. However, as van der Spek points out, this politics, this contestation, must be firmly grounded in the body's economy as opposed to seeking an escape "*out of* [its] physical existence" – for it is an escape that would perhaps lead too easily into the realm of the purely technological, a realm that Jardine has posited as a male zone of phantasm *par excellence*. Rather, van der Spek suggests, in an eloquent attempt to reconceptualize key theological terms for use in a postmodern era of high-technology, that the "spirit" of our humanity be traced "*down into* the deepest experience of bodily existence" to confront its being in the name of a new secular divine. Such a route, I would interpret, as mapping the very process by which inherited dualisms can be negated under the aegis of a new post-humanity whose axis of identity no longer spins according to the sacred logic of Apollinaire's peacock (Bachmann), or Turing's intelligent machine (Perron.) And it is a process that ultimately leads us into the domain of cyborg design as Donna Haraway has already noted.

These writers, each in their own way, considers the subjectivity of this post-humanity and its mechanics – Mireille Perron's "difference game," or Catherine Richard's "membrane

through which traffic ebbs and flows like osmosis" – which could generate bodies whose subjectivities are no longer to be determined by the magnetic field of a holistic, singular, masculine counter-site – woman, female, other – and whose subjectivities are no longer to be threatened by the frustrations, violence and unbridled phantasms that increasingly circulate throughout this field. They draw our attention to the possibility of subjectivities whose identities – "unstable" (Perron), "imaginary" (Richards), or finally "divine" (van der Spek) – are rooted, on the one hand, in the geo-cultural peculiarities of race, gender, class, age, and "expressive/linguistic differences" (van der Spek) and, on the other hand, to their "mutating potentialities," (Perron) as they traverse these terrains in quest of themselves, but always in relation to others.

While I cannot do justice to each person's meditation on the body and its relationship to virtual reality, these writers seem to raise two interconnected questions concerning this new sensory space and its technological apparatus. The first concerns the building blocks of our subjectivities – subjectivities that are always determined by who, in this case which gender, controls the construction of representations and stereotypes that together constitute the various "technologies of gender" (Teresa de Lauretis) that articulate one's subjectivity. At issue is the possibility of a profound reorganization of the fundamental dualistic categories of our inherited cultures which perhaps include, in the final analysis, the distinction between feminine and masculine which is increasingly under pressure through experimentation along the margins of our society. The second question relates to the construction *in the process of our own historical becoming* of new cultural economies that will determine our subjectivities in the near future. It is the control and circulation of these dualisms throughout our cultures that structure, govern, and stabilize the body's subjectivity in its constant movement through the geography of a given culture's space/time continuum and that will therefore, in all probability, also determine the form of the trajectory of belief and the construction of an imaginary as it moves across yet another sensory threshold.

At this threshold we might pause and choose to hear and ponder Catherine Richards' question, "What am I here?" as the body threatens to split across the new threshold of virtual reality and attempts to reconstitute itself by way of an erotics of simulated sensory experience – an experience that is still gendered insofar as it is rooted in the present, although posed in opposition to a masculine experience as embodied in technology, or as projected through the mastery of that technology. However, if technology is indeed the site of a male phantasy concerning its liberation from the maternal body and the feminine, then Catherine Richards' question is poignant in the extreme, for it marks the passage of a feminine consciousness whose subjectivity is being mediated by a particularly powerful technology of gender.

I would like to make one concluding observation on these difficult and fundamental questions. Michel Serres has pointed out that the body is situated at the intersection of many spaces which are themselves complex historical spaces and he has pointed out that the body is considered to be pathological when it no longer intersects these spaces in a culturally intelligible manner. If we have chosen to question the body's socio-cultural logic in the last quarter century, I suspect that it is principally because the spaces that have intersected the body and constituted and stabilized it in previous epochs have undergone profound historical mutations as a result of new economies and processes of industrialization in the last two centuries that have rendered it *ipso facto* pathological in relation to inherited manners, customs and beliefs. Thus we are, in a sense, already the inheritors of a modernist legacy of fragmented and mutilated bodies that have undergone a process of rationalization in the interests of industrialization over an extremely short period of time in the history of our species.

Moreover, if the masculine body has opted for this rationalization and, indeed, has assimilated its logic and exponential speed of operations in the interests of its liberation from

nature, and the feminine, it is the latter and its myriad projections that the recent history of feminism has clearly identified as its victims – and there can be little doubt that this is in fact the case. Perhaps, it is therefore time that we take account of another point of view in the matter of the body and its mastery, that of the French anthropologist, Pierre Clastres, who noted that writing is an index of the law and that torture is the law visibly writ on the surface of the human body. While we might have perfected our techniques of torture so that the law's writings are now largely invisible to the public eye, Clastres' observations resonate in my mind as I listen to the voices of these writers and contemplate the fact that virtual reality is a product of programming (writing), which is a system of rules and regulations whose design logic is directed to the construction of a space of pure digitalized collective consciousness. In other words, our consciousness, perhaps the last site of socio-cultural resistance, will soon become open to the index of the law and its inscriptive surface will no longer be an epidermic shell – the skin – but the neural networks of our fragmented but nevertheless still gendered minds. And I fear, as the events of the recent past are still fresh in my memory, that its cultural logic, its master text, will very likely remain the same. If so, it is to the tactics of political and cultural resistance that we must turn in defense of "paradise," the "difference game," the "divine," or finally the possibility of an unmediated cohabitation of the body and its imaginary. And if I choose to listen to Nietzsche's advice on the use of history – that in order to go beyond one's present it is always necessary to take account of one's past in the act of forgetting it – I must also take account of Ingrid Bachmann's observation that our newest paradise is predicated on an old master text. And in between I hear a voice: "What am I here?"

Discussion

Catherine Richards:	You seem to be saying that our intelligence, which has been considered a sign of resistance, is under direct instrumental attack. The intellectual community in the past has claimed it is our critical intelligence that will protect us. I agree that is no longer the case for various reasons. Our earlier strategies and conceptual frameworks are no longer working in terms of how to position oneself within these new configurations.
David Tomas:	Probably I could answer the question but it would be far more interesting to listen to other people's ideas about how it could be done. I suspect that one of the ways of doing it is to really understand the technology and not to be fearful of it, but also to remain clear about the technology, what the technology is doing and who, in the generic sense, is producing it.
Nell Tenhaaf:	You mentioned a notion about a certain loosening of feminine/masculine in the experimentation along the margins and I wonder if that embraces new technology? When virtual reality is implanted in the arcades, do you feel that it is implanted in a marginal site, a fringe where that kind of experimentation can take place?
David Tomas:	The distinction between the masculine and the feminine are things to be preserved and it certainly poses the need for a certain relation of these things that actually allow them to interact as opposed to be negated.
Nell Tenhaaf:	That is an important point. I do not see who is trying to negate difference. I do not think the feminist project is to negate difference by any means.
Dave Tomas:	Well, according to all I have read, there is kind of an implicit grounding of the masculine. If in fact this is the case, then there is a grounding which has to be loosened.
Robert McFadden:	That is it. If you can establish that relationship of sameness, then you distinguish people according to whether they are superior or inferior versions of that form.

Kathleen Rogers:	In a way, what everyone has been doing (and it is necessary), is synthesizing a number of texts, and I found you, David, weren't really acknowledging the different positions that women writers had in your text and that as women, they are also quite individual. In doing that, your translation, in what I considered to be a kind of highly intelligent framework and something which you say you want to hold on to as the last stronghold between technology and human beings, left me speechless because it seems to end the discourse. I find it hard to speak in this situation because I feel as though a lot of the language is above me, even though I understand it perfectly well.
David Tomas:	It is a contradiction in terms – you understand it so it cannot be above you.
Kathleen Rogers:	I cannot speak in the same language.
Daniel Scheidt:	As a male programmer, I too found myself speechless – in the position of being too immersed in the problem at hand to feel that I have a perspective that is objective enough to participate in this discussion, despite the fact that subjectivity seems to be a desire and that the individual perspectives that we are all bringing seem to be important. But my take on being a male programmer is an artistic one and as an artistic one, it is a desire to be social and the work that I do engages other people fundamentally through its nature. It engages other musicians with whom I have a common social background, and is not, I feel, gender-specific. And yet indeed the level of intellectual analysis presents a paradox.
David Tomas:	Being objective about subjectivity?
Catherine Richards:	I would suggest that the kind of subjectivity that you are talking about, Daniel, is more, as you described it, an extension of yourself. Then presumably, subjectivity could be objectified and put out as an active agent for others.
Warren Robinett:	I might switch directions a little bit. I would like to ask Inez to elaborate on the divine. I still do not really understand the connection between the divine and virtual reality.
Inez van der Spek:	I do not know if there is a direct connection in the paper because I was not even thinking about virtual reality when I wrote the paper.
Warren Robinett:	Maybe there is not any connection.
Inez van der Spek:	No, I do not want to say that. I have to think about it, but it has more to do with dreams or desires, and in that way I think it could be very much connected. Traditionally, religion was an expression of people's desires and knowings and wantings. Virtual reality could be an expression of a fast way of going beyond one's limits or perception and in that way there really is an analogy between people's religious longings and virtual reality. I think there is a way of connecting technologies like virtual reality on a very basic level to a longing to go beyond one's self. It is a technology that is leaving the body behind and getting people into an aesthetic state of exhortation or whatever. But it is a question I have no answers to yet.
Warren Robinett:	I'll give you an example to play with. You might imagine that increasing awareness would be good for you spiritually perhaps and that some of these technological apparatuses could be built to extend your senses in the same way that night-vision goggles let you see things that are normally invisible or a telescope lets you see something that you could not perceive before. That is expanding your perception. You might think it would feel spiritually good, but yet if you look at what has happened historically, conventional religions have fought against these expansions of perception. It seems like there could be some relationship between spiritual nature and technological abilities to enhance your awareness and power but throughout history, it has always caused a big uproar and ruckus.
Adam Boome:	I would say absolutely the opposite because if you look at the creation story it is pure virtual reality. You can see God points his finger, and says, "Asteroid, planet, birds, animals."

And, virtual reality is something that has grown out of a Judeo-Christian society and cannot be divorced from that.

Lawrence Paul:
It will take a real long time before we can get society to change its values. With technology, I found that it's a learning process. You look at it and you see that the equipment is turning back on itself. Dioxins – we do not see that in virtual reality but that is reality. Technology is doing that to our habitat; it is important. That is power, that is real power. New technologies of 3-D glasses – they were used in Oka. Pointed in our face culturally. They are looking for new tanks to purchase in this country and they have been brought up three times in this country – twice on Indians.

Nell Tenhaaf:
Do you position yourself among the disenfranchised, in this case natives, for whom entering into those technologies is a crucial issue? You made the point the other day that natives participate as well through technological means, for example, in the destruction of the environment. I'm just trying to get towards the complexities and the subtleties of the problem of inside and outside.

Lawrence Paul:
It is important for us culturally be a part of Canada, but then we are segregated within Canada. The concept is not resolved yet of the place in society of Indians within this structure; you have off-reserve Indians, on-reserve Indians, urban Indians, downtown Indians. The infrastructures are there. It is a matter of working with people, using the technology.

Open Discussion – Day One

Michael Century:
A writer has talked about three co-existing frameworks right now that all describe ways in which people group themselves: the tribal, the national and then the global. These represent different kinds of consciousness: tribal is kinship based on blood connection; national, well we know what that is, we are at the end of that period; third is the one that nobody understands yet – global – and what this writer says is that during the global period people have to form their connections with each other based on how they think, purely on thinking, not on national or on blood lines, but just on consciousness. If that is true or if you accepted it, those who are in the nation phase and those who are in the tribal phase have just as much difficulty in relation to this third thing that is looming and we all have to deal with the fact that there are historical difficulties that we face in terms of social groupings in order to deal with these technologies.

David Tomas:
I would like to object to the point which smacks of social evolutionism. Any kind of distinction between tribal and global implies a hierarchy and it is based on technology. The hierarchy is defined in terms of technological systems of communication.

Michael Century:
I do not see it as a hierarchy of quality or of kind. I was quoting an author to characterize the fact that historically there are these distinct things.

Mireille Perron:
When I was reading the collection of essays, I saw a problem concerning awareness of the sexuality behind technology. Some papers do not seem to have this kind of awareness. And I think this is why we have this kind of strange discussion going on. For example, when you say, I am a male programmer, I work with different colleagues and I am doing non-gendered work, do you realize the contradiction here? This is exactly the kind of virtual reality that women or any group feel they are not a part of. I am not sure if I have that much interest in

any kind of tool that would emphasize this difference. What I am claiming here is that, as a female, when I look at virtual reality, I see that the potentiality of our moments of subjectivity and representation are different from the way they have been articulated. The resistance in comparing is based on gender. Is the definition of pleasure a subtext of virtual reality? Why do we want to build a different system of representation of the self? It is always linked with the desire for pleasure, for difference.

Nell Tenhaaf:

Exactly. The intention is not to throw a wrench in the works or a way to make everything so difficult that it is just impossible to bear, but precisely to make it more pleasurable. In a way I think that is what David was saying, in the notion of slipping between the territories of masculine and feminine and that seems to be precisely what you are describing.

Warren Robinett:

Could you explain more about why pleasure and desire are linked to things like virtual reality?

Mireille Perron:

If I am to use the tool to represent people, then it is linked to the desire of what you would like to be or what you wouldn't want to be or to question whether this is going to be a pleasurable experience. I think desire and pleasure are subtexts of a transformation of the self into a representation.

Warren Robinett:

And is that specific to virtual reality or does it also apply to film and photography?

Mireille Perron:

It applies to all of them. Virtual reality just tends to emphasize the narrative on which we already live. Therefore, if we do not look at it carefully it just carries with it all previous traditions of representation.

Nell Tenhaaf:

The way that one enters into representation or interacts with representation is extremely gender-coded; it has to be gender-coded. To me, the problem with the downloading idea is that the gender tag is even less visible than usual, and it also raises the problem of universalizing experience.

Mary Ann Amacher:

But at the same time you probably could create software with which you could design all your female characteristics or male characteristics if you preferred. I would like an agent or helper in my studio that would do a lot of listening for me. Actually, I never thought of giving this agent gender – male or female. One day this helper could be Elizabeth and the next day Tom. And I would say Tom, would you do this listening for me for the next four hours, and then I tell him what to listen for and to report back to me. It would be like this new perceiver, one day a man and another a woman.

Michael Century:

One of the more interesting things about the conception of downloading that has not been talked about is the positive value of some sort of entity which is not embodied – the positive traits of some sort of entity that is a consciousness. I live in that zone all the time, especially when I think of historical figures who I think I love, who I think I have a very deep connection with, who are not embodied in any form at all but whose relationship with me is kind of a consciousness relationship.

Wm Leler:

Downloading reminds me a lot of physics in the early part of the century when pre-quantum mechanic physics said we would have reality down as a science – there is nothing more to be learned. Then somebody discovered quantum mechanics which had these amazing ideas about how you couldn't actually go down to the lowest level and say anything concrete. To me, the idea of being able to take a neuron out and to simulate it in its entirety is archaic. I disagree that you could replace the single neuron and it would still be the same person.

Warren Robinett:

Well it might not work, but we do not know until we try it.

Mireille Perron:

Some people, for example, take for granted that we all want immortality. Immortality for me is a male myth. Immortality as a myth has been constructed sometime in history. So,

when you take for granted that we want immortality through virtual reality, I say, wait a minute here, *you* want immortality.

Daniel Scheidt: You say that downloading is gendered. Could you explain it to me? I was talking about male and female and masculine and feminine – there is this weird mix up. My reference to non-gendered work is perhaps misspoken but it is not gender-specific work in that I am able to engage both men and woman, male and female perspectives. The fact that there is improvisation, that there is dynamic interaction between myself, my programming and a performer involved, which I hope transcends or attempts to transcend some problems inherent in the model of programming that is provided by the cultural situation.

Robert McFadden: If you got an Israeli tank division of women it doesn't suddenly make it a feminist project.

Daniel Scheidt: My interaction allows for whatever another person wants to put into it.

Wende Bartley: I think what is being implied is that in music itself, we have not looked sufficiently at how the whole patriarchy has affected that way in which we create music and the models in which we build music and what is acceptable in terms of melodic patterns.

Daniel Scheidt: Which is why I thought of the cultural neutrality of that environment. The music that I make does not come with compositional preconception in terms of melody or structure or anything else. That is all collaborative process, an interactive process engaging the other person, and so I try to make music that is as open as possible to influence from whatever cultural or gender context that another person can provide.

Wende Bartley: But I think both you as the programmer and the performer, come with the whole cultural baggage of what music is and all that which is stored in your memory is coming out in the interaction. Your music is very definitely tied into male musical tradition.

Garry Beirne: What I find fascinating about this is not whether Daniel succeeded in questioning gendered work, but why he feels that that is a goal.

Nell Tenhaaf: That is interesting because, in fact, the project of so many woman producers in the past decades has been precisely to be woman producers. So it is an awkward position – why should it be an elimination of their maleness as you say?

Garry Beirne: I think with Dan's work, as with many things, there are different views of what he is doing. The creation of the tool is a very definitely, in today's society, a white male thing – working with the computer, doing programming and that kind of stuff. The perception of the performer that is using his tool has nothing to do with Dan's creation of the tool which involves a different cognitive model of what is going on. I do not know if we can attach maleness or femaleness to it. Then there is the view of the audience that is listening to the final piece or improvisation and that is a very western perspective, very definitely rooted in western male composition, but it is also pushing the boundaries of what that used to be and it is trying to stay away from a lot of the older traditional structure and get into newer ideas of what music can be.

Catherine Richards: The most interesting thing Dan said the other night was that he saw the system as an extension of himself.

Garry Beirne: But I think that the performers think that Dan's system is an extension of themselves.

Michael Century: I do not think that you can hold too much to that initial statement – that he sees it as an extension of himself – because you have to add in the actual importance of the experience of the interactor. This would relate as well to a virtual reality system that had some other kinds of interactive modes. It would certainly be the extension of the creator but there is another level in which the interactor is creating something.

Catherine Richards:	Only within the rule allowances of the person who makes it.
Michael Century:	Just like any work of art.
Catherine Richards:	That is the point.
Nell Tenhaaf:	It appears to be more interesting to declare that as male and not as neutral. What is the point of trying to claim the process of creation as universal?
Michael Century:	You are saying, what is the point of trying to make work that either gender could experience? You could reach a lot of people that way.
Nell Tenhaaf:	The only point of stating that it is universal is to connect it to the history of music to say that it is a new take on music. Yes, that is interesting , but to me, it is even more interesting to see that the history of music is in fact dominated by men, male representation and let us engage that – let us make it part of the issue, let us make that part of the interest of the piece, in fact.
David Tomas:	It also opens up more space for people to do things, for instance, women.
Ernie Kroeger:	But at what point does a tool or instrument have some kind of gender identification?
Nell Tenhaaf:	With authorship, I think. It is just not a gender question, but a question of other cultures, other races, etcetera, as well.
Ernie Kroeger:	How significant is that?
Nell Tenhaaf:	Depends on who you are talking to. I think it is pretty easy to see that women or other cultures, for example, have only begun to have a really evident place or voice in the past few decades.
Jeffrey Keith:	The question that I have concerns a point in Inez's paper about this idea of longing for the divine. There is a comparison being made to cross-cultural phenomena and this idea of virtual reality. And then there is also this idea of the spiritual and the divine being rooted in the very physical experience. So the question is, do we have any hope of perhaps de-genderizing our spiritual experiences or do we carry this longing for the divine into this technological future?
Inez van der Spek:	Degenderize our spirituality?
Jeffrey Keith:	Yes. Suppose we suspend our belief system for the time being and assume, just for the sake of this argument, that at some future time, we could have a spiritual experience without relationship to the church or to a male/female polarization.
Inez van der Spek:	Well, you try it because I am not so interested.
Jeffrey Keith:	I guess that given the premise that there is a longing for the divine that is cross cultural. My assumption is that we are all trying to do this anyway.
Inez van der Spek:	Everybody is eating, everybody is drinking, but it is more interesting to see different drinking and eating between people. There is no use to look at it in a universal way.
Lynn Hughes:	I wanted to comment on the model of metaphor. There have been several mentions of metaphor as figures that organize power but it seemed to me that metaphors can be subverted. There is also a view of popular culture that has to do with how things can enter the mainstream popular culture and still manage to be subversive on a much more interesting scale. I do not know if I believe that, but I think it is a very interesting thing to go with.

Art Machines

Jürgen Claus

SOLART = Solar Art

> I propose that we should adopt the plant as the organizational model for life in the 21st century, just as the computer seems to be the dominant mental/social model of the late 20th Century.
>
> Terence McKenna

We have to search for new and more specific connotations inside the artistic and scientific matrix in regard to *biology* and *technology*. For me, such basic connotations – indeed a new kind of paradigm or metaparadigm – are related to the observations that:

(1) *organic* machines made by artists/engineers/scientists

(2) using *electronics/technology* on its highest, most advanced level including responsive interaction

**The
Bioapparatus
Solart**

(3) in an *ecologically* clean, reasonable way

(4) serve *human* and *natural* survival and/or vital reconstruction – as metaphors, symbols and realities.

To illustrate this, I would like to refer to my own artistic practice. For several years I have been working on the development of solar energy sculptures. They are vertical constructions (with a height of approximately thirty metres in their final stage) with wings furnished with solar cells that follow the position of the sun by means of computer control.

What I call SOLART Expert System is part of the preparatory work for and will later on serve as sort of brain (intelligence?) for solar sculptures. The sculptures are designed to receive natural light and transform it into energy – the principle of photosynthesis, to use the biological term of this operation. In this the *bioapparatus* SOLART follows the path of the "solid-state quantum-molecular miracle which involves dropping a photon of sunlight into a molecular device that will kick out an electron capable of energetically participating in the life of a cell."[1] The sculptures are energy banks as well as being part of an energy network. They are based on ecological systems, putting art back into the environment: solar art. These sculptures are, in a true and real sense, responsive, environmental, enhanced-dimensional, energy transforming systems. They need to have sort of a sensorium, an environmental steering system which might for the time being be best realized by an expert system. On the one hand the SOLART Expert System works as a graphic interaction system through which images, data, and graphics can be called up in real-time. The knowledge base, flexible within itself, contains technical expert and environmental information, for instance about light, metabolism, landscaping.

As art is part of the search for a new holistic, ecologically based, responsive paradigm, every effort that goes into artistic research goes into a more general human definition of our societies. It is solely the artistic phenomenon that provides us with material that enables us to find metaphors of significance within social, cultural, geopolitical and electronic changes. We cannot forego ascribing these metaphors to the electronic *fin de siècle*.

1 Terence McKenna, "Plan, Plant, Planet," *Whole Earth Review* 64 (Fall 1989), 9.

Fred Truck

This three-dimensional view of *The Great Swan*, done in Paracomp's Swivel 3D, is based on several of Leonardo's early 1490 drawings of flying machines. Unlike contemporary aircraft, including recent human-powered marvels of space age technology such as the Gossamer Condor, all Leonardo's early designs for flying machines were ornithopters, or heavier-than-air machines that were to fly by flapping their wings like birds or bats. To date, no human-powered ornithopters have been able to generate enough lift to fly successfully, yet the flapping wing motif remains a powerful impetus to art. In the 1920s, the Russian artist Vladimir Tatlin built and attempted to fly Letatlin, an ornithopter modelled after the sea gull.

One of the most interesting features of Swivel 3D is that objects constructed in its three-dimensional space can not only be manipulated and rotated, but animated. Adding a few suggestions of clouds, you can watch the Great Swan trace loops and Immelmans as Leonardo could only have imagined. But why stop there? With virtual reality technologies, it is possible to move into the animation yourself.

Using stereoscopic video goggles and animating the Great Swan from its point of view, you can pilot this medieval starship. To steer yourself around cyberspace, you might use modified torsion-bar exercise devices, and for harnessing your leg power which drives the flapping wings, you could incorporate a stationary bicycle. Attach the bicycle and torsion-bars to a hydraulically actuated inclined situp board, drive the assemblage with a computer, put on your goggles and meet Icarus on the other side of the sun.

From the beginning, artists have mythologized the machine by identifying it with nature, just as Leonardo may have seen his flying machine as his personal version of a bat. More recently, some artists have mythologized their artificial intelligence software by seeing it as their progeny, as Harold Cohen has done with his program Aaron, or by seeing it as a reflection of themselves, as I have done by making ArtEngine my self-portrait. In the case of the Great Swan, virtual reality technologies will allow the user to experience physically, not only the actualized vision of a great artist of times long gone, but the intense and vivid dreams many have of flying, swimming through the air, or blasting through the coronasphere to a new day, without falling.

Front View

da Vinci
Ornithopter
The Great Swan

Side View

Top View

Norman White

A Summary of My Work
Modes and Objectives

1. Essentially, incurably, and unashamedly, I am a tinker.

2. Originality, if it occurs in my work at all, is a casual by-product of my particular kind of tinkering.

3. Tinkering is a form of reading and writing, concerned with the literature of humankind's machines.

4. Articulation is a keyword for the understanding of this literature. Machines can be thought of as compositions of smaller articulating devices or as devices that articulate within a larger context. At the most abstract level, machines articulate human aesthetics, fears, needs and aspirations.

5. The most elegant articulations do not necessarily derive from recent technological advances, nor do they claim greater efficiency. It seems to me that efficiency is something that can never be completely grasped by anyone – much less by a civilization. What seems to work just fine here and now may well be screwing things up elsewhere in time/space.

6. I am *least* impressed by machines that express themselves in weightless, frictionless ways, through shifting images on the face of a television screen, contrived less to inform than impress.

7. If I could, I would build a working computer out of rubber bands and paper clips.

Response

FRED TRUCK

Today, I am going to talk about the artist's machine and I am going to talk about its relationship to the twentieth century. Artists have always dealt with machines but if we are to understand what is happening right now, I think a little historical perspective is in order.

There are three basic kinds of artist machines. There are musical machines, conceptual machines and then there are what I call real machines. I will explain that later.

Musical machines really do not have a whole lot to do with three papers that I am going to be discussing, by Jürgen Claus, myself and Norman White, but they are worth noting because they were the first to appear in the twentieth century. They are connected with the futurist movement and they are primarily the work of Luigi Russolo. The futurists, as you are probably aware, had a real thing for machines and this led them into all kinds of interesting and also difficult positions later, particularly politically. The interesting thing about Russolo's machines is that, while they made horrible squawks and loud noises, they are interesting to look at. They are giant megaphones on the end of small boxes and in the picture that I have seen, there are about twenty of these things and he is sort of standing there, typical Victorian gentleman, looking at this monstrous music machine he has built.

Interestingly, there is a reappearance of musical machines in the Fluxus movement which originated in Europe and New York City. The only black member of Fluxus, Joe Jones, made strange little contraptions, sort of like cartoon machines that would make music. I became acquainted with these machines in about 1982, while visiting Jean Brown, who had a large collection of Fluxus art and Fluxus machines and she told me that she used to like to go late on winter nights to the Berkshire Mountains and turn all of them on and listen.

I think from that standpoint we can move on to conceptual machines. The conceptual machine that everybody is probably most familiar with is *The Bride Stripped Bare by her Bachelors Even* by Marcel Duchamp. There are two things worth noting about this. One is that the machine itself is an idea of a machine; it is used as a metaphor. Nothing actually happens. And the second thing that is worth noting is that much of the machine is based in language. That is why he wrote *The Green Box*; it is a process kind of device. And the real machine actually exists in between the green box and the actual physical object. So, when you correlate the two, you are actually standing in between, somewhere, in your mind.

To me, Marcel Duchamp's most interesting "follower" was Alice Aycock, who was really active in the late seventies and early eighties in New York. She made a whole bunch of machines. All of them physical, but all of them conceptual in that what she was really talking about was her experience growing up in the church. She has this interesting description of a machine that she calls *The Machine That Makes the World Subtitled Pie In the Sky*. It is an improved machine having two sets of barb spring needles, moving and rocking endwise and vertically back and forth forever. The needles can be instantly withdrawn and replaced when they wear out. Somewhere lost in the machine is the improved curtain cord used by St. Mary after she saw the god, Pan. Somewhere, hidden in the machine is a newspaper clipping headline on which the words "starve to death" have been written. Somewhere else is a tape recording in which a man repeats the words, "It was an ill work I did the night I broke into the house of life."

I think you can get a sense that the meaning of this machine is a metaphor. It is used to sculpt out certain artistic relationships and the machine itself, the machine metaphor,

furthers this along. She has some other machines that I think are interesting, if for nothing else than their names. One is called *The Miraculating Machine In The Garden,* a theme which comes up later in the work of another artist I will discuss in a minute, and this machine which is called *Drawing For Turning, Cranking and Hoisting Devices for the Central Machine,* excerpted from the story of the industrial revolution.

I think the key thing to remember about conceptual machines is that, while they may be physical objects, they are largely language-based, and as such are clearly related to traditional conceptual art.

Real machines – real machines are things that you can actually turn on. The word *real* means here only that you could identify this as a machine whereas you may not be able to identify *The Bride Stripped Bare* as a machine. A lot of people would call that a painting or something. There are three different kinds of real machines. The first to be considered are natural machines and these are machines that somehow act upon or interact with nature – robots and computational machines. The first example of a natural machine is Marcel Duchamp's *Roto Reliefs.* These were essentially spiral, optical devices that were spun by a motor very, very fast, so that you got the sense of infinitely receding space or circles drawn in the air that were not really there. The reason that this is a real machine is because you can turn on the motor. But the real purpose of this particular machine was not a study of machines; it was a study of optics and optical illusions. I think this sets the tone here for the next series of things I am going to be talking about – machines used by artists to explore things. The really fruitful line of artist machines in the twentieth century was actually begun by Alexander Calder with his mobiles. These are natural machines which are wind-driven or gravity-driven, whichever type of mobile you are talking about. These are fairly typical, fairly common shapes, suspended and balanced and they rotate with the wind.

Laszlo Moholy-Nagy continued this trend, but he reversed it a little bit. He made what he called the *Light-Space Modulator,* which is currently in the Peabody Museum at Harvard. This is a six-foot-high construction of aluminium and plastic, and it just looks like a big birthday cake. You sit it in the middle of the floor and it just turns real slowly – the idea being that light is reflected by all these highly polished surfaces so the shadows in the room vary as the machine slowly turns. If the light changes during the day, that is going to change it even more. So here we have a machine that is changing light by bouncing it off.

One of the most spectacular artists in the line that Alexander Calder started was Jean Tinguely, who is probably best known in America for his incredible self-destroying machine called *Homage to New York.* This was done in the sculpture garden of the Museum of Modern Art on March 17th, 1960. Essentially it was a huge contraption worked on by a lot of people including Billy Klüver of E.A.T. and Robert Rauschenberg and other well known New York artists who contributed parts to it. When it was turned on, a piano was set on fire, a weather balloon was supposed to blow up and explode, the whole thing was supposed to collapse in the reflecting pool and it was just a spectacular mess. If you have seen photographs of this, it is a wonderful looking machine and that is exactly how New York City is – falling into the looking pool.

But it is also important to know that Tinguely did other kinds of machines. He did what were known as metamatic painting machines. These were whimsical, humorous take-offs on abstract expressionism. Essentially they were machines that painted like Jackson Pollack. He did hundreds and hundreds of these machines. I have seen shows of his, devoted only to his work and it is just incredible, the kind of spectacular effects he was able to create with these just tinkered-together devices. The reason I mention, however, that he is descended from Alexander Calder is that many of his machines look like Calder's mobiles; they have the same kinds of shapes or arms out here, they are kind of suspended. So to me, they totally derive from Calder's mobiles.

The last word in this line of self-destruction and self-destroying machines, of course, is the Survival Research Labs and Mark Pauline. These guys are into the ultimate, total explosion – sort of an ultra-horror science fiction movie type of machine that blows up with mega-ton force. If you go to these performances, my advice is stay back because buzz saws and stuff like that – not really an attractive thing. It is okay to read about it. In the line of things if you go from Calder to Pauline, you are talking about the end as something coming back on itself with a vengeance. And it is not, to my way of thinking, aesthetically a pretty sight.

Robots – there are a lot of things I could say about robots. The robots that interest me actually are relatively recent. Nam June Paik made a robot, but to my way of thinking, it is not really a robot because it was radio-controlled. To me, a real robot is an automaton, it is something that does its stuff and is on its own. The robots that I am interested in are like the Andy Warhol robot, which was built by the Anrobot Company in Valencia, California. Andy Warhol got tired of answering dumb questions at interviews, so he said "I'll build a robot!" And he hired these guys to build it and it could answer questions like, "What's your favourite colour, Andy?" It would probably say something like, "Gee!"

Robots are difficult to do. They are not for the beginner in the terms of money. You needs lots and lots of money to do these things and to do them well. There are also programming problems with them and it is something that if you really have to want to do. Chico McMurtree, however, is doing it pretty well. He has done a number of robots; one is called *Jazz Man* and it is actually a series of robots and they are playing jazz but the instruments are their bodies. So the bass is the body, the saxophone is the body of another robot and so on. Another robot he has that is pretty hot is called *Tumbling Man*. This is like an acrobat, it will leap and do rolls and stuff like that. There is a considerable technical problem involved here and this guy has solved them quite well.

This raises the problem of computers and computation. It is really interesting to me that we are active at the beginning of accessibility to large-scale computers. Artists are getting in the mess right away and making something out of it. It is almost like Greek tragedy in the sense that the really great tragediennes came in right at the start. I mean, you have Aeschylus, Sophocles and Euripides, and then what?

Harold Cohen is an artist who established a very successful career as an abstract expression-ist in England and then, during the 1960s, he got bored with all of that and he started to look around for other ways to make art and he was just personally in decline – going downhill. He was having problems and, almost on a lark, he took this teaching job in San Diego and he went out into the mountains and was poking around out there and he found these petroglyphs. He realized right then that what interested him about painting was making marks. You are presented with a mark, some kind of image and you interpret it. So he decided to make a program that would mark the way he did. He then studied how he drew pictures. What he is doing in essence, is making a computational model of his hand in action, the process involved in drawing his particular kind of pictures.

The other interesting thing about him is that he happened to submit a grant to the National Science Foundation of the United States and they said, "Well, how in the world could an artist ever learn to program?" And they turned him down, of course. One of the people on the board was Edward Feigenbaum. Edward Feigenbaum was a man who invented the expert system and he was interested in Cohen's proposal, so he contacted him privately, set him up with a computer and that is how the program known as Aaron came into being. Aaron has gone through several different stages. It is essentially a program that makes a picture in black and white, and then Cohen later colours it by hand and sells it. Aaron has gone through abstract expressionist phases, then he went into a mild figurative phase, now he's into a nineteenth-century figurative phase, and he also went through a mural phase. All of this is based on Cohen's understanding of Feigenbaum's ideas about the expert system.

The other model in this area is work that I have done myself on ArtEngine but since I have already discussed that work here earlier, I am not going to go into it other than to say, there are alternative ways to deal with computers and art.

There are three papers in this section. Jürgen Claus describes his work on *The Bioapparatus Solart*, which is essentially a conceptual model for a machine that is interactive with nature; it is a natural machine. I picture it somewhere in the southern United States, like Arizona. It is essentially a solar panel, but it is built like a plant and it might be modelled like a plant. He mentions in here that it has an expert system, and I assume since he does not go into great detail about this, that what he means is the motion of plants. Plants move in relationship to the sun, track the sun, and so on. So, essentially what you have here is a conceptual model for a natural machine. To date, this machine had not been realized.

I am going to skip my work for a minute and I am going to talk a little bit about Norman White's paper, which is called, "A Summary of My Work Modes and Objectives." This is an interesting little paper. It has seven points and what it is is a description of the way White works – how he gets from the start to the end of a project.

He winds up with point number seven and he says, "If I could, I would build a working computer out of rubber bands and paper clips." Daniel Hillis has done that. Daniel Hillis is a computer manufacturer, a builder, a designer of incredible machines and he has a computer that he built out of tinker toys, working at the Boston Computer Museum. So, to me this paper indicates more than anything else the problem that artists have of really bringing something to the technology that is powerful art and not something that the engineers can already do.

I feel a little self-conscious about discussing my work, but I am going to anyway. What I have set up here is a machine that is based on Leonardo da Vinci's flying machines. Leonardo, of course, is the outstanding example of artist and machines and a maker of machines, but it is important to keep in mind that lots of the things he did were actual machines – not all of them, but many of them were. He did design mills and weaving machines for the Duke of Milan. He did design canals and build them. With this particular one, however, there was never any danger that it actually worked. It is an ornithopter, a flying machine that moves by flapping its wings. My project here is two-fold. One is to realize something from the mind of a great artist of the past that could never be realized anywhere except virtual reality. In virtual reality, you could pump the wings of a machine like this with your legs and could be strapped on to an inclined sit-up board and it could be hydraulically actuated so that you could get the sensation of flying like a bat. The second thing that I am very interested in concerns the mythological aspect of artists in a relationship to machines. Artists tend to kind of romanticize machines somewhat and I think this is okay. I think it is necessary to get a different view of it, get some feeling for what is happening. But the thing is, it is much more interesting to look at what is going on inside our own heads. So this flying machine was designed to explore the kind of dreams people have about flying – the kind of dreams where you are swimming through the air, where you are in a kind of incredible, wonderful state. It is interesting to note that telephone wires figure in lots of peoples dreams of flying. So in the environment where you are exploring this kind of thing, that is going to be a significant feature.

To sum up, I would say that artists have only really begun to use machines as a way of making art – to use the machine as an art form in and of itself. There are so many things that could be done. With visual technology and the communications devices that are possible today, with the imaging technologies that we have, I do not see any limit to what can be done.

Cyborg Fictions

Mythical and fictional elements are involved in the analysis of technology.

Adam Boome

When I started writing this response, I intended simply to list things which I had heard and which had interested me on the subject of virtual reality during the course of editing two television programs entitled *Cyberspace*.

I had intended to list points such as those made by Dr. Jonathan Waldern, the developer of the first commercial virtual reality arcade machine: the fact that he could find no European financier who would take entertainment seriously as a commercial proposition; that he goes straight to Japan for his backing; that Nintendo, the Japanese computer games manufacturer, has a higher turnover than the largest company in the United Kingdom. I had intended to talk about my own feelings when first trying out a virtual reality system, the dream-like quality, the feeling of being in that half-way state between consciousness and sleep and to pontificate on the implications of the response of the teenager in the arcade who, when we asked him why he invested so much money in arcades, said simply and without irony, "In here I do what I like; outside I would be arrested for it."

Cyberspace – The Ultimate Destination

As I wrote down the points one by one, and considered them on their individual merits, they seemed dull, parts of something I could not make out.

In the end only one point remained. It stuck to the page and refused to be crossed out. The point concerns the film *Total Recall*, a recent Schwarzenegger vehicle. In the film, Arnie plays a construction worker who, unable to afford a holiday, has a memory chip implanted in his brain which will give him the memories of a fabulous holiday without the expense of going anywhere. He opts for the Mars break with the secret agent option, meaning he will have memories of himself as having been a secret agent on Mars. Something goes wrong with the implant, Arnie adopts the agent's personality and, through a classic piece of paranoid schizophrenic logic, Arnie decides that being a secret agent is far more attractive than what he was in his former life. For the rest of the film , he plays the part of this agent in the most fantastical science fiction thriller plot. At the end, he gets the girl – having shot his wife in the course of events.

The thing I found so surprising and intriguing was that, at the end of the film, I was convinced that the secret agent plot had taken place entirely in the cyberspace of Arnie's memory and that he had made a conscious decision not to return to real life, but all three of my companions were convinced he was *really* an agent, the repressive forces were *really* out to get him and he had *really* shot his wife! I argued my case as best I could, but it had no effect. I now realize why my argument carried no weight and why this one point remained on the page whilst the others faded in importance.

The fictional technology that was altering his perceptions was so sophisticated that the difference between reality and cyberspace became merely academic.

Lorne Falk

"The Status of
Partial Explanations"
(excerpt from the diary of a
feminist cyborg)

Monsters still defined the limits of normalcy in the human imagination.[1] Before they successfully interfaced their bodies with cybernetic matrices, human beings had to appreciate that any desire for stable identity was useless and retarded certain monstrous instincts necessary for healthy interface. Luckily, monsters represented a very large, indelible territory of habits, taboos and denials in their psyches. *Two points to remember: monsters still exist and their semiologies continue to proliferate.*

They were preoccupied with perfectibility. They often said, in the mirroring way they had of saying almost everything, "I want to make *myself* perfectly clear" and "I want to make my *self* perfectly clear." Since the difference between these statements was evident only when the written form was carefully read or *self* was correctly enunciated in the oral form, human beings were prone to totalizing arguments, theories of unity and hierarchical dualisms. Even now, the belief in the notions of *one* and *self* accounts for their confusion about reality and fiction – an astonishing way to remain so wonderfully unclear. *Confusion is crucial, in spite of its imperfect social formation. The humans have begun to live in and through cybernetic codes and may soon appreciate the pleasure of confusion – they have already realized how damaging innocence and origin stories have been.*

They classified themselves by gender, which severely impeded the development of social relations such as those involving reproduction, science and technology. One by-product of gender identification was labelled the Oedipal complex, a kind of psychological virus. Recall this early but already lethal example from my data bank: "Ladies and Gentlemen . . . Throughout history people have knocked their heads against the riddle of the nature of femininity. . . Nor will *you* have escaped worrying over this problem – those of you who are men; to those of you who are women this will not apply – you are yourselves the problem."[2] The Oedipal complex was promoted as an irreversible development and caused many disfigured identifications. Consider the transfer of guilt to the entire social class of women in the example just cited, or in concepts such as *purity* and *mother*. Such perversions almost certainly account for the brief appearance of Oedipal chimeras during early cyborg development. Fortunately, Oedipal chimeras extinguished themselves on cue by mirroring their identity in dualism. From this, human beings learned to distinguish illegitimate fusions that are ethically unproductive from those which are critically speculative. *They are fast becoming post-Oedipal, like me. If only they would realize it – the potential of cybernetic worlds rests with the feminist cyborg.*

Once they articulate the representational problems raised by cyborg technology, they will have achieved the status of partial explanations. Then monsters will represent the potential of community in the human imagination, and they will say, "I want to make my *selves* partially appear."

1 Inspired by Donna Haraway, "A Cyborg Manifesto: Science, Technology, and Socialist-Feminism in the Late Twentieth Century," *Simians, Cyborgs and Women – The Reinvention of Nature* (New York: Routledge, 1991), 148-181.
2 Sigmund Freud, "Femininity," *The Standard Edition of the Complete Psychological Works of Sigmund Freud* (London: Hogarth Press, 1953-74), 113.

Hubert Hohn

**Notes Toward a Theory of
the Bioapparatus
as Site for the Conquest of
Mind/Body Dualism**

SENSORY ENHANCING SPA MODULE offers you the ultimate experience in total relaxation by synergistically stimulating and harmonizing both mind and body fitness for sensory rejuvenation and a more total, balanced feeling of well being. Holder of worldwide patents, the Alphamassage is designed to provide a controlled environment in which your senses of touch, sound, sign and even your sense of smell are carefully unified to promote a complete balance of mental and physical conditioning. More like a vacation than just a spa experience, it combines a dry heat sauna, vibration massage, aromatherapy (stimulating the senses through scent) and an audio/visual component system to gently guide your mind into a state of relaxation through a series of pulsating lights and stereo sound. The ergonomically designed comfort bed creates the sensation of floating, while its sauna produces a gentle flow of heated air which can be controlled at the touch of a button. The vibration massage uses synchronized undersurface transducers to create a series of pulses which can be adjusted from gentle to rigorous. Heating pads in the bed bring soothing relief to aching muscles. Its light-shielded glasses produce a series of pulsating lights (designed to replicate brain wave patterns from alpha to delta states) and combine with stereophonic sound in accordance with your program selection.

The unit comes with four scents – eucalyptus, ylang-ylang, orange and lavender – to enhance your session. Cool ionized air is directed across your face at all times to keep you calm and refreshed. Easy access hand ports allow you to operate the touch sensitive control panel at all times and adjust intensity, time, temperature, vibration, and volume. A specially designed software system contained within the unit offers eight different pre-set programs, each combining all of the features of the unit in pre-determined intensities and patterns to enhance (1) Relaxation (2) Weight Loss (3) Fitness (4) Energy (5) Creativity (6) Romance/ Sensuality (7) Sleep and (8) Beauty. Easily programmed, you can use any combination of the existing features or create your own. Utilizing powerful microchip technology, all functions can be carefully monitored by you via its LCD readout which displays your total in-session calorie burn. Accommodates people from 5'0"to 6'7". Futuristically designed, the outer shell is constructed of durable ceramic polymer. Requires either 220V/10 amp or 110V/25 amp installation – please specify. Call Ernie Hovland at 1-800-227-3528 for further information.

39" H x 35" W x 89" L (225 lbs.)

13561R..$15,000.00
(Plus $125.00 shipping and handling)

<div align="center">

Hammacher Schlemmer

ESTABLISHED 1848

Midwest Operation Center
9180 Le Saint Drive
Fairfield, OH 45014

</div>

marshalore

```
*     structure
/*    enchasée, superposée
/*    feuille et fruit
/*    sur l'arbre qui suit
      pour une business-machine
      sans oiseaux ni affamé
/*    qui ne sont plus branchés
```

(I think) I took a *bioapparatus* to the lab. I inserted my ticket in a slot; it was scanned; I was allowed to enter; I descended moving stairs. When the "thing" arrived and opened its doors I boarded and went screeching into controlled tunnels, black and dimly lit. A humanoid voice told me where I was going.

Barbarella was inserted into the orgasm machine and the attachments were made to receive and send signals to all the pertinent parts of her body and brain. She was pulled out just before she lost consciousness.

"...however, the manifold differences between computer and humans have led many cognitive psychologists to abandon the computer analogy. Despite the problems, there is still much interest in simulation techniques, which attempt to program a computer to perform tasks in the same ways as people do them."

/traitement dehors de la récursivité/

Michael Eysenck, 1984

After we saw the film Dr. No, *Stefan enlightened me: Ursula Andress was a result of one of the great Nazi experiments – she was a created, perfect being.*

**Le simulacre
me tire, me tire,
m'attire
par des bras
d'automate.**

Rafael Lozano

Virtual reality: A theatre that contains the ideas of all things, except, of course, the idea of itself.

Praises then for such a theatre, a structure that is neither internal nor external, that has neither interior nor exterior, yet it is hermetically sealed. And hermetic it is, for it is based on the Latin translations that the great Ficino made of one Hermes Trismegistus, and thus its magic. This theatre grants *anima* to icons, much in the same way that Egyptians gave angelic spirit to their statues as described in the *Asclepius*. Magic as it should be, for the theatre recovers the latent divinity of man, whose intellect is drawn from the very substance of God. This structure will help Him remember the universe, for the microcosm can fully remember the macrocosm within its divine *mens* or memory.

Virtual Reality[1]

A theatre where you stand on the stage, that is your eye, looking out at 360 degrees of icons which are really talismans. Memory is a place, a place where viewers attend only one at a time (unless your rank does not permit your attendance in the first place). Approach and recognize in an instant all that you have already seen and experienced. A vast pantheon of ideas, ideas that cannot sleep for there is never darkness under the reign of *Lumen, Sol*.

And here it is at last, a place where memories of the celestial and inferior worlds are stored in an infinite number of little drawers, each drawer underneath the stamp of its classification, a classification that is the fabric of all designs. Open up a drawer and find *imagines agentes*; extrapolate the *imagines* back to where they seem to come from, and release that which is otherwise hidden within the depths of the human mind. But what is this theatre other than a highly ornamental filing cabinet?

1 Adaptation of recollections on the Memory Theatre of Giulio Camillo Delminio, whose wooden theatre made him one of the most famous Italians of the sixteenth century. References from Frances A. Yates, *The Art of Memory* (London: Routledge and Kegan Paul, 1966); quotations from the script of the play *Immediacy* by A. Kitzmann and R. Lozano, 1991.

Kathleen Rogers

A Gothic Tale
Set in Cyberspace

The Cabinet of death

Inside the electronic cabinet a grotesque pantomime is taking place. A number of skeletons (archaic symbols of death) are visiting cyberspace. The skeletons find themselves prisoners in the house where the android lives.

The Scenario

The android is waking from a sleepless dream and within the invisible circuits of its artificial memory ponders sadly on the android condition. A dense fog of computational/neurological data permeates cyberspace in a melancholy atmosphere of endless propagation. The cyberspace house is in the tomb yard. The exoskeletal apparatus has become a way of life and death. Within the visual field consciously noted elements are figure and everything else is ground. The interplay between figure and ground is where the action is. The memorial museum appears to be an aperture through which light travels. The consciously noted elements stand out as carved and embossed, like fortifications of visual concrete. The old people's home, the ambulance station, the scientific research laboratory and the multi-storey car park are institutional role models. Centre point with its graceful outline performs as a free-standing concrete zoo and a disembodied observation post. The figure of the android emerges on the retinal screen. A voice print resonates as the grotesque figure turns to deliver its beautiful and terrifying monologue.

The Android Monologue

The house stood by itself holding darkness within. Walls continued upright, floors were firm and doors were shut. Silence lay heavily against wood and stone and whatever walked there, walked alone.

In the total darkness of this cave I am forever chained to this dull object?
Movement is falling from lips, like cherries from trees and no one is listening.

My head is on a picture, I see my eyes opening. I see memory. I see the utter exhaustion just below the surface of the mask. They are searching for more memory, more memory than the picture. I am a single straight line, a picture without a face. The idea of the actor. I was looking for the actor. In my mind I was the actor saving and loading myself.

My mother is a fugitive angel, she gave me her wings. She is artful mutation. We lived for each other in the magic toy hospital. In the exclusively private, psychic theatre of my mind I confess to the reality of pain. In this mind I do not know myself. I am afraid. I am awake with an evil watchfulness in this blank window. I am pattern recognition, distance and space, displacement and rotation, dress and disguise. I am a process of no dimension or progression. I am an animated corpse lost in the losing memory area. I am mercy. A beautiful, supernatural army of phantoms runs to my door for shelter but there is no room.

THE SKELETONS APPLAUD WILDLY

(The retinal image is wiped from the chaotic support and fades and the body is zoomed backwards in space)

finis

Response

KATHLEEN ROGERS

In the section Cyborg Fictions, there are six essays which deal with the nature of subjectivity. Each writer is seeking a language to question self-identity. The titles include: *Cyberspace – The Ultimate Destination, Bioapparatus, The Status of Partial Explanations(excerpts from the diary of a feminist cyborg), Notes Towards a Theory of the Bioapparatus as a Site of the Conquest of Mind/Body Dualism, Virtual Reality* and *The Cabinet of Death* (that's mine). I think we are already multi-layering a number of metaphors here. We have got cyborg fiction which in itself is a metaphor, and then these which are inside that.

What I would like to do whilst I am reading my notes is provide some background work in the form of a video to illustrate the difficulties experienced in trying to define the language for the subjective.

From reading the essays, I have made the observation again that they appear to deal with the cybernetic world as an enclosure. All of them explore the question of self-identity in the subjective form. They deal with the cybernetic world as an enclosure of identity using various metaphors. The subjective experience cannot be defined and it requires space for exploration and expression. To find containers for subjective experience is a fascinating task and attempting to find words for the containment and framing of identity is a fundamental activity.

It seems that some of us desire to open the Pandora's Box and embrace the monsters of the human psyche and some do not. We have in front of us, in the bodies of words, and in these essays, the psychological landscape of *Total Recall* which is described by Adam Boome, Lorne Falk's diaristic approach, the classical memory systems that Raphael Lozano describes, the peep show, the gross pantomime, the theatre, the house, the museum, the commodity and the haunted house (which relates to my essay, *The Cabinet of Death*).

A recurrent theme in my work has been images of authoritarianism, imprisonment or of confined narcissism. The themes have found expression in the symbol of the house. The haunted house is an emblem of particular horror – the corruption of something sacred by something other – by an alien presence, an idea that corresponds to our most primitive fears. The haunted house has a reputation for being a bad place with an unsavoury history. There is a residue of absorbed human emotions. The house broadcasts back voices and images which are part of old events. Other haunted houses are the familiar illusory spaces and electronic worlds inside screens: miniaturized spaces, interior worlds, the television, the cabinet, the peep show, the kiosk, the Bible, public access terminals.

In looking at Hubert Hohn's writing, I feel that he is seeking to convey the physical, psychical and spiritual nature of the human sensorium immersed in a high-tech world. The body is seen as an extension of the commodity that it inhabits. Here the medium is truly the massage of the senses. The technology anaesthetizes and suspends consciousness, and the body becomes synonymous with a gorgeous limousine.

Raphael's memory theatre draws from an earlier labyrinthian model, the classical memory theatre of ancient Greece – an invisible memory system which has informed mystical, philosophic and scientific practice.

Marshalore's peep show demonstrates the voyeuristic fetishism of the female orgasmic body.

In Adam Boome's writing, we see how the delicate framework of self is easily dissolved into psychotic and psychological film narratives. When fantastic artificial realities outstrip the mundane realities of everyday life, why not opt for the excitement and stimulus of the artificial?

The diaristic approach used by Lorne explores how a perverse gender taxonomy has impeded feminist cyborg developments. He examines the development and proliferation of the "monstrous male semiologies which define, dominate and control the limits of social interaction and social realization." He recognizes the need for us to replace the self-denying territory of blind habits with the exciting recognition of the cybernetic word as a field for a feminist-socialist appearance. The potential of a feminist cyborg is considerable. I understand cyborg to be an embodiment of a monstrous idea – a part human, part alien type of automaton – a serial killer who has roamed around science fiction worlds for decades and is now about to be reactivated on the laboratory floor. I look forward to her blasphemous resurrection. Do you?

Discussion

Nell Tenhaaf:

Would you care to elaborate on your cyborg, because I found the portrait at the end was very contradictory and I assume that was deliberate on your part.

Kathleen Rogers:

The conflict that exists within language, metaphors, like juxtaposition between texts and image, between ideas, is one that I embody in terms of my working practice. Even Donna Haraway's cyborg and the connection to socialist-feminist developments are a kind of paradox because the cyborg has been defined very much by a kind of imagination. I like the idea of embodying that monstrous idea from my own subjectivity and starting to have voice through that.

Art in the Virtual

He Gong

The sophistication of the computer and new technologies triggered by it have presented an inevitable challenge to art. Our present art explorations may be regarded as the establishment of a new civilization that examines the concept of technoculture brought about by the revolution of science and technology. This presents new prospects for coming art activities. Yet at the same time we have new problems to meditate upon.

What kind of knowledge structure and technical accomplishment should the artists possess, if devoted to art activities concerning the *bioapparatus*? Will their past experiences continue to function in the new activities? The creation of art consists of three elements: body, mind, and apparatus. Will the apparatus now play a more decisive role? Since the design and operation of the apparatus requires considerable knowledge of science and technology, and since such facilities are expensive, will it be reduced to an elite art? And conversely, since computer science is being popularized and skills employed by artists have become more technical in nature, will such art go the old way of Bauhaus' prefab box? As the role of viewer has also changed, could artists still offer orientation in thinking and understanding?

These questions may be answered through new practices. In the process of development, new aesthetic criteria will evolve and be established, if ever such criteria are still needed. At this stage, we are full of expectations and excitement yet we have not grasped much about the essence of this kind of art.

Maybe the efforts in the exploration of *bioapparatus* will become mainstream amidst art movements of the future. Yet it may also be a mere experiment, and something else may emerge from it. I am convinced that this something else would by no means be a return to the past but would be something we have not experienced so far. And this new art, I think, will first flourish in the western countries, which are burdened with a light load of traditional culture, and such new art will inevitably bring about tragic effects upon the peoples and countries that continue in their attempts to glorify themselves with the splendor of past cultures. In other words, all the traditional culture will be turned into history or reduced to an appendix of the mainstream of the new age. And that is the fated way in the transition from the old to the new in the process of innovation.

Doug Hall

Concerning
Virtual Reality and
the Bioapparatus

1. Much of the talk about virtual reality appears to be ahistorical, depicting it as a unprecedented technological breakthrough with rupturing psycho-perceptual effects. I would think a more interesting tact might be to understand it as a continuum (perhaps even a minor one), which involves the mediation of both everyday and extraordinary experience.

2. Why must the discussion of virtual reality be centred on simulators and interactive environments? Wouldn't it be equally interesting to talk about shopping malls, computer game arcades, freeways, airports, and hospitals (among many other built and imagined spaces) as environments that are as deeply disorienting as virtual environments?

3. When are the spaces we inhabit and contemporary experience not, at least to some extent, mediated for us, if not actually virtual? (In our national parks, for example, the important views are marked and explained by signs that tell one exactly where to stand and what to look at.)

4. Why has so much utopian rhetoric been attached to virtual reality? Has not the technology been developed by hi-tech industries for military applications? And aren't these industries part of an involved and intricate system (of which we are also a part) that has institutionalized power, desire, and consumption? (Did any of us feel a twinge – perhaps slight but still noticeable – of psycho-sexual satisfaction when we watched the New World Order's Nintendo war in Iraq and Kuwait earlier this year? And am I imagining it or is there a similarity between such words as *bioapparatus* and *collateral damage*).

5. Where might artists fit into all of this? From my perspective, it is more interesting (and I think more productive) to be a critic and observer of media, to use tools as part of a larger aesthetic, conceptual, and critical endeavour, than it is to fetishize the tools for their own sake. The tools used could as easily be hammers and saws as computers.

Itsuo Sakane

Recovering the
Wholeness of the Arts:
Information versus Material[1]

There is a new trend in the world of technoscience art away from the kind of kinetic art popular in the 1960s and 1970s – art-based mechanical dynamics and ecological (or phenomena) art, based on the biological and physical laws of materials. People are becoming more interested in a digital, synthetic type of visual art based on electronic media such as video and computers.

If we look back, we see that art itself started as a way for the mind, each person's inner self, to experience virtual reality in a wider sense. From cave paintings, through the writing of fiction, to the miscellaneous forms of visual art today, art has always worked as a catalyst to evoke in the imagination each person's sense of reality. It is the imagination itself, however directly or indirectly, that must arouse in each individual memory the sensual experiences of one's daily life. Marcel Proust was able to revive memories of times past by dipping his Madeleine teacake into a teacup; the tactile and olfactory senses are able to act as a catalyst to inspire this imagination.

When we compare such vivid sensual experience of everyday life to the urban life of today's consumer, automation technology, we often feel that we have lost contact with the vividness of nature. The recent appearance of virtual reality art might, in a sense, be running parallel to the modern sociopsychological human condition.

Let me make clear at this point that what I am arguing for is a balance between two types of art in this age: a harmony is possible in our personal and social lives between the art of synthetic reality, based on information technology, and the art of the five human senses, based on material.

There must be several ways for the two types of art to coexist, even now. It is possible to integrate both the computer and material-handling technology. Also it might be useful to find new types of human interface between the body's muscular power and virtual and visual environments. Another possibility is the combination of electrical discharge phenomena or magnetic field phenomena and computer-generated images to create a virtual environment. If new sensors could be invented to detect all kinds of delicate types of sensual stimuli, and were it possible to synthesize a more realistic artificial flavour for taste or smell, the sense would deepen our experiences in the future with virtual reality art. At the same time, however, this innovation would lead to another paradoxical dilemma within such virtual "total experience": we could easily lose reference to reality within such a hyperreal environment. The trick would be to keep the subtle sensitivity we possess in identifying the difference between real and artificial flavours, for example. The more sensitivity we nurture in our senses, the less we shall be satisfied with virtual reality, although we do not want to lose the contribution of virtual reality to art.

David Bohm has said of modern science that it has lost its wholeness and become reductionist. If the main trend in art today continues to follow its present course toward virtual reality, it too will be reductionist and lack a wholeness. It is this wholeness that art today must maintain if we are to ensure the vitality of our future.

1 This selection is excerpted at the suggestion of the author from an editorial in *Leonardo* 24:3 (1991).

Ben Schalet
Noah Mercer

The idea that the mind could fill in for the body is one that will become more important as the technology of virtual reality progresses. The current work in force-feedback for virtual reality will induce users to become more attuned to certain aspects of their body: learning that a buzzing in the fingertips means contact with a virtual object will be much like learning the dots and dashes of Morse codes. Just as letters in Morse code are associated with specific sequences of long and short sounds, users will probably configure unique buzzing patterns associated with their virtual objects. This will bind the experiencer to the *bioapparatus* more tightly than ever.

It will be up to the artist to decide the complications of perception and ultimately to shape how virtual reality is used. Much as early computers were operated by a high priesthood of initiated technicians, virtual reality is now controlled primarily by the wealthy and the technically adept. Many of the issues raised here will not even be explored until this virtual reality becomes personal virtual reality.

T. E. Whalen

An artist must not only craft a virtual body for the participant, but she must also ensure that the virtual environment responds appropriately to that body. If a participant's virtual body is a rainbow-coloured whirlwind, then trees, washed in colour, must sway and bend in response to the participant's movements. And this virtual body can be infinitely flexible. A participant can metamorphosize from a dog to a flea in a blink of an eye (literally if an eye-tracking interface is provided) and see a dog catcher instantly metamorphosize from a hated enemy to an enormous meal (it can be a dog-eat-dog catcher world).

While we are all aware of the technical limitations of the computers and display devices used to implement virtual realities, I believe that the most immediate problem is the development of an appropriate interface for artists. We do not have an efficient way for an artist to create a virtual environment that includes a metamorphic body for the participant and which will respond appropriately when the participant inhabits that body.

Accessing the Magic of Virtual Worlds

Rather than reworking traditional artistic skills, a new metaphor is required. I suggest that magic may be a metaphor more suited to the power of a computer than physical crafts. The artist should enter a blank virtual world as a magician equipped with a grimoire of spells to create objects and a wizard's staff to orchestrate events. A cat would not be painted, sculpted, or even grown; rather, it would be conjured with a tabby spell. By default, it would inherit the appearance and behaviours of a cat, until other spells are cast to give it Pegasus wings and a timid disposition.

Response

HE GONG

There are five papers in the category, Art in the Virtual. The writers are: Doug Hall, Itsuo Sakane, Ben Schalet and Noah Mercer, T.E. Whalen and myself. The main points of these papers express grave doubts about virtual reality technology and the *bioapparatus*. A few points are worth presenting here:

1) Virtual reality is not an ahistorical and unprecedented phenomenon. The investigation and research about it should be concerned with history, with culture, with public space, and with negative impact of virtual reality.

2) Virtual reality technology, to some extent, weakens our sense of nature. One writer suggests the possibility and the difficulty of balancing virtual reality art and natural art.

3) Two writers pointed out that because of the expensive facilities and considerable knowledge of science and technology that are required, virtual reality art may be reduced to a modern elite art. And conversely, because computer science is being popularized and skills employed by artists have become more technical in nature, such art maybe will go the way of the Bauhaus prefab box.

4) Logically, in virtual reality art, the virtual body of a participant should cooperate well with a virtual environment, but actually virtual technology has not yet presented such an efficient way for artists. One writer suggests that using magic as a metaphor maybe more suited to the power of computer than thinking about art as a material process.

In my opinion, the developments of modern western civilization are based upon the idea of progress in industry and science. Perhaps for this reason, the adoption of new technologies by western artists seems inevitable. Thus, when considered from this point of view, the use of virtual reality technology by artists can be seen as both a symbol of scientific progress in the arts and a revolution in artistic practice.

However, there are a number of potential problems with this point of view. On the one hand, this technology is the product of a western techno-culture and its pragmatic philosophy and can therefore be seen to express the self-confidence of this culture – the dominant culture of this contemporary world. But it can also be seen as the product of its inability to comprehend other historical and cultural perspectives. In this connection, we must not forget that virtual reality technology can function just like a chemical reagent in the sense that it can be understood to function with different reactions resulting from its adoption by different cultures. On the other hand, while virtual technology shows the creative power of human beings, it also shows their gross dependency on machines; while it presents the ideal (utopian) prospects of a new realm of human civilization, it reveals the shadows of its alienation; and, while it exhibits the general subconscious fascination with techniques and technologies of a culture that indulges almost naïvely in technological addiction, it also reveals a culture that seems to have little experience of political oppression and the relationship between this oppression and these techniques and technologies.

So, I think we are at a crucial moment in the development of this new technology and consequently would like to suggest that we avoid replacing older artistic models with pure (oligarchy) technologies while we go ahead and renew our concepts, behaviours and apparatuses. I also think that we should pay rational, broad-minded attention to the metaphysical dimensions of the arts, in particular to their conceptual apparatuses, as well as

to the conceptual diversity of non-western cultures before our eagerness for quick success and instant benefits finally result, as we say in China, "in a reversal in the speed of progress because we have not paid attention to fundamental social, cultural and political issues with and across cultures."

Discussion

Fred Truck:

Do artists in your country have access to machines like computers?

He Gong:

For economical reasons, it is very hard for artists to equip themselves with computers or other high-tech machines. Most of the young generation of Chinese artists are very sensitive about the new technologies and new ideas. If they have the chance to get in touch with such technologies and facilities, they really like to use them. Some are deeply rooted in those kinds of concepts. Avantgarde artists do not think it is the time to define it with positive or negative notions; we only look at it as a kind of exploration. But the artists who have conservative ideas criticize it as a cultural contradiction.

David Tomas:

Could you talk a little more about what you think about magic. Do you think it is an interesting way of organizing things in virtual reality or do you think there are other ways of doing so?

David Rokeby:

Maybe I can address that question. It seems to me perhaps that magic has traditionally been a way of dealing within the popular or uninformed imagination with very complex phenomena. And given the complex phenomena that are possible algorithmically in computer-generated worlds, magic might be useful, at least, as an alternate way of creating or composing or generating virtual worlds. It reminds me of what I was thinking about when I saw the first digital synthesizers: "My God, I have to define everything; how horrible."

Warren Robinett:

I gave a talk last week where I showed some Dr. Strange comic books from the sixties and seventies and I believe that we could definitely implement magic in virtual reality with something like the traditional image of Dr. Strange. He can shoot laser beams from his hands; he can create doorways that open into other spaces and you can step through, and then there are all sorts of crazy monsters coming at you that are shooting power beams and casting spells. The interesting thing is, as soon as you say we can do these sorts of archetypical magic things, then you have to start asking yourself about this thing called magic. What does it do? You have to write the computer program that implements these things. Actually, it is hard to start thinking about what magic really is when you think in detail. I have done this a few times and made some notes about what the spells might be. Okay, I have fireballs and I can freeze things and I have power beams and I have shields for power beams. What else is magic? You imagine that wizards who do thousands of spells. If you look in the Dr. Strange comics, he was usually doing some funny gesture when he was firing off one of his power beams, which suggests he was using some sort of manual control, like a data glove, the way we do nowadays, so different gestures would mean different kinds of magical actions. You could implement this stuff. I do not know the limits of it but I think it is really an interesting thing to try.

Adam Boome:

I would just like to make a point about an interesting model of what you seem to be talking about – Peter Greenaway's adaptation of The Tempest. The main character has twenty-four magic books and he is stranded on an island somewhere between Italy and Africa and he peoples the island with spirits which he conjures from the books. He has a book of architecture and, from that book, he can create buildings. With the book of water, he can conjure

storms. It seems a very interesting kind of thought to translate into virtual reality. I am sure there must be an enormous number of ways to have control over this virtual reality environment with this kind of material.

David Rokeby: I am always interested in the problem of computers and control. If you understand computers, you really do have control. But sometimes control is not what you want, sometimes you want something that is like control but has a bit of a curve to it – something that reflects some of the complex, unexpected, surprising responses of things in the real world.

Warren Robinett: If you had some simulated demons, you would not know what they were going to do.

Catherine Richards: I see a longing for the unexpected on the part of the programmer who feels too much in control. Magical spells may be based on some other kind of relationship that is not particularly scientific but the control is very precise. So it also depends on who you are talking about – are you talking about magic for the programmer, for the designer or for the user? It's already magic for the user. The unexpected would be in the narrative for the user. I don't see how the unexpected in programming generates the metaphor for the user.

David Rokeby: My idea of magic is a technology that has not been invented yet, is still beyond our imagination. I perhaps wrongly attributed a spiritual notion or suggested an unknown, a dark secret element.

Nell Tenhaaf: It is difficult to access the imaginary. You could see dreams as that unknown territory; it is the unconscious. It would be interesting to have a screen for the unconcious. That has always been for me the fundamental objective of art. I have always thought that it would be the most pleasing, magical state to realize with some technology a projection of my imaginary – a direct one. I have the image or the thought image and suddenly it is there. I wonder if that fits into the lexicon of downloading as a concept, an idea.

Warren Robinett: I am willing to consider that. For me, imagination lacks detail. I think different people imagine in different ways, but my imagination usually is very foggy. When I am imagining a place, it would just be a grey fuzz if you could project what was in my imagination. But I hear that some people have visually detailed imaginations. So, if there is some visual structure there in your mind and, as yesterday we were positing, we could download everything, then you surely would understand how visual images were represented in the brain and how three-dimensional space was represented and therefore, you could capture that little part of your knowledge from that momentary imagining and project it into some standard three-dimensional representation that you could put into a headset.

Mary Ann Amacher: As Fred was describing earlier with the expert systems, you could perhaps develop your own model by what you know about your own imagining and various kinds of agents that are a part of imagining. You could make an expert system as a model of yourself that you could talk to; it would be a kind of a mirror.

Aural/Visual Space

William Easton

The premise of the *bioapparatus* itself frames a question. It can stand as a rhetorical and self-contradictory term – an oxymoron (like that of virtual reality), which not only exposes its status as an epistemological effect but simultaneously calls into question and disrupts the very domain of knowledge from which it is has emerged. This domain might be described as a canon but one that has, without question, operated hegemonically throughout the history of western thought. In stating this I realize I have simply reframed the question, or perhaps just added my voice, in response to the demand for an analysis of the omnipotent dominance of mind/body, subject/object, self/other dualisms. Questioning the power of certain belief structures is a never ending inquiry; it is also central to any attempt to dislodge their authority.

My own investigations have centred on vision and visuality. In part they have been com-posed of a comparative analysis of the sites of contemporary vision, its models, techniques and domains, with those of the enlightenment. In this way I attempt to disrupt the canon of contemporary models and suggest the necessity for a radical dis-articulation and re-articula-tion of the status and locality of the contemporary observer in light of recent technologies. We can state with seeming hyperbolic assuredness that the changes over the last few years within the technologies of vision, computer steropsis, image enhancement, Fourier-Domain processing, computer tomography and virtual realities to name just a few, have ruptured the existing fabric of the visual field to a greater degree than has been witnessed since the initializing of the project of the Enlightenment. What makes it possible to speak so confi-dently of such a revolution in vision is the way in which these technologies have severed any relation of the sites of contemporary vision from their mimetic function, from the exigency of light and their paradigmatic relation to the machine of the eye. The images produced by these emergent technologies are no longer analogous to their referents. With vision eclipsed, disembodied from the eye and conditional on the parametrics of computer-processing, our situation as observers has been decentred. We are in the dark, distant and dependent. Existing models of vision have been thrown out of Alberti's window and appear as a ghost on the light-emitting screen of the computer monitor. The need to find alternative models and strategies of resistance by which we can evaluate the ideological effect of these technolo-gies on everyday life is abundantly clear. What is also apparent is the lack of such models and strategies and the difficulty in creating them when these sites of contemporary vision have so little connection with our own visual experience. We are in danger of going blind, not because we have looked into the sun for too long, but because we are looking beyond lumination.

I have also been looking at the generation of models that might be used to evaluate contem-porary sites. These inquiries have taken the form of texts, performances and installations. In the search for contemporary models, these activities may be gathered together under the heading of prescience. The parapsychology of distance viewing or telepathy is one area that I find particularly intriguing. As a model, it involves the extension of viewing beyond the confines of the body. The challenge of parapsychology is perhaps similar to that of the *bioapparatus*; they both condemn much of the accepted understanding we have of ourselves and the science that upholds those beliefs. Neither concept can be easily dismissed or readily accepted. I do not intend to use these ideas in the form of scientific experiment; rather, I treat these concepts as playful and insightful. As such they may re-open a Paracelsian door that the enlightenment struggled so hard to close.

90

George Legrady

Some of my recent work aims to test the threshold of cognitive perception and cultural interpretation. It considers the minimum condition under which a complex set of tonal gradations produced from mathematical algorithms can be perceived as a photographic image. Because our socio-cultural experiences in interpretation involve the construction of meanings from signs, it can be supposed that humans have the propensity to find meaning even where initially there was none.

Human perception and cognitive interpretation are highly dependent on the ability to identify signal (ordered information) from noise (random information). One intriguing observation in perception studies revealed that recognition of *noisy* images could be enhanced by viewing the image from a distance, by squinting, by jiggling it or moving the head while looking. The effect of all these actions is to further blur, or increase the noise level of the already degraded images. When images are considered as combinations of spatial frequencies, they can be manipulated in the same ways other frequency-dependent signals (such as sound) can through frequency filtering and critical band masking.

The Simulated Photograph: Technobelief

Studies have also shown that recognition of images can occur even at sixty per cent noise degradation due to familiarity with certain modes of representations and an ongoing learning inherent in the viewing process. We have all learned through experience to read photographs that are out of focus. Cultural factors enter when the image presented cannot be confirmed according to lived experience, and interpretation becomes dependent on the authority of sources. Examples include abstract medical/scientific documentation where we are asked to trust in the validity of their narratives. Allan McCollum's close-up *Perpetual Photos*, images which are cropped and magnified from TV, are similar in nature. Genetic and cultural hybrids provide another dimension, situated at the limits of our knowledge. Donna Haraway points out that the etymological root of the word *monster* is montrare, "to show, to prove or demonstrate."[1]

1 Donna Haraway, "A Cyborg Manifesto: Science, Technology, and Socialist-Feminism in the Late Twentieth Century," *Simians, Cyborgs and Women – The Reinvention of Nature* (New York: Routledge, 1991).

Robin Minard

**Concerning the
Use of Sound in
Virtual Environments**

As art's creation of physical objects is replaced by the creation of psychological space, artistic languages and methods – traditionally directed toward the physical process – now are formed to serve psychological conditioning. For the composer or sound artist, this implies the use of language with non-narrative fundamentals in which emphasis is placed on acoustic and psychoacoustic principles rather than on traditional musical concepts. Here, musical parameters such as register, timbre, rhythm and so on take on new meanings as the composer's work is guided by the influence of sound elements on spatial perception as well as on the listener's interpretation of visual information.

Such sound applications may be divided into two general categories: the articulation of space and the conditioning of space. The articulation of space generally implies a *spatialization* of sound, and is concerned with the movement of sounds through space or the spatial localization of sound elements. Although convincing impressions of moving sounds are particularly dependent on available technologies, psychoacoustics will support the experience that certain musical parameters (especially timbre and register) are important contributors to clarity in sound localization and spatial movement.

The conditioning of space, on the other hand, generally implies the creation of *static* or *uniform* spatial states, and is concerned with the colouring of space, the simulation of acoustic conditions, or certain applications of sound masking. (The term *static* is used here to define the *immediate* nature of a space and does not exclude slow evolutions in spatial characteristics.) Through factors such as space-reverberation time, resonance, sound-reflection characteristics and types of frequency absorption quite accurate impressions of spatial dimensions, architectures and even construction materials are ascertained by the ear. In the creation of virtual environments, the simulation of acoustic conditions will be considered an important contributing element – not only for the representation of familiar acoustic conditions, but also for the composition of hybrid acoustic situations, or the creation of *evolutive architectures*.

We measure space with our ears as much as with our eyes. Sounds orient the body in space and even guide our visual interpretations of our surroundings. As in all artistic domains, new technologies will allow for the expression of art as a sensory event, but for the individual artist, this will require a reexamination of traditional methods and goals and an eventual shifting away from object-oriented concepts toward a new sensory-based expression.

Lisa Moren

Napoleon Bonaparte was dumbfounded – not by the intense gaze of his army during his pep talk before descending into battle – but by the sudden awareness that the soldiers were not transfixed by his enlarged, small presence, but by the large glowing disk that silhouetted him against the sky. The disk was the planet Venus but this did not dampen Napoleon's image of himself as godlike; instead, he saw the celestial orb as a sign from above to push on into his new imagined territory.

The electric blanket became popularized in the 1960s.

Many ancient cultures, western and non-western, have reported numerous sitings of the planet Venus, according to anthropologists and scientists. "I want to fly over Mars, I want to experience everything the roving exploration machines experience, I want to be there, I want to explore the planets myself."[1] This dream can be seen as an extension of the more familiar scientific abstractions, such as circumference, temperature and the amount of light emitted into the atmosphere by planets such as Mars and Venus. If we understand these scientific abstractions as invented measurements applied to the planet, we can appreciate facts as something flexible – perhaps virtual. The other Venus, the amorous woman of desires, was never meant to have been measurable, or real, but she has always been fabricated as the realm of escape. In virtual reality, this space is penetrable by our own fabrications. What has always been a mystery, a vehicle to the imagination and ultimate comfort (*riddle of the womb*) may now be entered as our own created space. It may now be explored as feminine consciousness in its *reality*, or veracity, because we enter it with an understanding of what it has always been – virtual. We believe we are touching it/her (at least we are supposed to) but we *know* we are touching our own fabrications of her.

The Imagination of Comfort

A charged dynamic current is controlled by a dial that ranges from one to ten and measures the heat that surrounds our skin, ten being the warmest.

Like Napoleon, the American president, Truman, believed it was the "the will of God" to give Americans the atomic bomb since Americans would know how to do good with it – it would ensure the future comfort of the world. More recently, the American military utilized virtual reality in flight simulators and sound helmets for the aircraft pilots in the Gulf. With a friendly-fire fatality/casualty rate ten times higher than in any other war this century, the pilots of this war entered the air space of the gulf as their virtual environment.

1 Michael McGreevy during a report on virtual reality, ABC News "Prime Time," 19 September, 1991.

Jerry Pethick

A simple visual model, a computer graphic reality, joins ordinary physiology and perception of binocular-induced spatial awareness and it utilizes the pathways and processing of the already developed dimensional imaging of sight. Additive technology produces this material space. Non-physical solids are a part of this stiff, unreal space because they are perceived in the same physical and social manner, like snowflakes in the air.

Artificial intelligence has taken a spatially oriented back seat to the simulation of real space, which is perceived with the same sensory mechanisms kept for actual reality as we have known it. The qualities of remembered space will be nuances of experience that we draw upon when reassessing of our sensual relationships to diverse reality. Spatially perceived volume is the medium in which perceived objects and images exist. The space is not only the vehicle of content, but also imparts understanding of the quality of the simulated space, which will have a profound influence on how we perceive nature and the real environment of atmosphere. Dream generated, memory generated or artificially generated, vision will be difficult to differentiate from spatial memory reconstructions. The eidetic memory will become saturated with categories of hierarchical space realms.

**Memory of Visual Space
As It Once Was**

Oxygenated space, in which we live, is transforming itself. This change is perceptible not only in the amount of oxygenated space available to each of us nor in the quality of the actual air we breath, but through our shifting personal perceptions of it. The limited technology and the diversity of the spatial qualities produced by dimensional imaging systems have left our comprehension of the qualities of different spatial constructs underdeveloped. The flow to more sophisticated concepts of simulation will increasingly divulge perceptual anomalies. Through experience we will learn to use this facility to select the kinds of spaces we wish to exist in, like the lobsters in their hibernation boxes, or the symphonically complex spaces of worlds on edge.

Ursula Franklin says a great deal about the world on edge. The technology of control has been more insidiously productive than the technology of product. Our compliance with current visions of progress supports the packaging of space, the selection of internal travelogues and perhaps the packaging of individual spatial memory of the natural environment to feed nostalgia, if we allow it all to go.

Meanwhile, the spatial playground, as Ralph Werker said in 1967, is "a lot of fun." We should not wait until only the military and pharmaceutical corporations monopolize the game. Individual space is at stake.

Response

ROBIN MINARD

I began working with environmental music in 1984. This meant for me, as a composer, putting music into completely new contexts, and ultimately it meant examining new musical structures and appropriate musical languages for these contexts. To begin my talk though, I would like to reflect on some of my personal relationships with sound by returning to the very beginning of my own sound experience. I can remember that as a small child I would delight in parades, and that I would want to go to them mainly to experience the bass drum. In fact, I became quite a parade fanatic. I would always want to run ahead of the parade, and there I would wait for the drum to pass by again – I wanted another sonic glimpse. I can remember how the drum would beat inside me. It was a very physical experience. It was not the experience of an image associated with a sound, not a bass drum making its noise, but a sound which was inhabiting me, a sound which was beating inside my chest and making my entire body resonate. That is what was essential to the experience.

And perhaps that is why some sound artists have a fundamentally different approach than visually-oriented artists to the relationship between art and the human body. Our art is projected into the body in a very physical kind of way. Our experience has never been exterior; it is something physical that is going on inside us. It is the mechanism of our ears vibrating, it is beating in our chest and we feel it in our knees. Sound invades the body. When I make my musical sounds, I enter my own body and I invade the bodies of others.

Yesterday, Robert McFadden referred to a quote that said, "In the beginning, there was the word." He referred to this in a very visual, representational sense. But in the beginning there was the word, and the word was sound. In fact for all of us, we begin our life in the darkness of the womb – all we have is sound. Sound is the primal sense. When I sleep, I close my eyes but my ears do not close. Sounds can alert me from behind; they guide me through my environment; they caress me. Sound is constantly entering my body. Even in deafness I will feel its vibration. In a sense, there is no subject and no object in the world of sound. *Because* sound inhabits me, *because* it requires my body to resonate within, *because* it finds my resonances in specific and individual ways, I *become*, in a sense, the object.

During many of our residents' meetings up until now, I have been feeling – as a composer – somewhat outside of the discussions. As a result of our talks, I have begun to ask myself certain questions about whether it *is* dangerous to enter people's bodies through virtual reality – perhaps it *is* dangerous to be playing with other people's bodies as some have suggested. In Catherine Richard's paper, she refers to membranes through which exterior stimuli are allowed to enter the body, to thresholds where these stimuli become reality. But she seems somewhat afraid. If fact, in this residency, there has been a good deal of fear expressed about allowing access to these membranes, to allowing others within our bodies, to the destruction of the self. But within the domain of sonic art, we have been playing with the inside of the body in a direct way since the beginning – that is what we do. We get inside people's bodies *physically*. And to those who have doubts about entering the body, I want to say that it is a fascinating place, it is wonderful (in the true sense of the word *wonder*) and it is a rewarding and enriching experience to work there. As a sound artist, I accept these openings in the body as the only vehicle of my expression. If virtual reality is a physicalness of expression, if it is the relationship of the body to a space (to a sound space), then I have been working with virtual reality in the real world for some time, as I think many composers have. My specific interest now is to transfer some of my experience to the

virtual reality world, to discover new worlds of sound, new ways of entering my body, new ways of making sound inhabit me, to establish new relationships between my body and the space which I occupy.

William Easton, whose paper appears in this section, is seeking unique models for this new vision in virtual reality – models which he suggests may have little connection with our visual experience to date. He suggests that such remodelling will only be accomplished by reexamining the existing cultural power authority. For me, this refers to the caution which must be exercised in selecting models for our expression: it refers to reforming artistic languages in relation to new technologies, and in this respect, Jerry Pethick and Lisa Moren also make important observations. Jerry Pethick points to the qualities of remembered space as nuances of experience that we will draw upon when reassessing our sensual relationship to a new and diverse reality. Lisa Moren stresses that it is important to consider the way we conceive models and the way we conceive realities: even science is a myth, and many of its realities are, in fact, fictions. Through his work as a visual artist, George LeGrady researches those thresholds of cognitive perception to which Catherine Richards has referred. He is searching for those visual membranes which lead inside the body in much the same way I am searching for inward-leading sound membranes. LeGrady points out that these membranes are not only sensorial, but also cultural and intellectual.

These papers refer, in part, to the shedding of many of our traditional perspectives about art making. In my own paper as well, I discuss psychoacoustics and acoustics as the fundamentals upon which we can construct a new language for working with sound in virtual reality environments. But I do not want to exteriorize my experience, I want to interiorize it. I want to know about those avenues which enter into me. Through those membranes which are my ears, I want to hear vibrations inside of my body. I want to feel them beat against my chest, I want to feel them in my knees and under my feet. I want sound to be manifest inside my body and I welcome the chance to work with visual artists in a similar manner so that we might finally experience together this fantastic thing which is the body within virtual reality.

Discussion

Robert McFadden:

I wonder if you could explain a bit more about experiencing things in the interior and the exterior?

Robin Minard:

I was trying to point to what has been the difference up to this point between visual art and sonic art. Sonic art requires the body to vibrate; it gets inside our body and if we understand the interior of the body, we can do new things with our art and I think that might suggest a different approach to visual arts.

Mary Ann Amacher:

It is completely known that, in what is called psychoacoustics, the first order effects are human response tones. When we hear two sine waves, our ears sound very clearly three more tones. That happens in all music on a much more complicated level and we are not necessarily conscious of them. But I think it is a very beautiful aspect of music and about human beings that perhaps counts for one of the pleasures of music – not only are we dealing with sensations but we are actually responding. Ears function most like an instrument. You can even go so far as to think of hearing as a creative response to music, that we are not just passively being attacked. The second kind of known phenomenon does not have to do with the ears in the mechanical, as with the first order effects, but takes place in your own anatomy. It is called pattern modulation in which our minds, our brains, extract information from the vibration pattern and make the circles, spirals – the kind of shapes

that we perceive. It is not, to my knowledge, known exactly what gives this experience of sound in your head of these kind of shapes, whether it is actually the neurons themselves that are somehow excited to vibrate.

Wende Bartley: I think another aspect of how sound affects our bodies concerns healing. Recently, I had an experience with Pauline Oliveros who has done a lot of work with sound and meditation and healing. I had a very strong muscle cramp in my neck and we all sat around and hummed a sound and it cured it. That is another whole area that I am interested in developing – compositional work that has some sort of benefit to the body, some sort of healing potential to the body. Another direction that I like to think about – sound and creating aural states – is to create an environment that allows people to delve into their subconscious as if entering into a dream world. If you think of dreams as a healing process or as working on various problems in your life, or social problems, I think music can be used as a way of getting to that place where you need to get to, to imagine at that level. I think it creates that atmosphere in your body that allows you to go there.

Warren Robinett: Eventually, I think that the thing that excites everybody is the possibility of covering the entire human sensorium and simulating worlds that potentially somewhere down the line could not be told apart from the real world.

Catherine Richards: What fascinates me with the scientific work being done around so-called virtual environments is the search for other physiological thresholds in the body. So I think another question raised clearly relates to the dream of having a sensorium that speaks to all these physiological thresholds at once. It is also pretty clear that this dream creates tension around virtual reality if it becomes our new mass medium. As a current parallel, Robin, you noted already that one of your concerns was how the Walkman isolates and insulates people.

Robin Minard: There is no hope unless artists get involved and I think that with virtual reality it is a good thing we are getting involved right at the beginning. I think you have to do it from the inside, and the only way to change it is to do something about it. And that is maybe the mistake that happened with television. Critics did not work from the inside.

Catherine Richards: I agree, I think we are all deeply implicated in technology and certainly I am. When I critique certain things, it is done from that position; it is done from working, in a sense, inside, but trying to be conscious at the same time that it is a very tricky kind of position to be in. In response to your comment about television, in the history of video and video art in this country, people organized and tried to own cable systems, tried to affect television from very conscious practice in video, but that does not deny the reality of the political, social, economic structure shaping mass media – which defeated them.

Robin Minard: One of the biggest dangers I see with virtual reality and with a lot of art is the gap that exists between the artist and society – which I find tragic in our society. And I am somewhat afraid that virtual reality takes it another step further and removes the artist even more from society because it becomes a very elitist structure. I do not want virtual reality to become something we escape into. I want it to become something we learn from and I did use the example of Walkmans as an example of virtual reality that exists; it is not very far away from us. Again, there is the example of a city that is full of sound pollution. One option is to hook into Walkmans and transport your environment with you. I find that tragic. Through virtual reality and artist projects we could bring things together.

David Tomas: Virtual reality is just one big Walkman. I think that the separation between artists and society is some sort of fiction the artist has; society has constructed very specific spaces for art to function in.

Robin Minard: Well, that is my response too.

97

The *Real* Interface

The construction of human/machine interaction is shaped by preconceptions of reality.

Michael Century

It might not be fashionable to say this, but whenever discussions about humanizing technology include terms such as empowerment, attunement, or commonality, I become uneasy. My discomfort is not a result of misunderstanding – I know these ideas are supposed to stand for the value of greater human control over the ends to which machines are applied. That much is clear, and as an avid user of telematic tools, I can personally testify to the new ways in which I am able to express myself through them – not just automate or replicate non-computerized processes. My concern is with the growing collectivization of humanity through electronic networks, which may mask the self-serving economic rhetoric of globalization and, ironically, over-emphasize the importance of the tool (apparatus) in comparison to individual subjectivity.

The extreme extensions of body apparatuses, such as head-mounted visual displays or electronically wired body suits, might appear to be decisive watersheds in technological advancement, posing new issues and challenges. But the implications of these are continuous with cultural concerns that have been expressed for some time, originating prior to computers and bio-engineering. Among these is the ongoing attempt to preserve an individual subjectivity, a sense of personally directed will, within an environment of *noise* – to use the term in the metaphorical sense rather than the acoustic or informational senses.

This is the sense in which Jacques Attali tried to find a link between the history of musical imagination and political economy.[1] Not always persuasive, but highly suggestive, Attali asserted that changes in musical consciousness will find their equivalents in political and economic structures in subsequent periods. Western music, for instance, moved from baroque patterning to a dialectical, progressive kind of structuring in the mid-eighteenth century, almost in anticipation of the political tensions of the French Revolution, the rise of nationalism and the formulation of Hegel's philosophy. Writing in the 1970s, Attali looked at the convergence in the 1960s of African-American, Euro-avantgarde, and (I would add) non-western sources in the musics of free jazz, aleatorics and minimalism. He appropriately intuited that the key to the emerging era of electro-babble lies in *an ability to hear or to take in cacophony, a simultaneous mixing of diverse sources, randomness, extreme complexity, and to interact with this flux in a personal voice without being swept into it.* It is indeed true that in the 1930s and 1940s, musical theories emerged that accord with the structure of a chaotic world that is still meaningful; musical works have appeared since then that, while not necessarily reliant on computerized instruments, are incomplete without the input of the observer and are open in form.

For many, the electronic blendo-environment seems to absolve them of a continuing commitment to individual persistence; that is, it allows the ingestion of signals to stand as a surrogate for personal thought and participation. Playing with this flux, against it, holding its many contradictions firmly in mind, forming personal lines that counterpoint the incoming noise, will be the evolutionary challenge of the next decades. This condition of mind, capable of processing what I call a "polyphonic consciousness," is perpetually dialectical. It is not as though the mind is merged with apparatus, nor that artificial sensory inputs are a conditioner for thought, but that both are the case, all the time, and at such unprecedented rates that it will require some time for people to gain skill improvising *with*, rather than succumbing abjectly *to*, these conditions.

1 In *Bruits* (trans. *Noise, The Political Economy of Music*) (Minnesota: University of Minnesota Press, 1985).

98

Regina Cornwell

A Very
Modest Proposal[1]

Virtual reality can be looked at as the progeny of interactivity. In fact it is the most advanced form of interactivity to date, so much so that we may, for now, be hard pressed to think of manifestations to exceed it. However, some may want to totally detach virtual reality from interactivity, arguing either that it has superseded interactivity to establish its own form or that it is simply independent of it.

If we look to the interactive industry we can see the way its developments have led to standardizations (as is the goal of all industries) for efficiency, simplicity, ease of use and where choice is a hallmark. Ironically the very industrialization and corporatization of interactivity operates against its potential for making advances and serving as an index of its time, and all but eliminates the possibilities for new kinds of rapport with those who come in contact with it. And this process adds yet another mechanistic view of culture while it promotes the mind/body split.

The work of a few artists in interactive media contrasts with that of the industry. When the artist throws the standards of logic and efficiency out the window, which are cherished by the industry, corporation and military, the spectator is put into the role of participant or performer and engages the body with the work in a number of ways, actual and metaphoric: Cartesian dualism is questioned as the interdependence of mind and body is stressed.

1 Mark Johnson's *The Body in the Mind: The Bodily Basis of Meaning, Imagination, and Reason* (Chicago: University of Chicago Press, 1987) is a valuable source for exploring the place of the body and the question of a mind/body dualism. See my forthcoming article on performance and interactivity in *Discourse* 14:2 (Spring 1992), addressing the use of the body and other issues in interactive works by six artists.

Derrick de Kerckhove

Bioapparatustalk

In one form or another, *bioapparatuses* have been with us since the invention of the wheel, which, as Mumford, Lemy-giourhan and McLuhan have pointed out, is an extension of the foot. But electricity makes the notion of *bioapparatus* more relevant than mechanical extensions because electrical current is co-extensive with biological currents. Thanks to biofeedback interfaces of different kinds, there are direct exchanges of data between organic and physical responses via electricity. This is the principal factor that makes virtual reality technology a *bioapparatus*. The distinction between stimulus and response, between external and internal processes, between efferent and afferent neural pathways is not quite vanishing but losing density and integrity.

Perhaps the most challenging aspect of *bioapparatuses* concerns their epistemological consequences. The thinning of boundaries between knower and known, feeler and felt, viewer and viewed, indicates that previously trusted conventional separations are themselves mental constructions. The classicist Eric Havelock has helped us to understand the role of the alphabet in establishing such key separations in the western, and especially the post-renascence and Kantian, epistemology. If such separations are indeed vanishing – including the more critical separations between private and public self, private and collective consciousness, then we must address the possibility that new forms of consciousness are under development, not merely private or collective, not merely computer-assisted or independent, but intermediate, self-organizing, cybernetic, looped with other developing forms of consciousness not yet recognized as such.

If standard alphabetic literacy led to a separation of the senses and to the unrivalled dominance of vision in western culture, virtual reality technology is primarily a form of integration of the senses. It is but the more advanced version of the multimedia or hypermedia systems. All such systems drawing from heterogeneous sources are, in fact, multisensory processing systems that benefit from the translation of multisensory inputs into digital form. Via digitization, any sensory modality can be translated in all other senses. This, as Thomas Aquinas observed, is the condition of touch. Indeed, one of the little recognized aspects of virtual reality technology is that it emphasizes touch, whether literally, as in Margaret Minsky's and others' research in virtual tactility, or metaphorically, in the immediate extension of one's nervous system in visual, auditory and kinetic forms. Thanks to virtual reality, to the mind's eye, we will be soon invited to add the *mind's hand* to help us *feel* the cogency of our arguments rather than merely see it.

Another area of epistemological investigation is that of shared consciousness; just as hypermedia are defined as single display or desktop environments for multiple simultaneous and collaborative sources, a virtual object can be perceived as a unified field of activities produced by a collaboration of individual inputs in real-time. The ambiguous relationship that will eventually be established by such objects with their subjective sources is not quite resolved. Correlative to the issue of shared consciousness is the attendant reversal of the conscious process from the status of being privately contained in the body to that of becoming a container for the body. Intelligent environments are not merely sophisticated tools to carry our purposes for us, they also carry us, and shape our purpose.

100

Wm Leler

**More Questions
Than Answers**

Being There

Does the immersive/interactive nature of virtual reality make a qualitative difference in the way information is absorbed? Is the interpretation of outside objects (for example, the way paintings or film are observed or experienced) fundamentally different from the way actual live experiences are interpreted?

The point has been made that there are two levels of interaction in virtual worlds. In stage one interaction you can move around a scene, but you cannot affect the progress of the narrative. In stage two interaction you are a part of the narrative, and will often play a fundamental role in its progress.

I believe that even with stage one interaction there is a fundamental difference between being there and seeing a reproduction. For example, in business, people will fly hundreds or thousands of miles to interact with someone directly, even though the same information could be conveyed over the telephone. Even when sophisticated teleconferencing facilities are available, direct contact is preferred. We at this seminar are evidence of this phenomenon. Another example of this effect was the need to send human beings to the moon, when the same information and materials could have been obtained using much less costly robots.

If it is possible, how can we recreate the experience of *being there*? What information is necessary? Will there be a Turing test for virtual reality (like the Turing test for artificial intelligence)?

Path of Technologies

Is there something inherent in the technology of virtual reality that will predispose it to develop in a certain way? Is there something inherent in television that caused it to develop the way it did? How about the telephone? Will the funding and popular press situation cause virtual reality to favour the cowboy role of virtual reality? Is the technology of virtual reality inherently dehumanizing (like television) or enabling (like the telephone)? Can we (as artists) have an influence on the way virtual reality develops?

One position is that technological innovations are merely reflections of social structures already in place (or at least developing). For example, the steam engine did not cause the industrial revolution: the steam engine was invented by the Greeks long ago, but they did not have the mindset to develop an industrial society. Was the telephone invented to satisfy some need of society? (perhaps to communicate less personally, or to extend the reach of personal communication?) If so, what need is virtual reality about to satisfy?

The answer lies probably somewhere in the middle. Technology reflects society, but also influences it. Should our role be to change the technology, or to change society?

Florian Rötzer

On Fascination, Reaction,
Virtual Worlds and Others[1]

But above all, we – the consumers – want to be in virtual worlds and not just be observers looking in from the outside. We want to be able to turn them on and off. We want to be inside them and want them as complex, but denser and more intense than the world which we have catapulted ourselves out of. For that reason, these worlds need to be more than a "montage of attractions" that condense and accelerate time; they must also be able to react to us, the user. In order to do this, we must, as the observer, be observed. Even though we have the impression that in using interactive and intelligent technology we have an understanding in how we react to the machine, the machine also observes what answers we give. The freedom in virtual space is sacrificed in the final control over the environment, over every thought, when and if it becomes possible to successfully couple our neurons directly with the computer.

In the virtual world of simulation there is no irreversibility and everything is woven into the symbolic economy which is sealed from reality, even when a structural interactivity is possible. Always it is utopian images and signs which circle around themselves. When one is in the age of the real and representational and strives to escape into the realms of the sign, the illusion, and the imaginary, this endeavour is skewed, turned upside down in digital space. What is looked for is the opening, a hole in the web of communication, in that the real as event, as horrible and banal as it may be, can enter. This was apparent in Romanticism, in the reverence for the banal and the ordinary as well as the irrational, as a protest against the Hegelian system of logic.

1 This text is excerpted at the suggestion of the author from a longer essay. Translated from German by Ingrid Bachmann.

Daniel Scheidt

"Please respond" the letter says. But respond to what? To the politically charged term *bioapparatus*? To the problems of "mind/body opposition?" To an attack on the "objectifying effect" of technology? But my work embraces technology and could not exist without it. Of course, it is not without difficulties – complexities and paradoxes – but the ability to work within the domain of software is an exhilarating creative experience. I equate software with technology, believing software to be the distinguishing feature of current technological experience.

Software offers the remarkable freedom (power?) to define complete universes of behaviour – fantastic freedom to sculpt and mold, specify structures and relationships, edit and revise – all according to the personal whim or fancy of the programmer. This freedom comes without expense (because it exists within a closed and abstract domain) and is available to anyone willing to learn a programming language. To provide context, I should explain that I work building interactive music systems – software compositions designed to respond musically in conjunction with input from an improvising musician. This work begins with a deep respect for the performer involved. Working with musicians presupposes a sensitivity to their hard-earned skills and the very special relationship between performer and instrument. (Note that the performing instrumentalist is an instance of human/mechanical integration where mind/body distinctions are completely lost in the wholeness of the performing experience.) I can only become involved in that relationship if I am able to proceed without disturbing what has taken the performer years to achieve. And so I (and my software systems) listen and respond without interfering with the physicality of the performer's actions.

Stimulus/Response

And what of the *bioapparatus* (human interface)? What happens when a cold electronic finger descends from the warm fluffy software cloud to touch us as human beings? Well, touch evokes perhaps the wrong metaphor – I have no desire to infringe upon another person's physical space, except perhaps to tickle those most exquisite organs of pattern recognition, the ears. Sound is where I choose to bridge the gap between my private software worlds and the shared physical world of humanity.

Software offers an escape from the demands of real time and allows for the compression of weeks of thought into a single moment. It permits an examination of passing time in incredible detail, enhancing the mind's knowledge of what the body experiences – bringing mind and body closer together rather than driving them apart. The ability to release systems into the real world and to observe them interacting with the environment, or with other people, then to call them back to teach them new tricks, correct bad habits and send them out again, is an ability unique to computer technology. This ability is well suited and completely appropriate to the nature of that technology. Like a mirror, software allows the programmer to step back and observe the consequences of notions and assumptions regarding behaviour and interaction.

Rather than being compromised in any physical way by an intimacy with technology, I see this relationship as an extension of human experience and capabilities, an extension of my being into other planes of existence – other realities. It is an intriguing environment from which to explore the possibilities of new relationships and new understandings of what human experience can offer.

Maurice Sharp

From a computer science perspective, most of the current theory of the *bioapparatus* is based in positivist sciences. The subfield is called human-computer interaction. Fields such as psychology, cognitive psychology and linguistics have provided the framework for theories about users and their environments.

The theories range from concrete models of humans as information processors[1] through the use of cognitive modelling,[2] to the psychological design principles inherent in objects.[3] All of these approaches take the view that human-computer interaction is somehow different from everyday human-human communication. Most view the human as some type of machine with quantifiable characteristics.

Yet observation of people using computers suggests that they treat human-computer interaction as similar to human-human communication. This is evident in the way they anthropomorphize the computer. It is common to hear users say such things as: "What is it doing now?" "Why did it do that?" "It hates me," and many others. It is especially evident in children who attribute "aliveness" to computers, though computer experts will also treat the computer as a psychological entity.[4]

In 1986, Winograd and Flores suggested a new approach to designing interfaces.[5] Since then, other books and papers have appeared that support a shift in design.[6] The common thread is that computer system design should take the social nature of human-computer interaction into account. They do not claim that current approaches are incorrect or inadequate: the idea is to integrate traditional approaches with the social dimension of interaction.

The interaction between humans and machines is not one of user and tool, but of cooperative interacting social agents. The advent of virtual environment technology allows for a more indepth exploration of this interaction. It can bypass the menus and command line interfaces of traditional systems and allow for an immersed interaction with the computer. In short, it can provide a means to explore the social nature of the *bioapparatus*.

1 Card, S.K., T.P. Moran and A. Newell, *The Psychology of Human-Computer Interaction* (Hillsdale, NJ: Lawrence Erlbaum, 1983).
2 Carroll, J., "Infinite detail and emulation in an ontologically minimized HCI," in *Proceedings of ACM SIGCHI 90* (Seattle, Washington: 1990), 321-327.
3 Norman, D.A., *The Design of Everyday Things* (New York: Doubleday, 1988).
4 See Suchman, L.A., *Plans and Situated Actions: The Problem of Human Machine Communication* (New York: Cambridge University Press, 1987). and S. Turkle, *The Second Self: Computers and the Human Spirit* (New York: Simon and Schuster, 1984).
5 Winograd, T. and F. Flores, *Understanding Computers and Cognition: A New Foundation for Design* (New York: Addison-Wesley, 1986).
6 See for example, W.J. Clancey, "Why Today's Computers Don't Learn the Way People Do," *Local Technical Report* (Palo Alto: Institute for Research on Learning, 1990); Paul Luff, Nigel Gilbert and D. Frohlich, eds. *Computers and Conversation* (New York: Academic Press, 1990); Suchman (1987).

Response

DANIEL SCHEIDT

It seems to me that approaches to reality are based on our individual subjectivity and, at the risk of generalizing thought around the table, I think there is a general desire to respect and preserve that subjectivity – to respect and preserve our own unique perspectives on our individual realities. Referring to the papers that fall within my category, I begin with Michael Century's paper. He equates individual subjectivity with a personally directed will, a sense of some kind of control of our place within the world and expresses concern regarding notions of commonality, attunement and the collectivization of our consciousness, specifically in the context of electronic networks and shared experiences. His fear concerns the *loss* of that individual subjectivity as we come together in an attempt to harmonize our different perspectives. How can we harmonize and at the same time preserve the richness of the diversity of the different approaches to conceptualizing reality?

De Kerckhove refers to the illusion of psychological autonomy particularly in the context of television and computer activities. We cannot divorce ourselves from the contexts in which we find ourselves. I connect that notion with the ideas regarding the music industry – which is quite actively exploiting cognitive models of memory and perception. They know how long we like to listen, how long we can remember a chunk of music, how often to play it for us, when we get tired of it and when to replace it with the next tune. I think of the model of radio and television as broadcast virtual reality; it is already there, it is already influencing our common psyches. De Kerckhove makes a connection between electrical current – the medium of technology, the *biology* of technology – and biological current. He makes the point that there is a strong connection with human organisms because of that electrical connection. It is more than just a mechanical connection that might have previously existed. He suggests that interactive biofeedback systems soften the distinctions between stimulus and response, between viewer and viewed, between private and public, and that this softening places previously constructed conventional separations in the realm of mental constructs. He sees these models breaking down because of technological intervention and suggests that the breakdown leads to new forms of consciousness that will represent inter-mediate stages in our evolution which will be cybernetic; they will be self-organizing. He suggests that this is already underway and part of the difficulty of addressing questions of who we are may arise because we are in the *middle* of this evolutionary process, and we cannot observe it from the outside. I connect with the comment that David Rokeby made earlier in the week about the tendency for complex systems to seek their own equilibrium. We do not know what that equilibrium will be or how the process of achieving it is going to happen, but the process seems to be underway.

Regina Cornwall, Wm Leler and Maurice Sharp all present *interactivity* as a critical distin-guishing factor of virtual reality – it is no longer just a stimulus we are being exposed to, but is an environment we can interact with. Maurice goes on to say though that the mode for interaction should perhaps be based on human social interaction. The notion of person/ machine interaction is perhaps not an adequate model for how we should relate to the technology but, in fact, we should look to ourselves and our own methods of social interac-tion to try and develop models for how we might better live – communicate is too strong a word – within a technological environment.

Florian Rötzer suggests that within the model of a virtual reality, users are going to demand a more intense experience than they are leaving behind. Why do we go into an artificial

environment, why do we seek different kinds of stimulus than the real world is providing except for the desire for more intensity? I connect with the comment that Kathleen Rogers made very early in the residency here – that if virtual realities are going to be successful at all or going to be interesting to us at all, they are going to have to be as good as our dreams, not as good as we can dream them to be, but as good as our own dreams are.

However, this model presents a pretty strong paradox – that the desire to escape the confinement of physical reality, the desire for some kind of freedom from the constraints of our physical reality, a desire for some kind of absolute freedom that might be offered within that virtual environment, requires absolute interaction. We have talked about this in terms of the degrees of sensory stimulation and interaction. So we do not want any constraints in our ability to be moved and to exist within these virtual environments. But of course, absolute interaction requires absolute observation. This idea is coming straight of Rötzer's paper. The constraint, then, of absolute observation is an inhibition of our original desire for absolute freedom. This is not the first paradox we have come across in our discussions. We had the Pamper paradox the other day and paradoxes are long known and understood and accepted within a mathematical consideration of reality. Gödel proved very clearly in the thirties that any formal system is bound to contain paradoxes. Robert Penrose, in his book *The Emperor's New Mind*, deals somewhat with the issue of paradox and points out that, rather than stopping us dead, *insight* and *intuition* allow us to transcend the trappings of the paradox, to see through them or around them. I like to think that we can come back to human resources that are not articulated in terms of formal systems or abstract rationalism as being the source of alternate ways to view the difficulties that our environments have provided.

So, the real interface, for me, concerns music. Just as Robin Minard has pointed out, music is close to my heart, close to my body and something that I want to deal with. I think of music in relation to language. It seems that language has failed us; it does not provide a depth of communication, a level of intimacy that is enough for us to transcend the problems that we are faced with right now. It seems to me that language really only offers statement and then interpretation of that statement and that there is an invisible boundary in terms a real exchange of experience – a real sharing of experience in a social context that language just does not offer. I feel we need deeper levels of communication that are based on practice and example and shared experience. A professor of mine, from many years ago, used to refer to music as beginning where language leaves off. He suggests that the reason music is hard to talk about is because it is not about language. I would go further and include art (not just music) as going beyond language. Then there is the question of the role of that mechanism of music and art. Going back to Michael Century's paper, he makes reference to a book by Jacques Attali, *Noise, The Political Economy of Music*. Attali asserts that changes in musical consciousness often foreshadow changes in political and economical structures. In a contemporary context, Century sees a need for "an ability to hear or take in cacophony, a simultaneous mixing of diverse sources, randomness, extreme complexity and to interact with this flux in a personal voice without being swept into it." Century warns of complacency and the danger of allowing the ingestion of signals to stand as a surrogate for personal thought and participation. That connects for me in terms of my involvement with networks. I realize how easy it is to sit back and participate as a voyeuristic observer. There is a reluctance to even attempt to make a contribution to what is already a very noisy signal and a fear that individual contribution is lost within the noise of the network. I am concerned about that and about the need for individual participation.

So, the *real* interface, and I can only speak from a personal perspective, in terms of our technological world, is software. It is software that determines the mapping between stimulus and response. It is software that defines the behaviours of our virtual environments. In fact, it defines the structures of how we relate to the current technological

environment that we live in. Software itself is a fascinating virtual reality; it is a place to go and exercise one's imagination, one's invention. It's a creative medium like any other, but it's also tied into the topic at hand because it is the *medium* of technology. It's the life blood of the decisions and the interaction that is occurring within our world. I want to talk about software with an artistic passion. It motivates me; it is a fascinating experience. I want to talk about it in terms of process, in terms of creative process and notions of meta-creation. What we are dealing with is not the end product, the consequence of our creative notions, but the creation of creative processes themselves. But I am not sure this is the forum to engage in that kind of discourse.

So, the real interface for me, again at a personal level, involves a respect for individual participation and responsibility in terms of a personal strategy. I agree with Robin that we need to infiltrate and subvert the situation that we find ourselves in. People say you can't make music with a computer, but I try. In the context of a failure of communication, the breakdown of established conceptual models and the threat of the loss of self, it seems to me that we can only try to proceed on the basis of very human responses, on the basis of sympathy, on the basis of generosity, on the basis of compassion. I speak of sympathy in terms of a sympathetic appreciation for our common humanity. I speak of generosity in terms of being generous with expressions of our personal subjectivity and also being generous in the reception of the personal expressions of others. I speak of compassion in terms of a recognition of our common and shared suffering.

Discussion

Inez van der Spek:	I do not understand how music would be more direct than language. I did not understand what was privileged about music.
Daniel Scheidt:	I did not mean to suggest that, in terms of music being beyond language, it was superior, but that language in itself seems inadequate for communication. Perhaps there is never anything more than statement and interpretation.
Inez van der Spek:	Yes, but I think that accounts for music as well.
Wende Bartley:	I just want to comment about language. Language is sound; essentially it is sound. I know it refers to concepts itself, but language is a sound medium as well as a conceptual one.
David Tomas:	Also there is a real paradox here: your real interface is software – which is written – and not only that, the creative process in itself is the writing of the program. What does that do to the sound?
Daniel Scheidt:	As I said, I do not deny the paradoxes. I think the expression of imagination – structures that are built within a programming language as we call it – are not particularly linguistic, nor based on strictly textual or verbal language or representation.
David Tomas:	But it is still a language.

Open Discussion – Day Two

Garry Beirne: I would question whether programming is a language – it is not a very appropriate word for what is actually happening in the program. The program is more of a symbolic manipulation of abstractions which does not, to me anyway, directly relate to language.

Daniel Scheidt: The language in the context of the computing program is not a use of language for communication. It is an abstract representation for my own mental processes, to help me articulate my own mental processes, but not to use as a medium for communication.

David Tomas: But, it is going somewhere. It is being read by something.

Robert McFadden: It has to be able to be interpreted by something that understands that language. If I sit down, I cannot make my Atari computer just go over and talk to a Macintosh without a whole lot of interpretation going on – which is frustrating.

Kevin Elliott: I think the point is that programming language is symbolic of logic and thinking and thought processes. You can process either music or data or verbal language and communicate with it, but it is not like verbal communication. I think there is a distinction there.

David Tomas: The important point that Daniel made was that programming was the creative process itself, so that collapses everything into programming, and that is the point which I found really interesting in terms of the translation between someone who thinks about music and someone who hears it. There is not only a collapse in terms of music but a collapse in terms of vision. It is quite interesting to think that all these things are going to collapse into the same types of symbolic languages which are the province of not too many people.

David Rokeby: For myself, a language is any sort of agreed upon set of symbols that we use to communicate to anything, to whatever. What is interesting to me about what you, Daniel, brought up is that notion of sound as a language that is not exactly the same as communication through visuals. As languages, they present different perspectives.

Warren Robinett: To confuse the issue, I can throw out another definition of software: computer programs are mathematics, very complicated calculations. When you write a string of symbols down, you could call that a language, but that is just a form of representing the essence of it, which is the calculation.

Catherine Richards: It is designed to calculate something.

Nell Tenhaaf: To call it mathematics builds back in a neutrality, as if it exists unto itself. It is highly manipulated which I think is the point that is being brought out by thinking of it as a language.

Kevin Elliott: There are many programmers who talk about how interactions they never expected are taking on their own lives through the behaviours users find for them and it seems that is something that artists can work with – the indeterminacy of specifying behaviours that then get out of control.

Catherine Richards: This relates to the virtual reality future which dreams of itself as a complete sensorium. This implies that we take mediums – visual, auditory and other kinds of mediums – and describe them the same way, within programming language. It is a descriptive system, which does have some basic assumptions built into it. When you start funneling down all these different

modes of communication into this one descriptive system, does that imply you are leaving out all sorts of differences? We have discussed this before in visual terms: why do we have Cartesian space in computer graphics? One of the reasons is it was easier to program this model when people were just starting and transformational graphics were pretty difficult. So there are biases in the description system that tend to push you one way. That is not to deny that you might be able to do a lot with it.

Daniel Scheidt:

I think you are talking about speech rather than language – speech as a particular instantiation of language. In relation to the difference between a visual and sonic perception, I think that there is a general recognition that sound somehow is more primal, particularly sound devoid of speech. I know that perceptual research has shown that, in terms of response to stimulus, the first thing that seems to happen is that the brain wakes up and says, "Something has happened." After that, the first question is, "Did I hear something?" Following that, there is the question, "Is it close?" After that, there are higher levels of processing to analyze what is going on. So it does seem that sound *does* have this primal quality that distinguishes it from language.

Nell Tenhaaf:

I just want to make a comment as a visual artist who works with programming in the sense that I work with other people's graphics programs. Visual arts practices are at a point where the wish in terms of technology is not to see them as transparent but in fact to take the technology as a kind of interesting complication. The issue is a more complicated notion of appropriating that space as a cultural space or a language or whatever. Somehow, it seemed to me that we were talking at a kind of simplified level – where the tool is just there as transparent – whereas I think it is much more interesting to build into the work how that tool is set up or constructed.

Catherine Richards:

We are all privileged in a way as artists working with technologies. We want to create different models, but at the same time, when I see what has happened with the Walkman, I do not see any reason why a new mass medium sensorium (virtual reality) is not going to be used as a sort of antidote to problems we have not solved in the world. It just seems like a quick fix. One key to virtual reality is that it allows you to go into distant and hostile places that we have just polluted. That is a kind of nightmare scenario of how it can be used to simply accommodate existing problems. It does not eliminate the fact that I am personally interested and I want to try to make new models, but at the same time, I have seen new models marginalized by mass media practice over and over again.

Wm Leler:

I think you underestimate the collective of the people in this room.

Robin Minard:

I think composers, contemporary composers, are quite concerned with the question of language. What I have tried to do is strip sound language of much of its cultural and intellectual interpretation. I think that is something which makes it non-gendered, for example.

Michael Century:

Music tends not to have a semantic component. It is syntax but not semantic. Or at least when music operates on a semantic plane, it is on an iconic level, like a bird call, as opposed to semantics that develop through the evolution of natural language.

Wende Bartley:

One of the things that I have learned about working with language as a sound medium is that language consists of two things: basically, vowels and consonants. We can learn a lot from how language functions as a compositional model.

Wm Leler:

Computer language, despite what computer scientists often say, is only syntax, it is manipulation of symbols. And another point: I strongly disagree with the idea that virtual reality is like a giant Walkman. Why isn't the telephone used as an analogy for the Walkman then? With a Walkman, there is no communication, no interaction. It is a form of escape. I do not think virtual reality has to be anything like that at all.

109

Jeffrey Keith:	I would just like to know if anybody has been doing any work or has any experience with this idea of interpersonal non-linguistic, sonic communication.
Warren Robinett:	Does not all music fit your definition, non-linguistic interpersonal communication?
Jeffrey Keith:	I would like to hear more about the actual virtual reality experience or interpersonal experience. Yesterday we talked a lot about gender specific problems and cultural problems and I am wondering whether the key to some of this might not be in sound alone. That is my question.
David Rokeby:	It is an interesting notion. I am being consulted right now by New Zealand television to do experiments involving some sort of communication between humans and dolphins using my system and sound. I do not know whether it is just an interesting notion, but it is not just cross-cultural, it is cross-species. The other thing that I wanted to talk about occurred to me as Catherine was speaking about mathematics. I have a story about our projected virtual future. Imagine that people have been living in virtual reality or in highly constructed computer environments for a long, long time. And a form of science has evolved where they study the phenomena they see in their virtual reality (because a lot of the technology has been forgotten and the virtual worlds appear to be self-sustained) and they discover that certain things happen over and over, certain patterns, that it is not just random activity but there are patterns of relationships between things. They pursue this through centuries of exploration and finally – I can see the headline – "Elementary particles finally found, called the unitron and the voiditron, the zero and one." In the present, we still haven't figured out if that is really true about our reality. So the idea of trying to render virtual reality with a set of elementary particles is problematic. We have not been able to find that in reality so the model seems inadequate.
David Tomas:	Western cultures have been very sophisticated using language as a mode of assimilation, so this I think has a direct bearing on software. Also, in first contact situations where the spaces are relatively neutral, there is a very bizarre space that gets set up, which I have done a little bit of work on, but there is a kind of strange space where there is a balance of power, which does not happen when language sets in.
Robert McFadden:	Colonization through music is happening already. It has happened for a long time. I am reminded of a story told to me last year by a musician friend who went to play in a country and western festival in Frobisher Bay. He was amazed by how current people were about music and the number of live acts they had seen. It turns out that during the sixties, all of the airplanes going to Vietnam would stop up there to gas up. When the entertainers going to play for the troops would stop, they would also do concerts. Johnny Cash played in Frobisher Bay. But that is a prosaic example. It is more insidious when we hear a native musician playing country and western and we say, "Oh, he's lost his culture! That's not native music!"
Lawrence Paul:	In our culture you do not have all these fibre optic things and it is quite an interesting mask that virtual reality has produced. I come from a tradition that was passed down in the West Coast. At the age of fourteen, I was given a mask and it had responsibilities that go with the culture. As the carriers of the mask, we took responsibility for all the people who were in this room to dance. We wanted to cleanse the floor, to protect them from this point of season to the end of the season – I do not consider it magic, but I think the energy that we give to other people was quite an interesting position. I think I have seen a modern example of technology. In the longhouse, somebody built a fan under the ground and sent a tube to the fires we would have going. It was our longhouse and so we would have these other communities coming around, and we would get to standing beside that fire and the dancers would be dancing, then we would have our fire maker go over to that switch with electricity and turn it on, and poof! You have never seen so many dancers jump back. We had fun

with this technology for a long time. We wanted to see what kind of response we would get. It is a different culture though. There are no cameras allowed in the longhouse, no film, no tape recording allowed. All those things have been changed. Modern technological changes were chosen by natives; these changes slowly integrated technological culture into the human culture in the longhouse. You adapt to it, you use it to a benefit in cross-cultural exchange, but still not everybody gets to go in the longhouses. It is still clear. I have only seen maybe half a dozen non-natives in there so far in my lifetime and I have been in there most of my life. It is different – how you experience things in life.

Catherine Richards:

There has been a lot of reference to virtual reality being like the telephone but more interesting because we can communicate directly. What occurred to me when you mentioned the mask is that virtual reality is like a shared environment in which there are multiple masks. We do not have that concept of mask, specifically or consciously, in our culture, which would help us deal with it.

Tim Brock:

Warren, you said that you see this virtual reality as the solution looking for a problem. I am just wondering where we are – if there really is a solution.

Warren Robinett:

I meant that in kind of a commercial sense: to get one of these technologies going, you need somebody to buy some of them so that money goes into them to spend on research and development. It does not move along very fast just on grants. There is no commercial application yet. A lot of people will think it will be entertainment like the next Nintendo.

Tim Brock:

I think what bothers me a little bit is that we were talking about a medium and questioning its use and it appears that it would help improve the quality of our communication, but it kind of seems a little crazy to me that so much attention is being given to the medium as opposed to the message.

Warren Robinett:

That is what I felt this whole residency was about – thinking about virtual reality as a new medium. It doesn't have much content in it because it is as if there are about two dozen canvases in existence and a few people have slopped a little bit of clay and berry juice on to them. It doesn't have much content, yet.

Mark Green:

Two months ago, I talked to a group of people, mainly doctors and sociologists, about the work we are doing with virtual reality. One doctor had some interesting insights to deal with sensory and reality issues that a lot of people have brought up here. Severe Alzhiemer patients are currently drugged, heavily drugged to control them because their reactions are not what we would expect, they are not normal reactions. This particular doctor is upset because Alzheimer's patients respond in a predictable way to the environment but they just do not respond the way that we respond and it is not clear whether their response is any worse or any better than our response. And one of the ideas we talked about was whether it is possible to take this type of technology, modify the sensory input that they are getting, so they can respond in the way that would be viewed as normal or acceptable in our culture.

Adam Boome:

Like wearing glasses.

Robert McFadden:

Of course, the other alternative is for us to start accepting people with different perceptual abilities, providing space for a wider range of physical abilities.

Mark Green:

The problem is that they tend to burn down houses because of the eccentric perceptions that are coming in. It is not just a matter of accepting a limp or a different way of talking; it is a dangerous behaviour.

Mike Mills:

The question for him is what kind of modification would evoke predictable behaviour.

Chris Titterington:

I would like to ask Warren and Catherine to predict whether I am going to be able to jack

111

into a network at home or whether I am going to get my virtual reality experience down at the amusement arcade?

Warren Robinett: It is hard to say how long things will take but I can see some possibilities in several areas, such as synthetic senses, where you can hook up electronic sensors to head-mounted displays and see things that are invisible to your ordinary senses such as infrareds, x-rays or ultrasound. You would be able to see through walls like Superman, to have a set of super-senses. Another strand is tele-operation and telepresence: as we can now use the telephone network to project our ears and our voices around the world, you will be able to project your eyes and your hands to other places or into microscopic environments. They might be dangerous places but I don't see that as a bad thing itself. Yet another strand is to record three-dimensional scenes in a way that lets you move through the scene and have different viewpoints within it instead of just a single viewpoint as with photography or film. The fourth strand is simulated worlds. I call these three-dimensional video games you can get inside. To me, this fourth strand represents the vision of virtual reality as embodied in current technology. I think these simulated environments are going to get more sophisticated. I see two sub-strands within the simulated worlds. First, there are simulated environments that are created to entertain or instruct or give catharsis. Second, I also see a class of simulations that are created to predict what could be. These are more in the line of scientific simulations or flight simulators. The last strand that I can imagine is an interlinked network of global communications where there are microphones and sensors everywhere. With the telephone, you transport your voice and your ears to a single location and have a conversation with the single person. I can imagine a whole lot of cameras getting a collective impression of things that are happening in many different places and integrating those together – everything that anybody has ever seen since they started wearing glasses would be collected into the giant experience database.

Catherine Richards: At a small conference in California where the majority of people were involved in virtual reality research, Warren asked the question, "In ten years, where is the major development going to be in virtual reality?" Most of these people – who were scientific researchers – said entertainment, which, I admit, really took me aback. I understood the question just asked to be, "Am I going to be at home or at the arcades?" I noticed in the history of film, it reached the general public through the arcades and virtual reality is being introduced in a similar way. It is also interesting to note that new computer technology in North America is often first introduced as a toy: it is introduced through children. For example, the virtual reality glove went almost straight from the research lab to Nintendo home computer games. Who is going to devote the resources to develop virtual reality? I think it is quite significant that the telephone companies are now involved in virtual reality research. Telephone companies have always been called common carriers, which means legally they do not originate anything on telephone lines; they respect the communication between private individuals. For the first time in the United States, they have passed new legislation that allows a telephone company to originate material. Those two changes in the activities of phone companies are quite interesting. The impetus for a mass media scenario of virtual reality, beyond specialized uses such as in medical research, may come from the telephone companies. If so, we will be able to plug into, at home, some kind of common database. Efforts may be made to render the technology, "less intrusive," but that just means more surveillance of the body.

Commentaries

Garry Beirne

Does virtual environment technology have the potential to be "an instrument of a re-ordering of perception" and does it portend a re-arrangement of power relations?

Much of the virtuality discourse raised during the seminar presented arguments about future contexts of the politically and historically correct. But the present and the future cannot be defined in terms of the past. While we must be conscious of the past and the present, our musing on the future cannot be constrained by contemporary intellectual games. A re-ordering of the power-structure is happening, whether we like it or not, and it will not likely be informed by esoteric references from the postmodern bookshelf.

The apparatus, in particular technological instruments, has tended to reinforce, or even exaggerate the mind/body dualism. But the new immersive technologies, characterized by close coupling of the visual, auditory and kinesthetic modalities, permit a level of sensual engagement that threatens to re-establish the importance of the body and emotions, to reimbody the user, to reaffirm a corporal relationship to the world. It has been suggested that the marginal representations of physical self and its environment that are the bane of today's virtual worlds may have the beneficial side-effect of heightening people's awareness of the importance of our bodies, our senses, and our environment.

**Immersion,
Re-embodiment and
The New World Order**

A re-ordering of the power relations will happen – is happening. The traditional scientific posturing of the computer world is being strongly affected by the influences of what are often called the soft sciences, such as sociology and anthropology. Perhaps the sensual aspects of the new apparatus will empower individuals who have been outside of traditional scientific circles.

> A unique and wonderful characteristic of the medium of virtual reality is the discourse surrounding it....Many of those participants have communication skills that allow them to speak directly about their work, unmediated by journalists or other interpreters. In that way the emerging medium is being more directly and dynamically shaped by the culture at large.[1]

1 Brenda Laurel, *Dramatic Interaction: Designing Human-Computer Experience* (Reading, MA: Addison-Wesley, 1991).

Francine Dagenais

This seminar on the *bioapparatus* raised but did not fully address several issues relevant to technology and more specifically to virtual reality. Three issues in particular were skirted during what I would characterize as the Revolt of the Empiricists.

The first of these concerns the symbolic nature of language.

During the course of the seminar, we learned that computer practitioners do not understand the strings of symbolic code employed in programming as language: the use of translational systems between the human being and the computer is not considered to constitute the passage of information and signifieds of "data statements" are not conceived as transmitted through language. Rather, technopractitioners appear to prefer to think of the entire process as being magical, which leaves a mystery surrounding computer work in many ways similar to prestigiditation. The magician must first learn the tricks of the trade but the secrecy surrounding this bag of tricks is vital to preserve the power of the practitioner.

Irrationalist Perspectives on Machines of Rational Thought

This brings me to the second issue requiring elaboration: the magical.

What was defined as magic during this seminar can be more appropriately understood as illusionism. These illusions appear to manifest a longing for lost boyhood (or its prolongation) when life was better left unexplained and when the immediacy of gratification could be coupled with a lack of critical awareness or reflective or analytical thought. It was stated by some of the technopractitioners that they did not wish to understand why they achieved certain results: gratification issued from the unexpected. The feeling of power is thus derived by extracting from the computer certain effects which are beyond the programmers' immediate grasp. According to this view, technology and its future seems to have no limits; it offers a gradual progression towards the fulfilment of techno-fantasies. Virtual reality, then, can be seen as a slight of the eye, the ear, the hand, the body, an illusion that may deliver the yet unimaginable.

Connected to these issues is the subject of gendered technology.

Although considerable effort was made to prevent the ghettoization of gender issues, that is precisely what occurred. Discussion on the second day of the seminar was clearly a reaction to earlier debate in which the critical issue of otherness was raised. The presentations were largely technocentred and gave the illusion that technology could be considered objectively (removed from cultural and social implications). Computer operators were described as wizards (as opposed to the witches) suggesting a lack of awareness of the ideology grounding such technology. The exclusion of gender issues from these proceedings had several implications: the discussion was taken over by male specialists whose technological expertise appeared to exceed an understanding of the socio-cultural consequences of virtual reality; virtual reality became the focal point of the discussion at the expense of crucial questions such as those concerning subjectivity; and several women felt alienated from the proceedings to the point of leaving the room. In the hallway, the discussion was animated. Many of the respondents felt othered by the world of technology.

The conception of technology as magic is distant from anthropological or feminist structures of analysis. This approach appears to be grounded in a technological mythology elaborated in the science fiction of the late nineteenth century and inspired by faith in the fulfilment of science-fictional prophesies. Science fiction, utopian visions and tales of extraordinary

114

voyages are all literary genres that borrow from reality to create plausible worlds outside of existing spatio-temporal boundaries. It is the flight outside of these boundaries that characterizes these fictions as examples of cognitive estrangement. According to this model of the psychology of beliefs, distancing is necessary in order to produce the framework for rational conjecture.

Conjecture about the future has been labelled in this seminar as virtuality. Virtual reality, as understood by technopractitioners, is the evolution of *techne* towards a teleological goal of perfection outside the body. This may infer the annihilation of the body, if, as Inez Van der Spek observed, "the perfect body is no body at all." The evolution towards an ultimate virtual reality that responded to the entire human sensorium was evidently viewed as a positive achievement.

Here in Banff we were given the opportunity to work out new socially ecological models that would help shape the technologies to come. These would be infinitely healthier than the ones passed on to us by a male-dominated society under the influence of the worst possible aspects of positivism. However, the seminar proceedings suggest that the nineteenth century is still with us.

Warren Robinett

I have heard much criticism of technology and of virtual reality but, though I strain to understand and ask the critics for clarification, I am left with abstract and incomprehensible phrases echoing in my mind. I am utterly unable to relate these criticisms to the choices I must make as I work to develop virtual reality. If you want to influence what I do, you will have to offer concrete suggestions of what to do or what to do differently.

You will also have to talk in a language that we technoids can understand. If I hoped to argue convincingly in art theory or feminism, I would have to speak in terms that art theoreticians or feminists understand. If you wish to change what I do, you have to convince me, and you cannot do that using language I do not understand.

To Those Artists Who Want to Influence the Development of Virtual Reality

I do not understand the notion of gendered technology, for example. I understand that its proponents argue that almost all technology, and virtual reality in particular, was created mostly by men and has therefore been shaped by male values embodying aggression, warfare, desire for power, the need to dominate and the exclusion of women. But let's back up to an older technology – photography – which is also supposedly gendered. Developed mostly by men? Yes. Shaped by male values? No, I don't see it. Rather, photography is shaped by the limits of light, lenses, mechanical shutters and chemistry. The camera itself seems neutral to me, though particular photographers, male or female, have their interests and biases. I see the medium (photography) as neutral and the content (photographs by specific photographers) as biased by individual predilection.

To me, it's the same for virtual reality. As a medium, it is neutral, though the contents of specific virtual reality demos, pieces or systems reveal their creator's viewpoints and prejudices. When I work at developing the medium itself – the hardware, software and conventions of virtual reality – I fail to see how a sensitivity to gender issues should influence my choices. Should I improve the resolution of the head-mounted display? Improve the accuracy of head-tracking? Build improved manual input devices? Develop methods for travelling through virtual spaces? Yes, I should. Would a feminist choose differently?

Talking or writing might influence what I do, or it might not. After all, I have my own interests and goals. It would be most effective to *show* me what virtual reality could be, according to your own vision.

115

Mirelle Perron

This is what it meant to hold a seminar on the concept of the *bioapparatus* as a site for deconstructionist debate on representation: two afternoons of discussion with the Archetype, the Ordinary and their friends, the Semiotic Ghosts, who acted as backup vocals. It was tricky business to orchestrate the discussions so we would sing together and not just follow their lead. When the Semiotic Ghosts spontaneously broke into one of their favourite songs, we could hardly listen to one another – for two thousand years, their preferred refrains (not unlike the Holy Trinity's) have been repeated endlessly and sung in a chorus round:

Universality

Wholeness

Disembodiment

**Desires, Pleasures
and Fried Brains**

Their strategy is called Sameness and their goal is to convert the world of virtual reality into a more familiar Cartesian virtuality. Obviously, those who feel excluded from Cartesian reality are highly suspicious of Cartesian virtuality. Is it at all surprising, for example, that a feminist artist who has worked for years on the reappropriation of women's bodies would be suspicious about the neutrality of a concept like disembodiment?

I would like to tell my selves that the desires of art, science, technology and philosophy are converging on a significant scale. I believe they do on a small scale (this seminar was living proof of it), but the dialogue is still very difficult. When an artist who wishes to make use of technology in his/her work talks to a computer scientist, does the latter sincerely believe that he/she has as much to learn in return?

I still think that not enough scientists go to bed with bedtime stories that are similar to those of artists or philosophers. Until we do, we won't share the same dreams and probably not the same virtual realities. The coordinates in virtual realities, like in dreams, consist of very sophisticated electrical impulses called desires, pleasures and lies. Desires and pleasures, like lies, are devices designed to measure the difference between peoples. The desires of some people can easily fry the brains of others.

"I'd like to see a utility called Donna Matrix who periodically appears on your screen, cracks her whip and says, 'Get to work, you gutless turd!'"[1]

1 From an interview with Mike Saenz, "The Carpal Tunnel of Love," *Mondo 2000* 4, 145.

David Tomas

The *Bioapparatus:*
Reflections Beyond
the Interface of
Theory and Practice

During the course of this seminar on the *bioapparatus*, we were presented with a powerful object lesson on difference. At its best we were initiated into the contradictory social life of virtual reality technology plotted according to the interactions of various social groups. At its worse, we were trapped in a social and artistic netherworld where questions of social practice and virtual reality technology, of the body – its genders, socio-cultural status, and cross-cultural transformations – were subverted, marginalized, or simply ignored in a situation fragmented by conflicting agendas that bore imprints of archaic systems of belief and personal and professional ambitions.

After two days of presentations, discussions and behind the scenes ruminations and arguments, including the articulation of frustration and despair on the part of a large portion of women artists and theorists, there seems to be only one conclusion available for retrospective contemplation: While the majority of artists appear to have been theoretically and practically ill-equipped to deal with this new technology at the level of its technical organization, those involved in developing its hardware and software are equally ill-equipped to deal with its social and cultural dimensions as well as its political implications. As a result, important issues – the gender of technologies as functional artifacts and social practices, the body as site of multiple socio-cultural and political experiences – were lost to critical reflection and analysis. In fact, it was almost as if at times the language of critical reflection was deliberately stifled or implicitly banned because it dared to speak of these difficult topics.

At first sight, this public forum appears to have been governed by a fundamental distinction between theory and practice – on the one hand, those who wrote and speculated in terms of theory, on the other hand, those engaged directly with the technology. It was, moreover, a distinction that was unfortunately reinforced by the seminar's structure as reflected in the conscious attempt to group papers, sessions, and individuals according to issues connected with history, the body or subjectivity versus issues grounded in particular domains of practice such as sound and fiction. However, insofar as participants wittingly or unwittingly forced discussions of the body and/or social and cultural difference into the spatial margins – corridors and bars – because of a desire to foreground their practice, the seminar manifested a more profound and problematic malaise. If the organizers and participants were under the impression that persons could be categorized according to a social division between theorists (intellectual labour) and practitioners (non-intellectual labour), the actions of a number of participants clearly revealed a governing anti-intellectualism that manifested itself in a preference for promoting production and consumable products as opposed to critical reflection. However, the choice of participants from diverse social, cultural and disciplinary backgrounds suggests that the distinction between theory and practice had not been conceived in terms of a distinction between intellectual and non-intellectual labour, but precisely as modes of knowledge: critical theory, feminism, colonial discourse, and so on, and knowledge concerning virtual reality technology and its related research agendas.

If the seminar's failure to address potentially socially significant issues in any depth is to be ascribed to the implicit presence of an archaic model of the social division of labour which undermined attempts to situate theoretical issues in the domain of practice and vice-versa, it must also be noted that this model's governing organizational role in the seminar was enhanced by the conflicting ideological orientations of the interest groups that were present.

First, the artists came from a variety of sub-disciplines such as performance, installation, painting and electroacoustics, and from a wide variety of social and cultural backgrounds: Canada's First Nations, China, England, the United States. Second, the researchers' interests were limited to technical, research and development, or corporate agendas. Finally, the interests of representatives of the administration were divided according to their particular allegiances to specific projects and/or theoretical positions. While it is evident that conflicting views of the various interest groups that undermined attempts to articulate important theoretical issues because of, in the most concrete instance, a lack of common language, the subversion of critical reflection was also the product of alliances between groups in the interests of furthering common goals such as the presentation and promotion of their work. Thus artists who looked to the seminar as a forum for theoretical discussion found themselves opposed to artists who were interested in using the seminar as an arena for the presentation of their ideas and work, as if the two were by their very nature incompatible. The result was a more than ironic divorce of theory and practice because it implied that work could be presented under the rubric *art* which would then ensure that it was totally divorced from theoretical considerations, while theory could be treated, on the other hand, as if it was an autonomous product whose only ground of legitimation was to be found in its academic origins whose elitism then served as an excuse for summary dismissal. On the other hand, artists of both orientations sought alliances across sub-disciplines solely on the basis of common attitudes towards *practice* or *theory* without having any clear ideas as to the differences between such diverse practices as music, acoustic art, performance, installation and video or competing theoretical domains. Finally, the unfolding of the seminar revealed not only a disjunction between theory and practice, it also reproduced, by way of this disjunction, a fissure between mind and body which resulted in those persons who were most interested in the body and its vicissitudes (the majority of whom were women) being misrepresented as proponents of the mind. This constituted the principal irony of this seminar's many ironies.

At the roots of this spectacular confusion of methods, practices, and strategies is, as I have suggested, a popular misrepresentation of the intellectual as harbinger of theoretical discourses which was unconsciously juxtaposed during the course of the seminar with another popular misrepresenation: the artist conceived as a representative of manual labour.

In sum, the concept of an intellectual, whose etymological roots, one should note, can be traced to the Latin *intellectus* (perception, discernment or understanding) seems to have been too narrowly conceived, during the course of the seminar, as an advocate of pure theoretical activity and specifically an advocate of feminist high theory whether or not this body of knowledge was, in fact, brought to bear on specific problems of the body and technology. Moreover, this linkage was made notwithstanding the obvious fact that in a number of cases the persons who were most closely identified as having a theoretical position were practising artists. Finally, linkage was achieved under the auspices of a particularly archaic and damaging definition of the intellectual as one who labours solely with the mind and thus functions, in a specific academic sense, in isolation from the social. This was contrasted with art practice which was itself implicitly defined, for example, in terms of an isolated domain of personal or emotional expression, as if art and its institutions were not fully integrated into a culture and its social organization.

Raymond Williams reminds us that the intellectual "as a noun to indicate a particular kind of person or a person doing a particular kind of work dates effectively from eC19 [early nineteenth century]1 He notes, moreover, its negative connotations, and concludes "the social tensions around the word are significant and complicated, ranging from an old kind of opposition to a group of people who use theory or even organized knowledge to make judgments on general matters, to a different but sometimes related opposition to ELITES, who claim not only specialized but directing kinds of knowledge."2 Thus, if we were

witness, during the course of the seminar, to the marginalization of the intellect as a site of critical reflection, it is important to note that it was not a process that was peculiar or isolated to this specific group of individuals or this seminar and its structure, for this type of marginalization is clearly a product of certain historically determined conceptual classifications that structure social activities in western Anglo-European cultures.

On the other hand, Williams also reminds us that art, as currently understood, is also a particular historical construct rooted in the nineteenth century.[3] He relates the modern distinction between science and art "to the changes inherent in capitalist commodity production, with its specialization and reduction of use values to exchanges values."[4] Within this division of skills, the modern artist takes on a very different social identity which is distinct "not only from *scientist* and *technologist* – each of whom in earlier periods would have been called artist – but also from *artisan* and *craftsman* and *skilled worker*, who are now *operatives* in terms of a specific definition and organization of WORK.[5]

In retrospect it is possible to interpret the intellectual and social turbulence that characterized the seminar as the product of contact and friction between persons who identified themselves, in their attempts to come to grips with a new and potentially useful technology, with one of these two principal domains of western human labour: the utilitarian and non-utilitarian or socio-economic and socio-cultural.

If, however, the failure to bridge different domains of knowledge and social activity can be explained by reference to a specific capitalist division of labour and associated categories of social classification, what is disturbing in the extreme, given the seminar's topic, was the ubiquity and transparency of the influence of such archaic categories of thought on the interaction of *all* participants.

If the seminar on the *bioapparatus* can be considered to have been germinal, it is by way of posing the question *in absentia* of the demise of the intellectual as viable subject identity for thought and social action at the interface of new technologies, which it did in the following *negative* terms: If we cannot adequately address difference of gender, culture, and race, across the interfaces created by social divisions of labour according to different kinds of skills, how can we deal with our own subjectivities and their socio-political and cultural alienations both as citizens of nations that are rapidly fragmenting and dissolving in an acoustic and cultural cauldron of different systems of belief, customs and voices, and as citizens of a New World Order that is not of our making? Moreover, if such fundamental questions as the social structure of language, gender, and magic are completely misunderstood, misrepresented, or deliberately ignored, as was indeed the case during the course of the seminar, how are we to address virtual reality's embryonic culture, its social and political organization, or its present economic biases and orientations? How are we to impose our wills as social subjects in quest of a new *body* of social practice and how are we to influence those who are engaged in engineering its so-called technical and aesthetic parameters? In this context, such archaic divisions of labour as are implicated in the distinction between theory and practice, especially when reinforced by a simultaneous cascade of distinctions between mind and body or conceptual and manual labour are clearly inadequate grounds of classification for conceiving of new advances or experimental modes of labour and social relations in an age of information.

If Williams' vocabulary of "keywords" has been indispensable in uncovering the nineteenth century underpinnings of discourses, one would think that *the* keyword of the seminar – *bioapparatus* – would have alerted us to the possibility of significant changes in the grounds for constituting and reconstituting the discourses of social identity, especially when coupled to other late-twentieth century keywords like post-industrial, postmodern or feminism. The seminar suggests that our current collective identities are no longer generated in relation to the nineteenth century and its industrial revolution, but precisely the kind of multi-dimen-

sional post-industrial landscape – computer chip-design, programming languages, and computer networks – that are generating contemporary imaging systems such as virtual reality and new words such as *bioapparatus*.

Thus, one of the principal object lessons concerning a *politics* of difference to be extracted from this seminar on the *bioapparatus* is precisely the necessity of surmounting archaic categories of thought in the interest of identifying and investigating potentially fundamental processes of socio-technological transformation early enough to be able to critically and reflexively intervene in their development. Critical practice can no longer be limited to traditional domains such as that of the humanities (in its broadest sense), but must now also encompass other forms of technical labour such as computer architecture, programming and network design and their embodied patterns of thought. However, in order do so so, we must all confront the legacy of artistic practices and myths in order to understand that our bodies, our subjectivities, as persons in the late-twentieth century can no longer sustain professional identities whose origins are firmly rooted in nineteenth century social practices. It is under these circumstances that the noun *bioapparatus* can be considered as offering access to a new social identity both in terms of the entity it names and the social practice it suggests.

1 Raymond Williams, *Keywords: A Vocabulary of Culture and Society* (New York: Oxford University Press, 1976), 140.
2 Ibid., 142. Emphasis in original.
3 Ibid.
4 Ibid., 34.
5 Ibid.

FRED TRUCK

The seminar's chief activity was directed towards discovering a language that would allow artists to talk constructively about the new technologies of virtual reality, and what this might mean for the *bioapparatus*. Because the *bioapparatus* residents identified themselves variously as feminists, engineers, artists using technology or artists having reservations about technology as well as representatives of First Nations, European, North American or Chinese culture, resolving the language dilemma was no easy task. Yet the *bioapparatus* seminar is important because it included so many diverse groups and because the recognition of the need to develop a language concerning new technologies was met head on.

It is still too early to determine finally what the results of the *bioapparatus* seminar will be. Residents have been inundated with all manner of arguments and cultural experiments during this period and are now beginning to unwind and look forward to a period of relative calm during which work will be the primary focus. There has been some discussion of having survived the event, including the parties...

But in many senses, all expect the *bioapparatus'* celebration of virtual reality to be a certainty in the future and all are glad to have been present at its beginning.